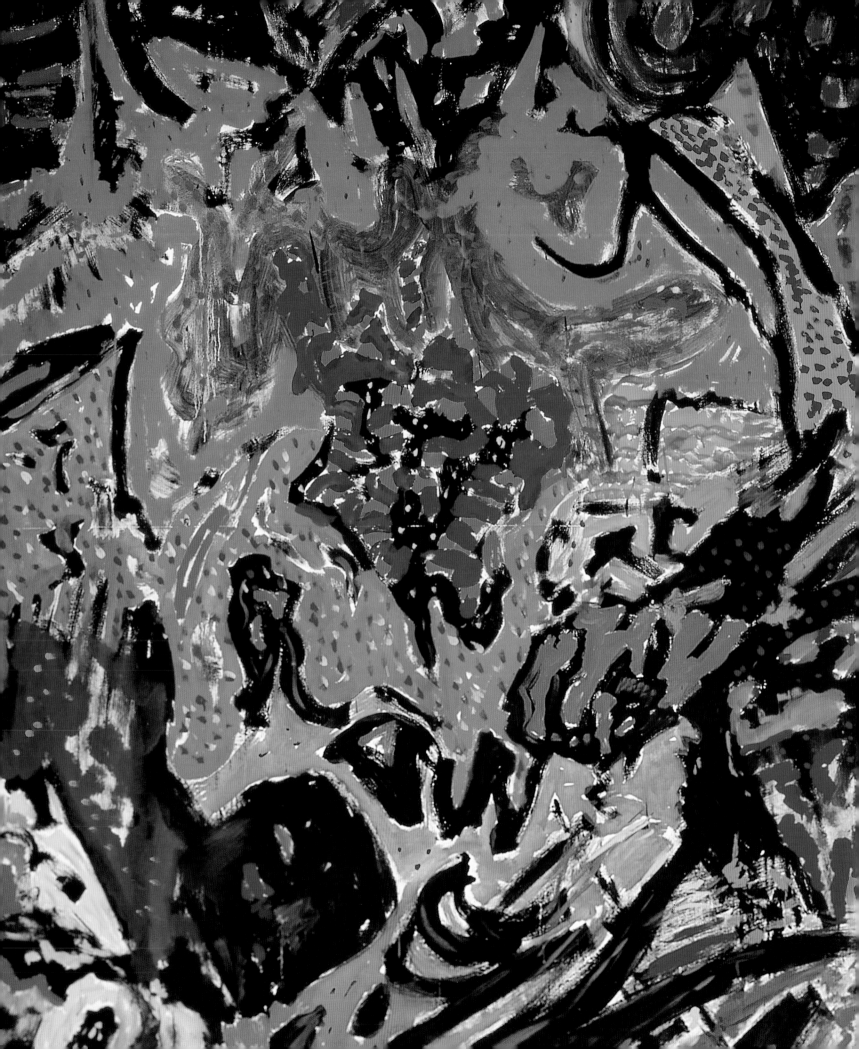

Cornelia Homburg

with contributions from
Sean Rainbird
Catharina Manchanda
Robin Clark

German Art Now

Saint Louis Art Museum

MERRELL
LONDON · NEW YORK

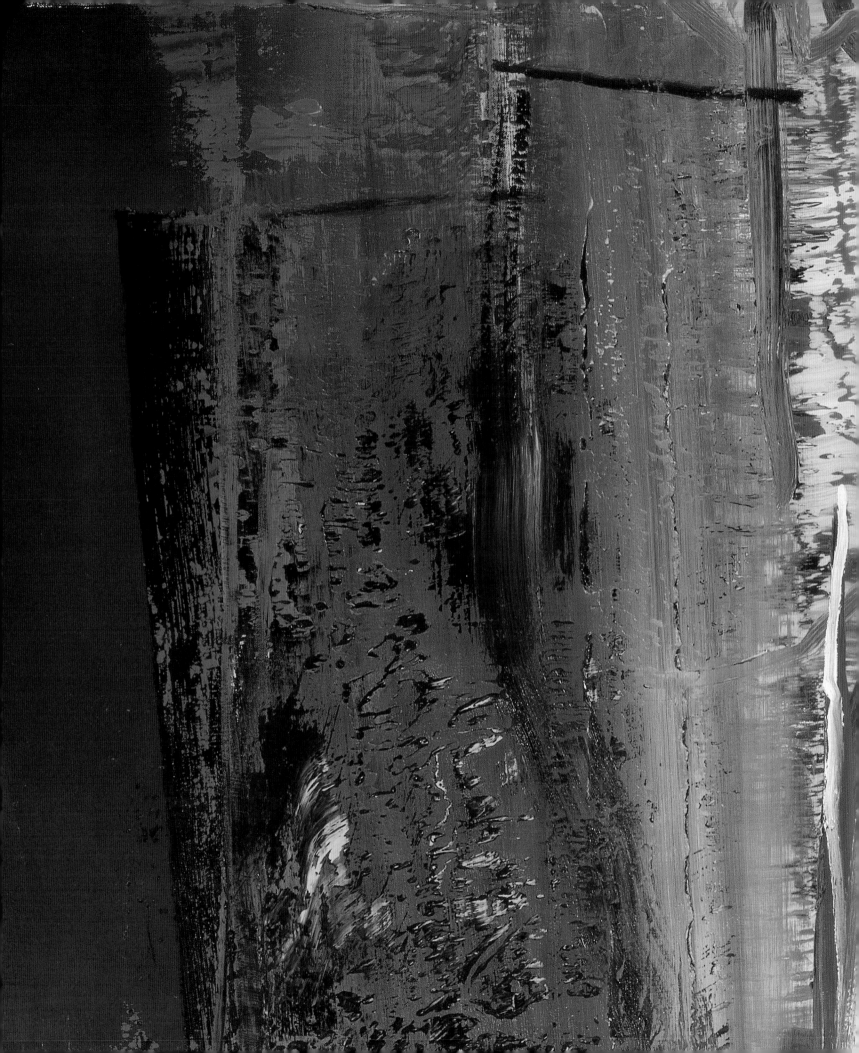

First published 2003 by
Merrell Publishers Limited

Head office:
42 Southwark Street
London SE1 1UN

New York office:
49 West 24th Street
New York, NY 10010

www.merrellpublishers.com

in association with
Saint Louis Art Museum
www.slam.org

Published on the occasion of the exhibition
German Art Now
Saint Louis Art Museum
October 18, 2003 – January 11, 2004

 ALTANA

German Art Now and related programming are supported by
the German pharmaceuticals and chemicals group ALTANA AG
as part of their cultural engagement worldwide.

Library of Congress Control Number: 2003104583

British Library Cataloguing-in-Publication Data:
German art now
1.Art, German – 20th century
I.Homburg, Cornelia II.Saint Louis Art Museum
709.4'3'09045

ISBN 1 85894 235 7

Produced by **Merrell Publishers**
Designed by **Brighten the Corners**
Edited by **Mary Ann Steiner**
Indexed by **Vicki Robinson**
Printed and bound in Italy

Front jacket/cover:
Gerhard Richter
Betty (detail), 1988
(cat. 31)

Back jacket/cover:
Thomas Struth
Pantheon, Rome (detail), 1990
(cat. 42)

p. 2
A. R. Penck
Fritze (detail), 1975
(cat. 19)

pp. 4–5
Gerhard Richter
Ölberg (detail), 1986
(cat. 30)

p. 8
Andreas Gursky
Library (detail), 1999
(cat. 38)

p. 10
Sigmar Polke
Helena's Australia (detail), 1988
(cat. 28)

p. 12
Anselm Kiefer
Brünhilde Grane, Brünhilde's Death
(detail), 1978
(cat. 12)

pp. 16–17
Georg Baselitz
Picture for the Fathers (detail), 1965
(cat. 1)

p. 18
Gerhard Richter
Betty (detail), 1988
(cat. 31)

pp. 28–29
Markus Lüpertz
Interior III (detail), 1974
(cat. 17)

p. 92
Gerhard Richter
January (detail), 1989
(cat. 32)

p. 104
Bernd and Hilla Becher
Blast Furnaces, U.S.A. (detail), 1979–86
(cat. 36)

pp. 114–15
Thomas Struth
Pantheon, Rome (detail), 1990
(cat. 42)

p. 134
Thomas Struth
At the Swinemünde Bridge, Berlin
(detail), 1992
(cat. 43)

Contents

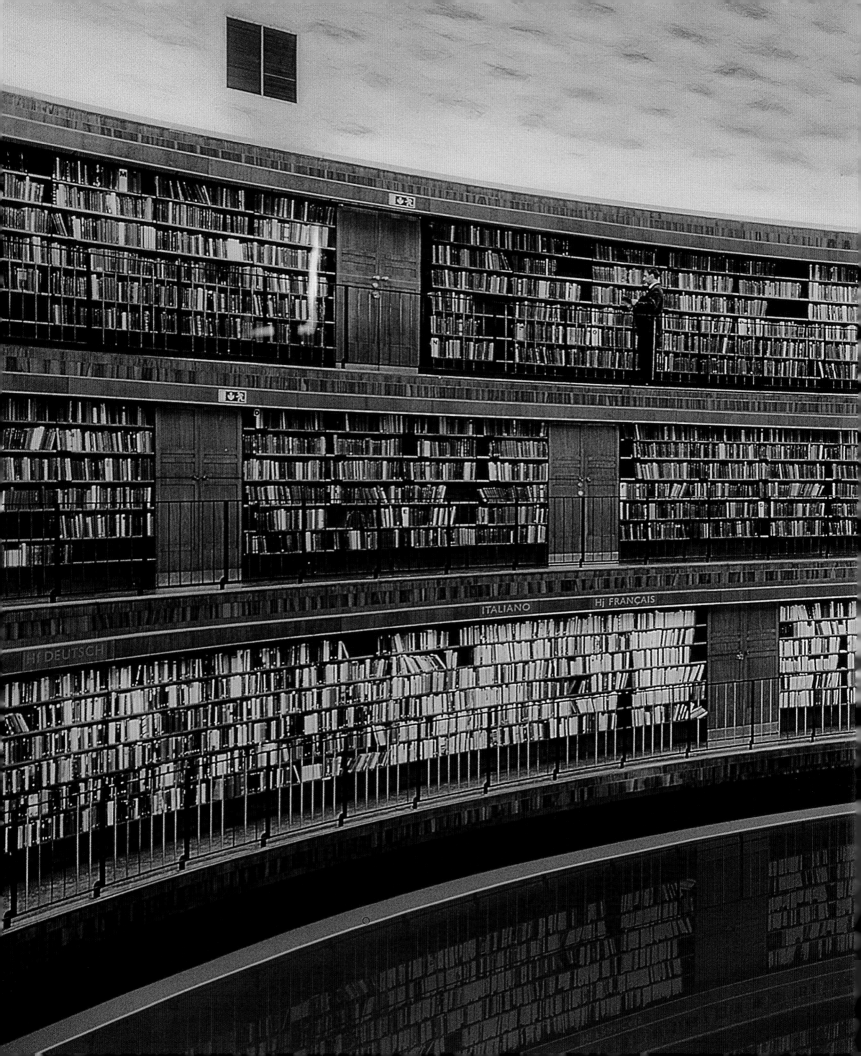

Foreword

The Saint Louis Art Museum's collection of modern German art is one of the largest and most diverse in the United States. It ranges from masterpieces of Expressionism in the early twentieth century to monumental and iconic images from the end of the century. Long recognized internationally for its holdings of works by earlier twentieth-century masters – Max Beckmann, Ernst Ludwig Kirchner, Max Pechstein, and Emil Nolde – the Museum is delighted to celebrate a major acquisition of more recent German art in a special exhibition. What had previously been an outstanding collection of German art has now become a singular one.

German art has seldom been easy. It is often entwined with its nation's history, sometimes expressing its glories, but just as often decrying its tumult and suffering. The works included in the present exhibition are alike in very little except that they were all created by artists whose lives encompassed the experience of a defeated and divided Germany, and whose careers have been strongly influenced by questions about the roles and responsibilities of the artist in that atmosphere. From the revolutionary sculptures of Joseph Beuys in the 1960s to the photographic investigations of Thomas Struth in the late 1990s, these are works concerned with art and society. Whether in abstraction or figuration, this presentation of German art from the late twentieth century embodies a powerful beauty.

That this Museum is able to present its holdings in the form of an exhibition worthy of international attention is due to a long and fortunate history of collecting and the generous support of visionary individuals. Morton D. May, who was an outstanding benefactor to the Museum throughout his lifetime, bequeathed his definitive holdings of early twentieth-century German art in 1983, and in so doing set the stage for subsequent generations of donors in St. Louis who have made possible the Museum's acquisitions of later German art. We are extremely grateful to John and Anabeth Weil, Don and Barbara Bryant, Roxanne Frank, and Ken and Nancy Kranzberg for their strong leadership and support of the present initiative. We thank John and Alison Ferring, Gary and Sherry Wolff, Tom and Barbara Eagleton, Ronnie and Jan Greenberg, Tom and Linda Langsdorf, Bruce and Kim Olson, John and Sally Van Doren, and the Mary Ranken Jordan and Ettie A. Jordan Charitable Foundation, who have also provided generous and enthusiastic support that makes possible this important and ambitious initiative.

Particular thanks are due to each of the artists represented in this exhibition – Georg Baselitz, Bernd and Hilla Becher, Andreas Gursky, Candida Höfer, Jörg Immendorff, Anselm Kiefer, Markus Lüpertz, A.R. Penck, Sigmar Polke, Gerhard Richter, Thomas Ruff, Thomas Struth, and the estate of Joseph Beuys. Michael Werner merits a special note of gratitude. His long-term commitment to many of the painters and his seminal role in bringing them first to national and then to international attention makes him a generous and outstanding partner in this endeavor.

Generous support for the exhibition and the related programming is being provided by the German pharmaceuticals and chemicals group ALTANA AG as part of a long-term collaboration between the Saint Louis Art Museum and the ALTANA Kulturforum, which plans to bring this exhibition to Germany. We are especially grateful to Nikolaus Schweickart, Chairman of the Board, ALTANA AG, and Andrea Firmenich, Director of ALTANA Kulturforum in Bad Homburg, for their support and enthusiasm for this project. Special thanks also are due to Markus Launer of ALTANA AG's New York office for his assistance and support. We are pleased to have the partnership of ALTANA AG as part of their extensive cultural engagement worldwide. Support for the publication is being provided by the Morton D. May Fund, an endowment established by Morton D. May for the benefit of the Saint Louis Art Museum.

Finally, I wish to express my gratitude to our exhibition curator, Connie Homburg, whose professionalism and tenacity have brought this project to fruition.

This exhibition and catalogue could not have been realized without the help of many people. First and foremost I would like to thank all the artists whose magnificent work has had such an influence on the international art scene and has enabled us to create this exciting show. I am especially grateful to Georg Baselitz and his assistant Detlev Gretenkort, Jörg Immendorff, Markus Lüpertz, and Sigmar Polke for the time they spent with me and for their willingness to answer my many questions. This experience has been truly inspirational. I would also like to express my appreciation to Michael Werner, who has shared with me so much of his knowledge about the artists and who has lent such generous support to our project. Thanks are also due to Gordon VeneKlasen, director of Michael Werner Gallery in New York, for his enthusiastic involvement, and to Fiede Leray in the Cologne office for her help.

The catalogue would not have been complete without the contributions of Sean Rainbird, senior curator at the Tate Gallery in London, who wrote an insightful overview of the artists' work, and Catharina Manchanda, who provided an assessment of the photographers. To both I am very grateful. Robin Clark, associate curator of contemporary art at the Saint Louis Art Museum, deserves recognition for her contribution of catalogue entries and her overall involvement in the project.

At the Saint Louis Art Museum many more people were instrumental in achieving this exhibition and I am thankful to all of them. Brent Benjamin, director, has lent his enthusiastic and unrelenting support to this project

and I am deeply grateful for his continuous encouragement. My thanks go to John Easley, assistant director for external affairs, Judy Graves, chief financial officer, and William Appleton, assistant director for public programs, and their staffs for their vital roles in this endeavor. I appreciate the special efforts Jeanette Fausz, registrar, and her crew have made for this project, and I thank Linda Thomas, assistant director for collections and exhibitions, for her coordination of the exhibition. My research assistants, the Aronson interns James Glisson and Tamara Huremovic, have been invaluable in the completion of this project. Tamara's dedicated help with this catalogue is especially appreciated. As always, my assistant Susan Shillito has provided constant support to the many aspects of my work, for which I thank her. I am grateful to conservator Paul Haner for his extensive involvement, as well as to designers Jon Cournoyer and Jeff Wamhoff and their colleagues for realizing the exhibition. As always, the beautiful catalogue could not exist without the expertise of Mary Ann Steiner, director of publications, and her staff. I thank all of them, and in particular I am grateful to Pat Woods for her heroic efforts to arrange the excellent photography.

This project is very special to me because it has attracted the active involvement and support of significant collectors in St. Louis. They recognized the importance of the Museum's collection of German art and were immensely helpful in making this undertaking happen. I thank them for their encouragement of my activities at the Museum. I would like to

mention in particular John and Anabeth Weil, Roxie Frank, Tom and Barbara Eagleton, Don and Barbara Bryant, Gary and Sherry Wolff, Ken and Nancy Kranzberg, Ronnie and Jan Greenberg, John and Sally Van Doren, John and Alison Ferring, Tom and Linda Langsdorf, Bruce and Kim Olson, and David and Rita Wells. The involvement of Andrea Firmenich of the ALTANA Kulturforum has not only led to a generous sponsorship of ALTANA AG but has also provided new exciting possibilities for collaboration that are a pleasure to explore. I am delighted that this exhibition will be presented in an extended format in Europe.

To all of the above and to those whom I have been unable to mention individually, I extend my heartfelt thanks.

Cornelia Homburg

German Art: Why Now?

German painters whose work took shape in the 1960s and 1970s have long been accepted as major figures in the art of the second half of the twentieth century. Many photographers who emerged from the Düsseldorf classes of Bernd and Hilla Becher have enjoyed big solo exhibitions and popular acclaim for their work in the last decade. Why choose this moment to present the achievements of these artists in an exhibition at the Saint Louis Art Museum? In part to celebrate the Museum's recent acquisition of a major group of paintings and sculptures that complement and enlarge its already significant holdings in German art and to create a collection catalogue. It is also an opportunity to underscore the institution's strong tradition of collecting German art.

In the early 1980s the Museum received the important collection of German painting formed by the legendary St. Louis collector Morton D. May. After showing an early interest in twentieth-century French painting and buying works by Picasso, Rouault, and others, May developed a passion for German art. In the late 1940s he discovered the work of Max Beckmann and amassed what is now the largest museum collection of Beckmann's paintings. The painter and the collector became friends while Beckmann was teaching at Washington University in St. Louis. May also purchased works by many of the Expressionist painters, including Ernst Ludwig Kirchner, Max Pechstein, and Erich Heckel, but also Wassily Kandinsky, Franz Marc, and August Macke. When this extensive collection was bequeathed to the Saint Louis Art Museum in 1983, the institution

suddenly was able to show important artistic developments in Germany that beautifully complemented its French-oriented holdings of the twentieth century.

As a result of this magnificent gift, the Museum began to focus on more recent developments in German art. In the 1980s, it organized one of the first exhibitions in the United States devoted to contemporary German painting. Soon after, the Museum began to collect German art of the postwar period. It acquired major works by artists such as Gerhard Richter and Anselm Kiefer that were among the first by those artists to enter a museum in the United States. Collectors in St. Louis also began to acquire German contemporary art, which allowed the Museum to add further significant examples to its collection, some as gifts and some as purchases. Most recently, the Museum added to its collection a large group of major paintings and sculptures by some of the most prominent artists in Germany today, enabling the Saint Louis Art Museum to offer one of the most comprehensive presentations of German twentieth-century art in the United States.

This exhibition and book present an opportunity to further the historical evaluation of the work of Georg Baselitz, Joseph Beuys, Jörg Immendorff, Anselm Kiefer, Markus Lüpertz, A. R. Penck, Sigmar Polke, and Gerhard Richter, all painters and sculptors who began to play important roles in the German art scene of the 1960s. They proposed new directions, and at the same time they all addressed Germany's recent past and political present. These artists have created a new image of German art making

that has had far-reaching effects on younger generations of artists, both in Germany and in other countries. In the United States, their work was introduced in the 1980s in such exhibitions as *Expressions: New Art from Germany* in 1983, *Berlinart* in 1987, and *Refigured Painting: The German Image 1960–88* in 1989.[1] More recently a group of German photographers has attained enormous prominence; among them are the Bechers and their students Andreas Gursky, Candida Höfer, Thomas Ruff, and Thomas Struth. As stylistically diverse as the painters and sculptors, they have opened up new horizons for photography as a medium. These artists are no longer new discoveries whose work must be introduced to the public. It is now possible to evaluate their impact, investigate their shared concerns, and at the same time highlight each artist's unique vision.

It can hardly be stressed enough that these artists who have worked at the same time in the same country do not constitute a group. Though Joseph Beuys was a senior figure who opened new avenues of thinking about art for the generation of painters that followed him, each of them developed an individual form of expression and a personal concept of art making. While their work, like his, often included installation and performance elements, and later sculpture, these artists all were painters on a primary level and all occupied a critical position in relation to abstraction. Some rejected it outright, like Immendorff, who wished to communicate social and political content; others, like Lüpertz, used representational

motifs in their work but considered their paintings overall as abstract entities. Polke started out by using borrowed imagery, but soon began to alternate between abstraction and representation, depending on which approach corresponded best with his ideas. In yet another strategy, A. R. Penck developed a system of signs and symbols that can be read, but his compositions attain a high level of abstraction.

These artists all felt an urgent need to deal with Germany's recent history in their art. With the exception of Beuys, they did not participate in World War II, but, having grown up during and after the war, they were well aware of its destruction and they all lived consciously with its legacy. None of them was willing or able to ignore the issues of guilt and responsibility that were connected to this history. Beuys developed in his work themes of suffering and healing out of his direct experience of the war, but the younger generation confronted Germany with its past in dramatic and provocative ways at a time when the country was not ready to discuss its memories and responsibilities. For example, Kiefer's 1960s *Occupations* series and his use of imagery appropriated from the Nazi ideologues earned him the criticism that he was idealizing and promoting Nazism. In the 1970s Lüpertz, too, was attacked as a sympathizer when he presented his series *German Motifs*, in which there are depictions of Nazi uniforms and emblems. Richter's images of his Uncle Rudi in an SS uniform, or of his aunt who was killed by the Nazis because she was considered "unfit" to live, constituted an

uncomfortable reminder of how closely related every German was to recent history.

Outside of the immediate references to the Nazi era and World War II, these artists were deeply influenced by the fact that Germany and Europe as a whole were divided into an eastern and a western part. As Rudi Fuchs once explained, Germany was historically a crossroads; influences from the east were equally important as ones from the west, and each introduced very different kinds of experiences and ideas, which were then synthesized in German art.[2] With the separation of Germany into two countries, East and West Germany, after the war, and with the establishment of the Iron Curtain, this exchange was interrupted. The struggle between eastern and western political systems dominated Europe's politics. Many artists had lost their homeland due to this separation and thus a part of their identity. Baselitz, for example, frequently had recourse to imagery from books and photographs that he had brought with him from his native Saxony, in the East. Penck tried to survive as an artist in the East, remaining in the German Democratic Republic (GDR) until 1980, when he was forced to leave because political pressures became too strong. Although he had felt isolated and spied upon in the East, he suffered an intense sense of loss and disorientation after moving to the West.

Thus a constant awareness of recent history and the resulting restrictions informed the development of each of the artists in this exhibition. Western influences, especially American, were strong

and vitally important. For painters who saw the vast canvases of the Abstract Expressionists in exhibitions such as the 1958 *New American Painting* in Berlin, the experience was immensely liberating, and it opened new directions for their art making. The appearance of Pop Art in the 1960s was also vital for many of them. Nevertheless, the special situation in Germany forced artists to develop new traditions in place of those that had been interrupted. The art created in the 1960s and 1970s responded to a breakdown of an immensely rich and old culture, and it reflected the efforts of a new generation to find its way in uncharted territory and to establish their own identities.

The art forms they developed featured a strong emphasis on the individual as different political beliefs coexisted, leading to a variety of content and forms of expression. Germany's astonishingly swift economic recovery after the war encouraged many people to try to lead as normal and traditional a life as possible and to forget the horrors of the past. This attitude made it more difficult for new and unusual ideas to emerge, and many artists felt that existing art practices and aesthetic approaches were far too restrictive. Each of these artists was driven by a fierce need to develop a new artistic language that went beyond existing structures and was appropriate for a new time. Polke, for example, who commented ironically on many German clichés, began to use ordinary fabrics instead of traditional painting canvases and applied resins to the backs of these supports to make them translucent – a total reversal

of traditional approaches to painting.[3] Richter explored the supposed boundaries between abstraction and representation only to conclude that he could successfully make use of both, and Baselitz inverted his imagery to introduce a level of abstraction that he felt was crucial for the understanding of his paintings.

Photography, whose presence on the international art scene manifested itself a little later, was also exploring new avenues. Already in their work of the 1960s, Bernd and Hilla Becher seemed intent on excluding any chance or personal element from their photographs as they chronicled the industrial structures that they felt passionate about. Through their art and their teaching they inspired a whole generation of inventive photographers who take very individual approaches to their work. Gursky, for example, uses the computer to manipulate his vast images so that he can create the view of the world that he wants to see. Struth's depiction of interiors in which people contemplate art and architecture opens up new insights into photography in its relation to other art forms. The large scale on which Struth, Gursky, and other of their colleagues work has revolutionized thinking about photography as a medium.

This exhibition and book presents only a selection of works and artists from Germany, choices determined in part by the collection of the Saint Louis Art Museum. The exhibition nevertheless highlights a number of artists who have contributed significantly to the formation of new ideas about art making and who have achieved great prominence in doing so.

Their works present a fascinating insight into artistic practices in Germany. In recent years, interest in German art of the twentieth century has been growing steadily in America. Collectors, museums, and the art market all reflect this trend through exhibitions, acquisitions, and rising prices. Even though most of the artists are still alive and are making art at this moment, their earlier work has already had such an impact that further historical assessment is warranted; this book and exhibition are intended to begin that process.

Notes

1 Jack Cowart, ed., *Expressions: New Art from Germany* (exh. cat.), St. Louis: The Saint Louis Art Museum; Munich: Prestel, 1983. Kynaston McShine, ed., *Berlinart, 1961–1987* (exh. cat.), New York: The Museum of Modern Art; Munich: Prestel, 1987. Thomas Krens et al., *Refigured Painting: The German Image 1960–88* (exh. cat.), New York: Solomon R. Guggenheim Museum; Munich: Prestel, 1989.

2 In a 1984 lecture by Rudi Fuchs in Chicago, in conjunction with the exhibition *Expressions: New Art from Germany*; published in *Georg Baselitz: Bilder aus Berliner Privatbesitz* (exh. cat.), Berlin: Staatliche Museen zu Berlin, Nationalgalerie, Altes Museum, 1990.

3 Penck also used tablecloths and bed linens, but in his case it was because of economic hardship rather than aesthetic considerations.

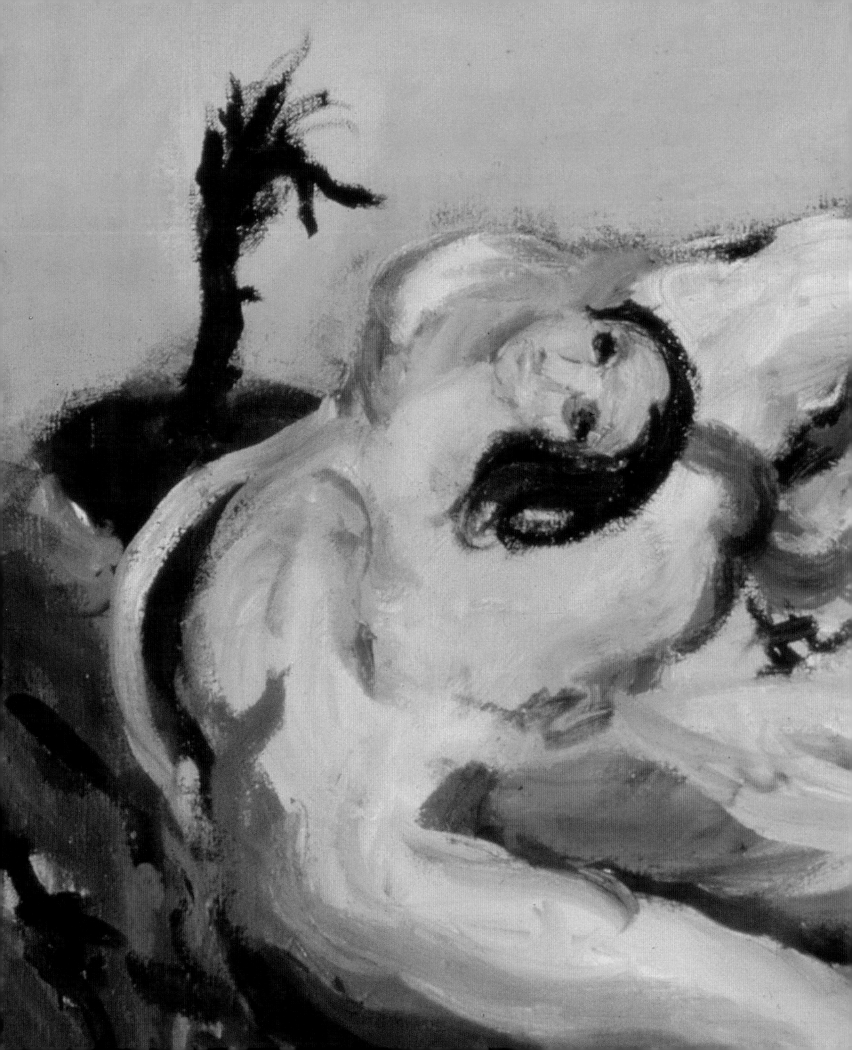

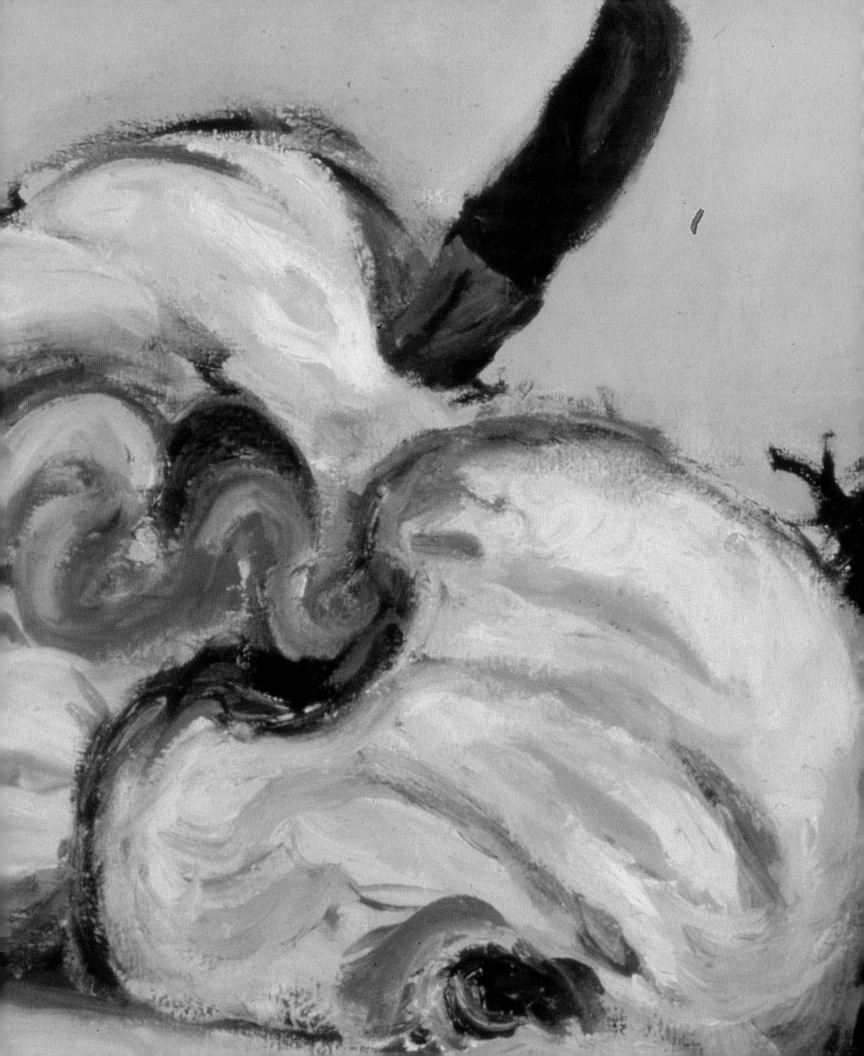

Sean Rainbird

Past Battles, Distant Echoes

The challenge faced by an exhibition curator is to create a coherent display based on representative, high-quality works by individual artists. The curator aims to identify a thread that will lead viewers through the exhibition, usefully illuminating work that may have many levels of meaning and contextual complexity. A still greater challenge is to build a group of similarly significant works into the distinctive core of a permanent collection. Purchasing key works or acquiring them by gift requires a strategic vision sustained over a period of years. Such is the challenge the Saint Louis Art Museum set itself in the late 1980s, basing its efforts upon the historic riches it possesses in its collection of art from the German-speaking world. At the core of these are its extensive and superlative holdings of paintings by Max Beckmann, most of which are owed to the commitment of one man, Morton D. May. The impact made upon him on encountering Beckmann's paintings in the 1940s led May to compile a comprehensive group of works from all periods of the artist's career. This representation in both depth and breadth sets a standard for any subsequent acquisitions by the museum. However, if the case of Beckmann provides an exemplary presence of a German artist in St. Louis, the way in which the museum acquired his works is atypical of the reception, exhibition, and acquisition of German art in the twentieth century. Major collections of pre-World War II German art have perhaps more characteristically been owed to the efforts of exiled collectors assembling or reassembling groups of Modernist paintings

and sculptures by artists who had been defamed by the National Socialists.

German art has a tradition of being marked by controversy, ever since the running skirmishes between modern and academic art, between naturalism and symbolism, and between Modernism and regional traditions swept through Germany during the late nineteenth and early twentieth centuries. Opposing forces struggled to define competing arguments to establish relevance and legitimacy. Controversy erupted most recently in the early 1980s when heated debates accompanied an expressive, figurative painting from Germany that suddenly made a great critical and market impact in Europe and America. This "new" expressionism and figuration coincided with a critical re-examination of the role of painting. During the previous decade or so, painting had appeared to be an increasingly redundant, even anachronistic, vehicle for artistic expression in the face of new mediums such as video and photography. Still more prominent were interdisciplinary practices such as happenings and performance art, the dematerialization of the object in Conceptual art practice, and new approaches derived from growing interest in theory fostered by disciplines such as feminism. When a show of recent art from Europe toured five cities in America between 1977 and 1979, Gerhard Richter was the sole painter among the twenty-six artists selected.[1] In tune with the conceptual bias of the exhibition he showed a series of his *Grays*, some of the most reductive abstracts he has ever made.

When the "new" expressive figuration arrived from Europe, principally Germany, in the 1980s, it was masculine, vigorous, and confident. It had the backing of powerful commercial interests, coincided with a boom in the art market, and won influential institutional backing.[2] Many of its practitioners were, however, anything but new. Nor could they be solely viewed from the perspective of "new figuration." Sigmar Polke, for example, had already had two distinct phases in his twenty-year career: first, a German variant of Pop, which filtered through into paintings such as his 1964 *Why Can't I Stop Smoking?* (cat. 25) as a consumer world of objects, advertisements, and leisure pursuits; and second, a body of work playing on the notion of artistic genius in paintings such as *Higher Powers Commanded: Paint the Top Corner Black* (1969; collection of Josef Froehlich). He also spoofed the severe rationalism and modular structures of Minimal art in such paintings as *Carl Andre in Delft* (1968), with its grid of blue glazed Dutch tiles, and constructions such as his 1967 *Potato House* (cat. 26). Polke's irrepressible invention and personal elusiveness continued to dictate the development of his career. The 1980s constituted something of a return to painting following a decade of extended travels and experimentation, often collaborative, with photography, film, and video.

The magic of the chemical processes by which photographic images were created and reproduced influenced Polke's re-examination of his materials when he returned to making

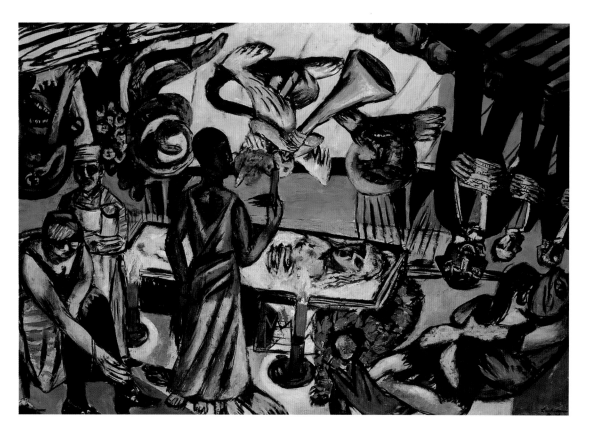

Fig. 1
Max Beckmann
Death
Tod, 1938
Oil on canvas
Staatliche Museen zu
Berlin, Preussischer
Kulturbesitz, Neue
Nationalgalerie

paintings. He began using a wide variety of substances and suspensions, allowing them to flow freely across increasingly large supports. Perhaps not surprisingly, swiftly transforming phenomena such as clouds, the milky, veiled apparitions of nineteenth-century séances, and religious visions became the subjects of his paintings. Polke experimented with physical substances, mineral or chemical, in the spirit of a search for profound knowledge, based on the essential elements of the physical world. Many of these concerns crystallized in his contribution to the German pavilion at the 1986 Venice Biennale. He linked deep geological time, in the presence of a meteor placed on the gallery floor, with a wall painting that responded to

changes in the humidity of the lagoon and the number of visitors in the space, thus drawing together distant past and present. His inclusion of a series of paintings based on curlicues in Dürer's woodcut celebrating the triumphal procession of Emperor Maximilian (c. 1518) introduced the dimension of art to this representation of the natural order. Creativity, as sublimely displayed by Polke in installations such as the one in Venice, or in such virtuoso works as his *Paganini* (1981–83), could also have dangerous uses when wielded by the wrong hands. His *Watchtower* series of the mid-1980s, including the works *Camp* (1982) and *Degenerate Art* (1983), addressed anxieties about cultural achievement being undermined by political ideology,

while reactivating this dormant German theme as a legitimate subject for his painting.

The early 1980s also saw Georg Baselitz fully accepted as an internationally important painter and sculptor. Baselitz's "fracture" paintings of 1967–69, such as *Three Stripes, Cows* (1967; cat. 2), had confirmed an engagement with the formal questions of painting over its narrative aspects. In 1969 he had begun to invert his figurative motifs (cat. 3) – a radical step, even if Beckmann, in paintings such as *Death* (Fig. 1), provided a well-known source for releasing certain elements in a picture from gravitational forces. Baselitz made this into a signature of his work and used it as a means of drawing attention to the primacy of the formal and material aspects of each painting over its narrative subject. Besides Baselitz's pictorial invention, an abiding nostalgia for the idea of *Heimat* (the emotional comfort associated with home), seen in his recurrent use of images of huts and farming implements, was also well established. His underlying conceptual approach was affirmed in the 1970s with the isolated pools of paint, unrelated to to any representational function, on the surface of some of his most mimetically accurate pictures, for example, his series of naked portraits of himself and his wife, Elke, his forested landscapes, and the pictures of eagles.

The German artists, including Polke, Baselitz, Anselm Kiefer, and younger ones such as the Oehlen brothers Markus and Albert, Martin Kippenberger, and the Berlin *Neue Wilden* ("New Fauves"), including Rainer Fetting, Helmut Middendorf,

and Salome, reopened longstanding aesthetic questions about the possibility of creating a subjective style and expressing emotions in paint. Critical, too, was the issue of art's autonomy in respect of its relation to historical events. This was particularly relevant in view of German artists such as Kiefer, who confronted the specter of Germany's recent past by direct reference to Germanic myths and legends (*Brünhilde Grane, Brünhilde's Death*, 1978; cat. 12), or Markus Lüpertz, whose semi-abstract *Dithyramb* paintings of the 1970s had consciously "German" motifs such as steel helmets, rifles, and ears of corn (*German Motif – Dithyrambic III*, 1972; cat. 16).

These paintings, made in the decade before 1977, referred through the word "dithyrambic" in their titles to the origins of drama. By implication, in the usage of the term by a painter, they also addressed the beginnings of painting. From the late 1960s to mid-1970s, a decade of Minimalist and conceptual dominance in art, Lüpertz's ostentatious retention of figurative motifs appeared to go determinedly against the grain. However, he addressed formal issues of picture-making as much as his counterparts on the abstract side of the divide. One reason for his use of recognizable motifs was an anxiety to avoid the reductive austerity of Robert Ryman, for example, exclusively using the color white, or of Alan Charlton, using only gray, which the loss of figuration appeared to entail. To avoid, on the other hand, the rhetoric of gestural expressionism of his own formative years, Lüpertz produced from the mid-1960s onwards what Rudi Fuchs

described as stately, monumental dithyrambic paintings. In ancient Greece, the dithyramb was a hymn to the god Dionysus, chanted as a lyric exchange between a chorus and a leader. The dignity of Lüpertz's paintings rested in their strategy of repetition, with the visual equivalent of dithyrambic meter and its intrinsic musicality creating pictorial rhythms and compositional structures. His colors were generally muted and contained within clearly defined contours. Nonetheless, in spite of this archaic dignity, their inclusion of distinctively German motifs brought them closer to a conscious attempt to grapple with the tragic consequences of more recent German history.

When paintings by Lüpertz, Kiefer, and others of their generation reached a wider international audience in the 1980s, the issue of a specifically German identity sparked furious rows between opposing camps of theorists and critics.[3] Right across the century, the envelope of conflict surrounding the visual arts in Germany had affected institutions and the market as well as critical debates. Many of the arguments had surfaced even before World War I. Then, they were about the values of a home-bred, distinctively German art in opposition to the acquisitions of (predominantly French) modern art by forward-thinking museum directors such as Hugo von Tschudi, director of the Nationalgalerie, Berlin, from 1896 to 1909, and Alfred Lichtwark, who championed contemporary art as the first director of the Hamburger Kunsthalle. Such was the subject of the charge made in 1911 by the conservative

Worpswede painter Carl Vinnen when he led protests against the acquisition by the Kunsthalle Bremen of a Van Gogh landscape. These fault lines lay unperceived for a generation before being reactivated in the service of nationalist cultural ideology in the 1930s.[4] Perceptively and presciently assembled public collections were subsequently emptied of modern and Modernist art. Many artists were forced into exile or the silent inactivity of "inner emigration."

The interpretation of contemporary art in the German-speaking world, by both Germans and outsiders, can be traced in great part to the ways artists have responded to the disruptive impact of Germany's turbulent political and social history. Through the twentieth century, the nation experienced a succession of political upheavals and ruptures. Having begun the century as a monarchy, still newly constituted, the nation ended it, reunited after forty-five years of division, as a social democracy. Each of the successive models of government imposed a different form of administration, with far-reaching effects on peoples' lives. For individuals, continuity was thus largely defined not through the externalities of social or political stability, but through the trajectory of individual destinies. Naturally these circumstances also affected artists, for whom the abrupt shifts in economic and political leadership resulted in profound changes in the professional and cultural context in which they worked. One might, for example, interpret Richter's consistent maintenance of a running total of works he had

made, first recorded in his lithograph *Picture Index* of 1969 (it lists 243 paintings), as a response to the discontinuities outlined above. Equally his listing marks a determined effort to level out by simple numerical sequence all the peaks and troughs of his production. It might also indicate an underlying strategy to apportion equal weight to each of the many idioms – abstraction, figuration, and so on – which might otherwise be interpreted as confusingly contradictory components of his art.

Continuity and predictability were initially usurped by rupture and uncertainty when, after World War I, a revolution produced a fledgling democracy. This was followed within fifteen years by an extreme ideological dictatorship. Defeated in a second major European war, an exhausted Germany became a pawn in a geopolitical schism between the rival ideological and economic systems of communism and capitalism. Germany, which had been divided into four military zones of occupation after 1945, was the most sensitive fault line in the confrontation of the United States and the Soviet Union. If Germany was the front line in the Cold War, Berlin, a western enclave surrounded by the Soviet-influenced part of the country, was its flashpoint. A grotesque echo of this political division was sounded in all other fields of activity, including culture.

The socialist freedoms of the German Democratic Republic (GDR), occupying the eastern part of Germany, were commemorated by artists organized, like other workers, into politically influenced collective groups to serve the interests of the state. The officially acceptable style was a non-elitist figuration, which prescribed a form of ideologically oriented narrative. Early subjects in the form of paintings and, frequently, murals included celebrations of advances in the field of heavy industry, for example a 1949 mural by Arno Mohr, Horst Strempel, and René Graetz, *Panneau Metallurgy Hennigsdorf*; portrayals of the process of collective decision-making at the workplace or in a domestic environment, as in Rudolf Bergander's *House Management Committee* (1952); or a depiction of the popular appreciation of cultural artifacts, for example in Horst Schlossar's *Farmers' Delegation at the Socialist Artists' Brigade* (1952). Clearly Gerhard Richter's graduation project in 1956, a mural in the German Hygiene Museum in Dresden, which documentary photographs show as a frieze of robustly healthy, happy citizens at play in a coastal landscape, conforms to this pattern of decorating public buildings in the early years of the GDR.

Although Richter chafed under the constraints of working in the East, this early experience in thinking about painting in combination with architecture, as complementary extensions of the visual field, was, arguably, of lasting influence. Several younger artists whose careers developed during the 1990s, in particular Franz Ackermann and the late Michael Majerus, went a step further, integrating paintings fully into external structures, thus creating specific environments for their pictures. Richter's mural is painted over, but he retained a fascination for the dialogue between painting and architecture. His *Atlas*, begun in 1969, is a filtering device for the barrage of mass-reproduced images which he encounters every day. An ongoing archive of his sources, including photographs, clippings, and sketches, collaged and assembled into standard-size frames, it contains several sections with perspectival line drawings of ideal spaces. Into these Richter has inserted scaled-down images of several of his painting series of the 1970s, including groups of his color charts and cloud paintings. These private visions acknowledge, perhaps, the slender opportunity of ever actually exhibiting such pure distillations of individual themes in real spaces at that time. Richter's preoccupation with the built environment extended beyond these models of grand halls to views of cities and, later, rural landscapes.

Over a period of two years, beginning in 1968, he turned his attention to monochromatic paintings of cities. Seen initially from just above street level, Richter's viewpoint gradually ascended until, in 1970, the cities were seen from high in the sky. They were distinguishable only by the pattern of their streets and rendered anonymous by the aerial perspective. While acknowledging that there is no overt reference in these paintings to historical events, one might relate such views to the documentary photographs of aerial bombardment of wartime Germany. Richter had earlier suggested the fusion of personal and national memory in such works as *Uncle Rudi* (1965; The Czech Museum of Fine Arts, Prague), a monochrome painting of a German

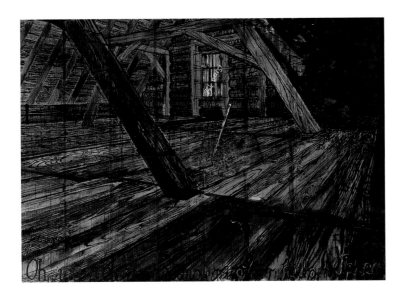

Fig. 2
Anselm Kiefer
Parsifal III, 1973
Oil and blood on paper
on canvas
Tate, London

military officer. In a group of urban landscapes that include *Cityscape Sa 2* (1969; cat. 29), Richter based some of his images on photographs of architectural models taken from specialist building journals. As photographs of fictive constructions, these imaginary schemes were as far removed from actual reality as the monochrome paintings created by the artist. Richter underscored this in one multi-panel variant on this theme in which the sections of buildings in abutting panels remained discontinuous rather than neatly following through.

The assertion by authorities in both East and West Germany that they alone were true conservators of Germany's cultural heritage and guardians of German history took architectural form in the competition to renovate old museums and build new ones on both sides of the border from the 1950s onwards. These ambitions, allied to regional muscle-flexing, underpin, for example, the creation in Frankfurt in the 1980s of a "museum mile." Similarly ambitious undertakings in

the East included the rebuilding of the Dresden Zwinger in the 1950s and long-term state support (from 1976 to 1987) for Werner Tübke's panorama dedicated to the peasants' war of the early sixteenth century, *Frühbürgerliche Revolution in Deutschland* (1983–87). The immense circular painting (123×14 meters) is housed in a purpose-built cylindrical structure at the Panorama Museum Bad Frankenhausen, sited near the nineteenth-century shrine to the Emperor Barbarossa at Kyffhäuser in Saxony.

Anselm Kiefer's paintings of the late 1970s and early 1980s reflect almost this level of architectural pretension and all-encompassing ambition. Edifices connected with German history, such as Wilhelm Kreis's 1938–41 design for an unrealized Soldiers' Hall, began appearing in Kiefer's large-scale woodcuts (*The Rhine*, 1983; collection of Céline and Heiner Bastian, Berlin); and *Shulamite* (1983; Saatchi Collection, London). Cultural, military, and political intellects of German history from preceding centuries, which together forged the nation in the crucible of battle and in struggles for national identity, were portrayed in inscribed paintings such as the *Ways of Worldly Wisdom – Arminius's Battle* (1978–80; The Art Institute of Chicago). While Kiefer confidently and controversially addressed the weight and power of Germanic mythology and legends as indistinguishably formative and destructive elements of Germany's past, his archaic imagery struck a raw nerve with contemporary German audiences.

Kiefer had already begun to move in this direction a decade

earlier. In 1969 he traveled abroad, making photographs of himself "reconquering" foreign landscapes by raising his arm in the Nazi salute in a grotesque reprise of the *Sieg heil*. This series of photographs retained a conceptual lightness in physical form, but his later works appeared, with each decade, to increase exponentially in scale to a point where their material presence became overwhelming. However, their monumental imagery, such as the concrete statues of Mao Zedong depicted in a recent group of paintings about another flawed ideologue, or the vast panorama of the night sky in a recent painting such as *Stars* (1995; Akermann Foundation, Kleve), demands such an operatic scale.

The essentially conceptual nature of Kiefer's 1969 *Occupations* series, as the photographs came to be called, was thus superseded by visual rhetoric on a grander scale in later paintings and books. His perspective pictures of the mid-1970s, set in the woodgrained interior of his studio, developed into allegorical landscapes in which momentous events were re-enacted. Some dealt with recent history, such as the aborted German invasion of England (*Operation Sea Lion I*, 1975; collection of Norman and Irma Braman, Miami Beach). Others took Nordic legends as their source, such as that of Parsifal, a hero of divine origin with particular resonance because of the National Socialists' admiration for Wagner's treatment of the subject in his last opera.

Kiefer's motivation in selecting such subjects for his paintings lay in their relevance for the present as allegorical reflections, not merely as

Fig. 3
A. R. Penck
West
Westen, 1980
Acrylic on canvas
Tate, London

meditations on various points of Germany's past history. In a moment of anger, for instance, he inscribed on to the roof beams depicted in *Parsifal III* (1973; Fig. 2, p. 23) the names of several of the Baader-Meinhof group, who were active during the period when Kiefer made the cycle of Parsifal paintings. Their extreme Maoist ideology led them to commit acts of violence against the state that included bombings, kidnapping, and murder, an extreme expression of the seismic generational conflict in Germany between those who had experienced the war and those who grew up afterwards. The younger generation felt that the war in Vietnam and the student revolts in Paris, Berlin, and elsewhere were as definitive as the trauma of Auschwitz had been for the generation before. After the 1980s Kiefer turned his attention away from German subjects to explore the roots of knowledge in western civilisation in subjects such as the Great Library at Alexandria and the environmental devastation caused by western democracies.

A few artists of eastern German origin elected to stay in (or return to) the German Democratic Republic after the war. They included Lea and Hans Grundig and the Rhineland expressionist Conrad Felixmüller. His *Machinist* (1951; Staatliches Lindenau-Museum, Altenburg) depicted one of the staple images of the 1950s GDR: a committed worker, an individual representative of his or her co-workers and elevated to the subject of a painting. Most of the artists discussed in this essay were born in the East but chose to move to the West, usually in early adulthood. Of the artists whose work has been recently acquired by the Saint Louis Art Museum, A. R. Penck was unusual in remaining so long in the eastern part of Germany. He stayed there even while exhibiting in the West, until his situation became so intolerable that he felt compelled to leave. There he evolved a pictorial language of pictograms and signs in which reductive symbols and stick figures enact recurrent themes of crossings and connections across barriers and boundaries.

When Penck moved permanently to the western part of Germany in September 1980, he perceived stark differences between intimately connected yet utterly alien states. Such a reality was unimaginable to anyone not familiar with the particular and entrenched circumstances routinely experienced by Germans sharing a common cultural history and language. Shortly after moving, Penck made a contrasting pair of paintings entitled *East* and *West* (both 1980; Figs. 3 and 4). Firmly drawn black figures

on a white ground denote the West, while the reverse, white figures surrounded by a cloaking blackness, symbolizes the East. The imagery in *West*, with its plurality of figure types and Penck's deployment of figures right across the canvas suggesting activities on the left and the right, must be understood as something of a prediction for one so recently arrived. By contrast, the notations and figures in *East* were based in his recent experience. Symbols generally come in twos, suggesting an either/or polarity governing people's behavior. The "A" to one side of the central figure is contrasted with a second "A," this time with a small "B" attached to it, on the other side of the figure. Through such a device Penck wished to suggest the existence of a second, unofficial system alongside the regular apparatus of the state.[5]

Jörg Immendorff's celebrated *Café Deutschland* paintings, begun in 1978, documented his cross-border artistic dialogue with Penck through the otherwise insurmountable Berlin Wall. The two artists had first met in 1975 and discussed working collectively. Two years later, another meeting led to collaborative activities and exhibitions. Immendorff spent his formative years in the Düsseldorf State Art Academy (Staatliche Kunstakademie), whose rector, since 1988, is Markus Lüpertz. As a student of Beuys between 1964 and 1966, Immendorff initially became involved with happenings rather than painting. Politically committed throughout the 1960s and 1970s, he remained interested in the social effects of art. In his *Café Deutschland* series, the artist

Fig. 4
A. R. Penck
East
Osten, 1980
Acrylic on canvas
Tate, London

created an allegorical interior setting where he assessed the condition of present-day Germany and his own position within it. The setting was based on a pub called Revolution in the center of Düsseldorf. Alongside actual patrons, such as himself and Penck, engaged in counter-cultural bar-stool discussions, he included current and symbolic pillars of the opposing German states, for example their leaders, Helmut Schmidt and Erich Honecker, Marx and Engels, the Brandenburg Gate, and the German eagle.

In West Germany the language of figurative representation long current in the East and opposed there by dissident artists such as Penck, had been rejected after passionate debate throughout the 1950s. The chief cause was widespread unease with a form of representation which had been debased by two decades of National Socialist ideology and then subordinated, in the German Democratic Republic, to a state ideology of socialist realism. The National Socialists had prohibited abstraction and advanced instead a "correct" form of heroic neo-

classicism in the visual arts. Inspiration for postwar German artists rebuilding their careers after a long interregnum, or starting out after the disruptions of military service or a wartime education, came from the nihilistic, despairing existentialist art of Alberto Giacometti, Germaine Richier, and Jean Fautrier, which emanated from postwar Paris. Enabling powerful emotions to be expressed through non-objective or highly abstracted imagery, this movement, along with the art of mentally disturbed artists such as Antonin Artaud and the *art brut* of Dubuffet, constituted the formative inspiration for Georg Baselitz during the early 1960s when he published his *Pandemonium* manifestoes in 1961 and 1962.

Also during the 1950s, the generation of Willi Baumeister and Richard Oelze, whose careers had been interrupted by war, spearheaded the emergence of a younger Art Informel generation. To this belonged Emil Schumacher, Karl Otto Götz (Richter's teacher at the Düsseldorf Academy), Gerhard Höhme, Hann Trier, and Bernard Schultze. Many of these artists had travelled to America, or to Paris where, for example, Schultze was inspired to work in a Tachiste idiom through his meetings with André Lanskoy and Jean-Paul Riopelle. The arrival in Europe during the late 1950s of the first significant exhibitions of Abstract Expressionism, in Berlin, Kassel, London, and Venice, consolidated the influence of energetic, gestural abstraction in the West, this time with renewed confidence and vigor, emanating from across the Atlantic.

Of special importance for German artists during this period was Arnold Bode's initiative in Kassel in 1955 to mount an exhibition showing international developments in contemporary art, which he called Documenta. His objective was to mend the broken thread of modernism, reacquainting artists and the German public with the forms of art that had been prohibited during the Nazi era. He also aimed to bring new impulses to the German cultural landscape through exposure to international developments. The city of Kassel had no record of recent engagement with contemporary visual culture, although this was possibly an advantage when introducing new trends into the parochial, cut-off world of the postwar Germanies. Moreover, Kassel was situated near the border with the GDR, allowing easy access for visitors from both parts of Germany. Having missed the first Documenta, Gerhard Richter visited the second one in 1959 and recorded the sensations that paved the way for him leaving Dresden, where he had trained and lived, for the West: "I was enormously impressed by Pollock and [Lucio] Fontana. … The sheer brazenness of it! That really fascinated me and impressed me. I might almost say that those paintings were the real reason I left the GDR."[6] Bode's concept was for a Documenta to take place every four to five years, thus allowing distinctive new forms of art to emerge during the intervening years. This model persists to the present day. While international in tone, there have always been significant German accents in the history of Documenta. Chief among them

is that of Joseph Beuys, who first showed in Kassel in 1963. The 1987 Documenta, a year after his death, represented something of a memorial for the artist.

Beuys's influence on the postwar generation of artists, including ones like Anselm Kiefer who studied under him, was immense. His fifty-year career provided the link between artists of the 1940s and 1950s and the generation of Richter, Polke, Baselitz, Penck, Lüpertz, and Kiefer, which grew up after the war and emerged in the 1960s. Beuys it was who first addressed the issues and problems surrounding the debasement of subject matter and materials during the Third Reich. He reintroduced the oak leaf, with its nationalistic and militaristic overtones, and reclaimed the color brown for his distinctive *Braunkreuz* (brown cross), which appears, for example, in his *Iphigenia/Titus Andronicus* (1985; cat. 9). According to Caroline Tisdall, the journalist and filmmaker, Beuys was "very deeply rooted in the German language. His whole idea of rehabilitating some of the Germanic imagery and symbols was because he felt that any country which cannot look at its own history is built on foundations of sand and will turn more and more to our form of modern materialism which completely denies spirituality. He felt that was really dangerous not only because of materialism, but also because of a backlash; spinning back into neo-Nazism. One wishes he had been there when Germany was reunified and the whole spiritual vacuum was exposed. You had the legacy of both forms of materialism; capitalist materialism and the

de-spiritualised, grey, eastern materialism."[7] On its own, Beuys's strategy of close identification of the charismatic artist with his work could be interpreted as a dangerous route for a German artist to take. This was particularly so in view of the recent past, in which a messianic Führer had been frequently portrayed as the creator who had molded and shaped the German state.

Throughout his career Beuys addressed what he perceived as a sense of profound trauma within postwar Germany. Beginning with his own wartime injuries, which left him with metal plates in his skull and in brittle health for years after, and including a heart attack he suffered in 1975, the metaphor of the wound permeates his entire output, from his choice of themes to his selection of materials. Felt, from which he made *Felt Suit* (1970; cat. 7), one of his most celebrated multiples, acquired its personal importance following the possibly apocryphal, certainly legendary, plane crash he survived in wartime Crimea. The insulating properties of the felt in which he was wrapped while his wounds healed, also its manufacture from hares' fur compressed into a usable fabric, was thereafter closely associated with Beuys's theory of sculpture. In this dynamic constellation of opposite forces, chaotic, warm, fluid substances at one end of the spectrum were transformed by energetic forces into solidified, cooled formations. Beuys formulated a concept of change enacted by reciprocity, or the generation, storage, and release of energy. He used the constituent properties of his materials to suggest their character

or function. Conductivity, for example, is associated with copper, and there is a mythological connection of iron with Mars, and by extension masculine power. During the 1960s Beuys expressed these artistic ideas mainly in a series of actions, in which he was usually the principal participant.

His actions, increasingly in the public domain as the 1960s progressed, during which Beuys's fame (and notoriety) increased, provoked widespread reaction. This arose particularly in response to the informality of his actions and the installations he created from elements used in those actions. For the student generation agitating for social and political reforms in the late 1960s, Beuys became a natural and revered leader. He opened his sculpture class in the Düsseldorf Art Academy to all-comers as a direct provocation to the existing regulations, which restricted the number of students officially permitted to attend. His environmental concerns led him to found grassroots democratic parties, initially for animals (he believed humans were not paying attention and lacked the intuitive intellect of animals). He was one of the founders of the German Green Party. Jörg Immendorff's *Beuysland* (1965; cat. 10) pays tribute to Beuys's influence on his generation of artists. Beuys's *Felt Suit* multiple featured in one of the many protests of the day, when a group opposing the acquisition by the Kunstmuseum Basel of Beuys's sculpture *Hearth* (first installed at the Ronald Feldman Gallery, New York, in June 1974) paraded through the streets of the city wearing animal masks and

Notes

1 See *Europe in the Seventies: Aspects of Recent Art* (exh. cat.) Chicago: The Art Institute of Chicago, October–November 1977 and touring.

2 See, for example, *Refigured Painting: The German Image, 1960–88* in note 1, p. 15 (exh. cat.) Toledo: Toledo Museum of Art, October 1988–January 1989 and touring.

3 See, on the one side, Donald Kuspit, "Flak from the 'Radicals': The American Case against German Painting," and from another, Benjamin H. D. Buchloh, "Figures of Authority, Ciphers of Regression," both in Brian Wallis (ed.), *Art After Modernism. Rethinking Representation*. New York: The New Museum of Contemporary Art, 1984.

4 For a fuller discussion, see Hans Belting, *Die Deutschen und Ihre Kunst*. Munich, 1993. English translation *The Germans and Their Art: A Troublesome Relationship*. New Haven and London, 1998.

5 *The Tate Gallery: Illustrated Catalogue of Acquisitions 1980–82*. London, 1984, pp. 194–95.

6 Gerhard Richter, "Interview with Benjamin H. D. Buchloh", 1986, in Hans-Ulrich Obrist (ed.), *Gerhard Richter: The Daily Practice of Painting: Writings and Interviews, 1962–1993*. Cambridge and London, 1995, p. 132.

7 *Joseph Beuys's "Bits and Pieces" 1957–85. Caroline Tisdall in Conversation with Sean Rainbird*, unpublished interview, spring 2002.

felt suits. Beuys, as ever seizing the initiative, joined the march, signing the suits as the march progressed. When afterwards many were abandoned in the courtyard of the useum, Beuys used a pile of them and reordered the existing elements of *Hearth* to create *Hearth II* (1977), which was acquired by the museum. Whether used ostensibly against his interests, or to project his artistic persona, the cult of the felt suit remained centrally identified with the creative personality of Beuys.

The dialogue incorporated in the *Hearth* installations of 1974 and 1977 centered on the social and sectarian wound represented by the recently intensified "Troubles" in Northern Ireland. Beuys travelled there several times during the early 1970s, creating major works such as the encyclopedic agglomeration of drawings for *The Secret Block For a Secret Person in Ireland*. He exhibited and lectured in both Northern Ireland and the Irish Republic. He founded in Dublin the Free International University for Interdisciplinary Research to promote knowledge and dialogue and as a more effective means of confronting and then healing social, sectarian, and political conflicts. Although Ireland represented a pressing case for effective remedy, Beuys expanded his concept of dialogue in his contributions to the 1972 and 1977 Documentas to include discussion of wide-ranging political, social, environmental, and cultural issues. On a more intimate scale, Beuys took it upon himself to give a voice to those he believed could not express their needs or suffering. The mold from which Beuys cast his *Backrest of a Fine-limbed Person*

(Hare-type) of the 20th Century AD (1970–72; cat. 8) was a plaster cast that had encased a sick child's torso. It was given to Beuys by an acquaintance and transformed into one of his most significant editioned sculptures. Beuys had expressed very early his concern for the suffering of the individual, and particularly of vulnerable members of society such as children, in his 1966 Düsseldorf Academy of Fine Arts action *Infiltration Homogen for Concert Grand: The Greatest Composer of the Present is the Thalidomide Child*. The central element of this action was a felt-wrapped grand piano. The felt muffled or suppressed the piano's sound, denying the instrument and, metaphorically, the subject of its title, a voice.

With the recent emergence of younger painters such as Daniel Richter, Franz Ackermann, and Michael Majerus, mentioned above, German painting has regained critical attention after a decade dominated by the penetrating observation of photographers, many trained by Bernd and Hilla Becher at Düsseldorf, including Andreas Gursky, Thomas Ruff, Thomas Struth, and Candida Höfer (see cat. 38–43). Bernd and Hilla Becher began working together in 1959, photographing the industrial buildings of the Ruhr district in Germany, then from the mid-1960s, similar structures elsewhere in Europe and the United States. Their impact on the later generation of photographers owes as much to their style of sober realism and detached observation in the tradition of August Sander, Albert Renger-Patzsch, and Neue Sachlichkeit photography as to a disciplined serial treatment

of their subject matter. Post-reunification, the German–German context has been transformed more into an economic and structural question than an artistic one. Younger artists in the East no longer automatically move westwards. Indeed, the lower costs of living in the East have drawn increasing numbers of students from the western part of Germany. The strength of feeling during the late 1980s, when Baselitz resigned his teaching position at the Berlin Academy of Fine Arts in protest at the appointment of the East German Volker Stelzmann, has evaporated. Gerhard Richter even felt able to place *October 18, 1977*, his elegiac cycle of history paintings about the Baader-Meinhof group, in The Museum of Modern Art, New York, and to see the closely related monumental diptychs *January*, *December*, and *November* (cat. 32–34) in American collections rather than direct them to one of Germany's own museums as admonitory reminders about a fractured past.

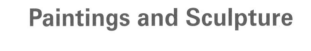

Paintings and Sculpture

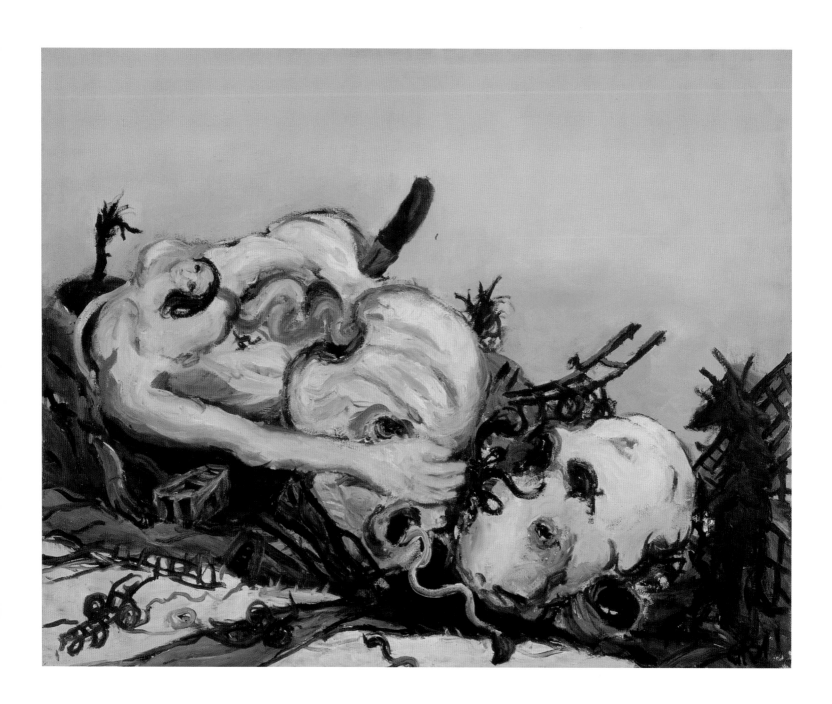

Picture for the Fathers
Bild für die Väter, 1965
Oil on canvas
51³/₁₆×63³/₄ in. (130×162 cm)

Picture for the Fathers is a frightening yet beautiful painting. Body parts are piled in a heap. The delicate head of a woman is attached to a massive body whose arms stretch out at awkward angles to hold on to an amorphous form with gaping holes. A knife is plunged into her side, blood and intestines are escaping. Worms move in and out of orifices in masses of dead flesh. The putrid pile is arranged at the edge of a vast field scattered with farm instruments such as harrows, ploughs, and wheelbarrows. The hues of decaying flesh and bloodiness stand out against the field's grayish-green color, evoking desolation and emptiness. Above all rises a background, warm and glorious in an undefinable yellowish-orange tint that is completely empty and forms a dramatic backdrop for the horrors described in the lower part of the composition.

Both the painting's title and content define Baselitz's position as a painter and his relationship to recent history. World War II and the separation of Germany into eastern and western parts had resulted for Baselitz in a loss of his homeland. The ensuing sense of displacement and rootlessness became an important influence when he constructed his artistic identity. By the early 1960s he had assumed the position of an outsider artist who operated outside of the existing structures of society, of art making, and who had a preference for other cultural outsiders such as Antonin Artauda, Lautréamont (Isidore Ducasse), and Charles Meryon. He announced his position programatically in 1961–62, when, along with his friend Eugen Schönebeck, he published two *Pandemonium* manifestoes. Some of the language suggests imagery that is prescient of *Picture for the Fathers*. "The ice beneath the foggy maze is broken. They are all frozen stiff – those who believe in fertility, those who don't believe in it – those who deny their pens and those who revere them. Fiery furrows in the ice, flowerlike crystals, crisscross icicles, starry sky torn open. Frozen nudes with encrusted skin – spilt trail of blood. The amiable are washed up, deposited as sediment … The many killings, which I daily experience in my own person, and the disgrace of having to defend my excessive births, lead to a malady of age and experience. Ramparts are built, byways pursued, sweets on offer, and more and more slides, sleepier and sleepier."[1]

Baselitz had experienced World War II as a child and had grown up in its aftermath. The enormous destruction, the breakdown of a country, the annihilation of its rich culture, and millions dead – these were facts that had to be faced by those who came to maturity after the war. In *Picture for the Fathers* the artist placed responsibility for his country's desolation at the feet of the previous generation. His own generation, which had to live with the results of the actions of their fathers, was rootless, without models to follow, and in urgent need of creating an identity for itself. As an artist Baselitz needed a new language of art making. He chose not to follow any of the prevailing directions of painting, such as European or American forms of abstraction, nor the burgeoning concept of Pop Art. Instead he focused on a painterly style and representational imagery that stood out markedly at the time. C. H.

Courtesy Michael Werner, New York and Cologne

Three Stripes, Cows

Drei Streifen Kühe, 1967
Oil on canvas
63¾ × 51³⁄₁₆ in. (162 × 130 cm)

Georg Baselitz
Two Cows, Three Stripes
Zwei Kühe, drei Streifen, 1967
Pencil and charcoal
Öffentliche Kunstsammlungen Basel,
Kupferstichkabinett

In 1966 Georg Baselitz embarked upon a new investigation of the relationship of content and form in his paintings. He began to make compositions that seemed to be cut into pieces and then put back together again without regard to their original position. The effect is a fractured, broken, or even torn image. Baselitz would destroy a composition's cohesiveness and leave the viewer with little to read the narrative of the painting. He related his approach to the Surrealist practice of the *cadavre exquis*: a poem or image is created by several people, each writing or drawing on a section of paper which is then folded over to be concealed from the next author; the process results in a disjointed but continuous composition that defies traditional structure.[1] In *Three Stripes, Cows* the associative organization of the *cadavre exquis* has been replaced by a more calculated and complicated compositional arrangement, even though the rough application of paint on the raw canvas still has a sense of spontaneity and immediacy. The compositional stripes referred to in the title are repeated in a different format in the carcasses of the animals and in the indication of background in the upper right corner of the canvas. In our wish to read the image, we can identify two cows and a dog broken into different pieces.

After the emotionally charged imagery of Baselitz's earlier work, paintings such as this seem to focus exclusively on pictorial issues. Baselitz chose "banal" subject matter, such as paintings of cows and dogs. In 1966 he had moved from the urban metropolis of Berlin to the rural surroundings of Osthofen in West Germany. The countryside itself would have suggested such rural subject matter, but even more importantly this simple imagery allowed Baselitz to focus on the compositional and pictorial qualities of picture making.

Baselitz's rejection of a narrative format and the interruption of visual unity reflect his intention to undermine conventions of picture making and reading/viewing. He was aware of earlier developments of Cubism and Surrealism,[2] but his actions had a fresh urgency. Germany's art scene was dominated by the abstract canvases of Art Informel in the 1960s. If Abstract Expressionism offered a new freedom and self-confidence and if the emerging Pop Art suggested a more direct use of existing imagery, these developments still offered only a partial solution for Baselitz. He pursued a different approach that incorporated gestural energy, yet remained with representational subject matter. The fractured paintings define a phase of this investigation. *Three Stripes, Cows* is full of intensity and, even if unintentional, it conveys a feeling of menace or fear through the forceful use of lines and the expressive heads of the animals. Energy permeates the composition. The banality of the subject seems to have been transformed by the painter's focus on painterly means. C. H.

Collection of Anabeth and John Weil

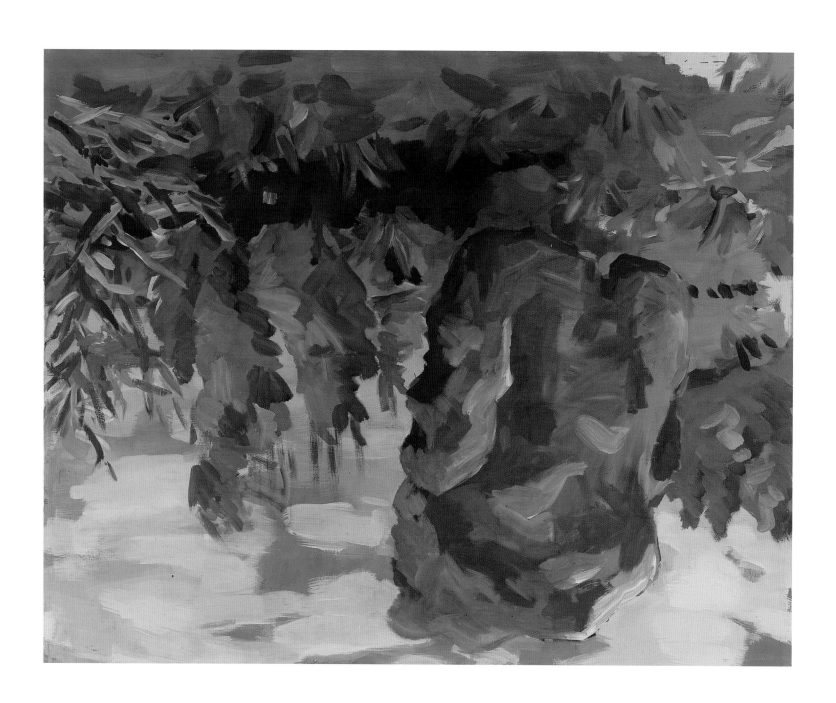

Landscape with Pathos
Pathetische Landschaft, 1970
Oil on canvas
78 3/4 × 98 7/16 in. (200 × 250 cm)

Georg Baselitz
Juniper Bushes
Wacholderbüsche, 1970
Pencil
Ludwig Forum für
Internationale Kunst,
Aachen

Landscape with Pathos was among the first paintings in which Baselitz presented imagery in inverted form. The artist argued that his paintings should be considered as objects in their totality and that their understanding should not be guided by subject matter. He sought to free his paintings from their roles of illustrating or interpreting an object, arguing that "all paintings are inventions by painters and the so-called reality which appears in these paintings exists only because it appears in these paintings." For Baselitz, who believed paintings were always abstract and could never be illustrations of reality, the decision to turn his paintings upside down was a way to demonstrate this point of view.[1] He intended to force the viewer to experience his work first as painting, and only secondarily (if at all) as having content.

Despite his proclamation about the irrelevance of subject matter in his paintings, Baselitz nevertheless would not yield it either. Quite to the contrary, he often chose motifs that had personal relevance. *Landscape with Pathos* is based on a photograph in a small booklet published by the Landesverein Sächsischer Heimatschutz in Dresden, 1939. Baselitz collected many of these publications in his youth and brought them with him to the West; they are still in his library today. The booklets contain black and white photographs of landscapes and monuments from his native Saxony, many of which he has used in his paintings. In this case the original photograph still shows the lines that Baselitz drew to determine which section of the image he wanted to use for the left part of his composition. The large rock he added on the right, which is hovering in space, is not falling, but neither is it anchored to the ground.

Images of trees in a forest and of boulders strewn in a landscape "as if cyclops had played with them"[2] have a long tradition in German art and literature. Romantic painters such as Caspar David Friedrich, who had lived and worked in Saxony, portrayed the mysterious grandeur of the Saxon forest or the majestic force of an ancient tree. Romantic writers also used such settings for their novels and fairy tales.

While Baselitz was conscious of his own personal associations as well as the historic models for this work, he distanced himself from his emotional engagement by portraying the rock as too big, too massive for the landscape, "like an overly large sound in romantic or Wagnerian music."[3] Its seemingly accidental position in the composition further undermines the romantic effect of the narrative. The emotional impact of the painting becomes even more questionable with the inverted presentation of the imagery. It appears as an arrangement of colors – green, gray, blue, and white – and of decisive brushstrokes. The effect is a rhythm, an arrangement of forms that focus on the act of painting and the intensity of visual experience. C. H.

Jointly owned by Alison and John Ferring and the Saint Louis Art Museum 6:2003

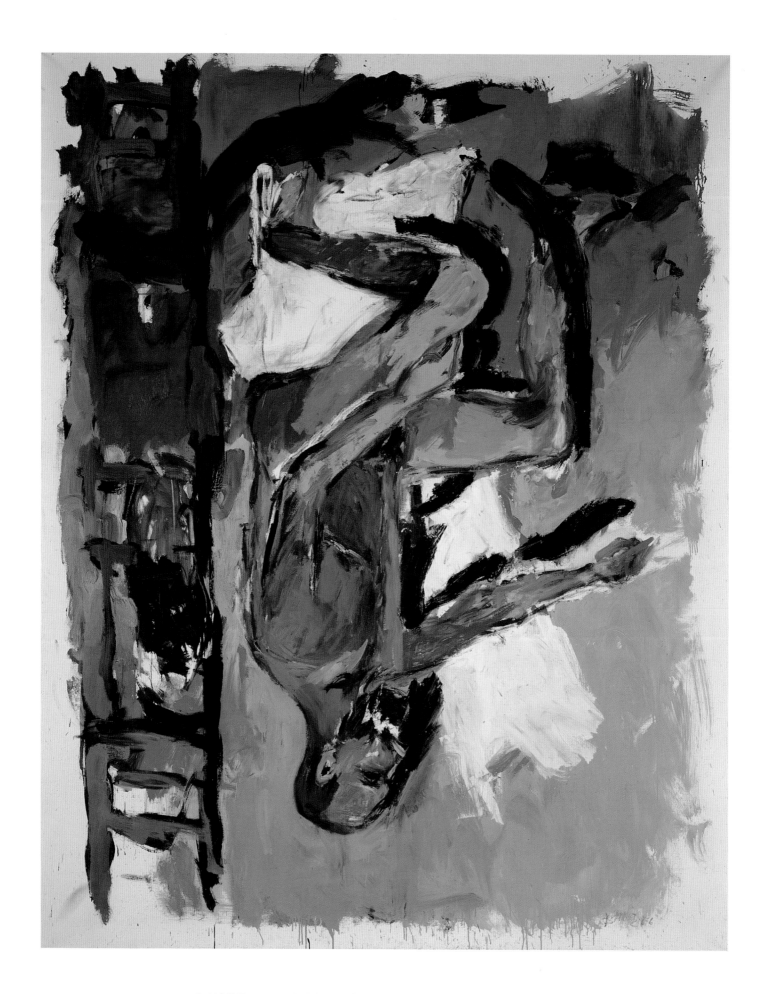

Seated Male Nude – Morocco

Sitzender männlicher Akt – Marokko, 1976
Oil on canvas
98⁷⁄₁₆ × 78³⁄₄ in. (250×200 cm)

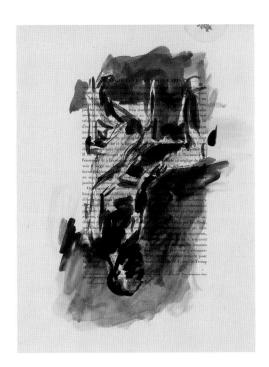

Georg Baselitz
Untitled
Ohne Titel, 1976
Pencil, ink, and India ink
on book page
Courtesy of the artist

A rich range of blue and pink tones are predominant in this composition, and they are further highlighted with accents of white, yellow, red, and green. The nude figure is painted in relatively dark tones against the bright background. The left side of the composition is anchored by the geometric shape of a ladder, but the right side is open, floating, almost dissolving into the white expanse of the empty canvas visible around the edges. It is a gloriously painterly work, whose delicate shades of color seem to flicker and dissolve as in a canvas by Monet, and forceful brush marks suggest rhythm and movement. As the title suggests, the artist was inspired by the intense light of North Africa.

The painting is part of a group of portraits that Baselitz made of his wife, Elke, and himself in the 1970s. He sought different pictorial solutions for paintings of the human figure; as Baselitz argued that the whole painting, and not the subject matter, was the object, he came to focus on a small range of motifs, but opted for a great variety in the execution of his compositions. In some works, such as *Bedroom* (*Schlafzimmer*) of 1975, the artist used concentrated areas of yellow, red, and blue, in front of which he placed his figures. In other paintings, such as *Elke V*, 1976, color has been relegated to the background while pronounced, almost harsh brushwork renders the composition predominantly in grays and blacks. In *Seated Male Nude – Morocco* Baselitz sought a more lyrical rendering.[1]

While the motifs he chose for this body of work were of personal significance, they also have a long tradition in the history of painting. *Male Nude* is a self-portrait, and artists have traditionally portrayed themselves with the help of a mirror, thus engaging the viewer with their direct gaze in the completed work. Baselitz, however, portrayed himself sitting in front of an imaginary easel in the act of painting while nude – thereby conflating this proclamation of artistic identity and the long academic tradition of the nude model, in which the identity of the model is completely irrelevant. The title suggests an interest in a generic figure and the effect of placing it against a strong backlight.[2] The painting, however, goes further, for Baselitz plays the role of maker, in charge of this pictorial investigation, while he assumes the role of model. Thus he maneuvers between observer and observed, between form and content. C. H.

Saint Louis Art Museum, Funds given in memory of Dr. Alvin R. Frank 54:1998

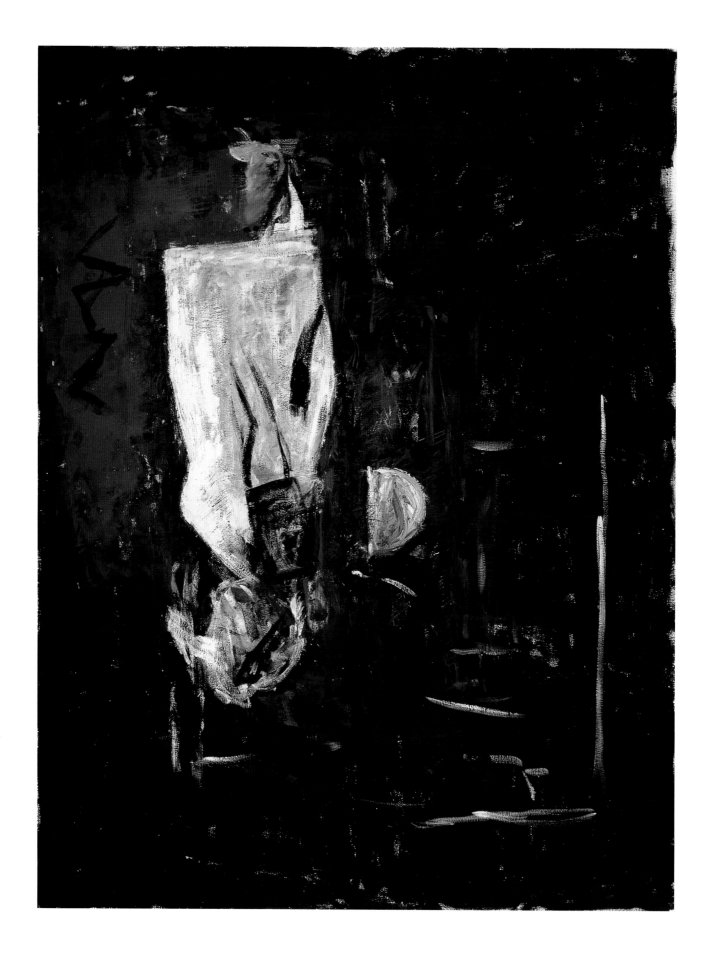

White Woman
(Woman of the Rubble)

Weisse Frau (Trümmerfrau), 1980
Tempera on canvas
129¹⁵/₁₆ × 98⁷/₁₆ in. (330×250 cm)

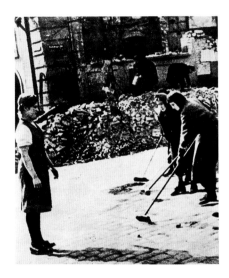

Photo of young Russian
woman supervising
German women at work,
seen in a 1979 issue of *Stern*

In around 1980 Baselitz's work moved even further toward an expressive, free use of color. While still incorporating a motif, his paintings came to be dominated by an almost autonomous brushwork. The dark tonality of *White Woman* consists of a rich palette of brown, black, deep red, and mauve tones that create a surface of expressive layers from which an inverted white figure emerges. With paintings such as this, Baselitz came closest to his earlier dictum that his work was pure painting. The composition's impact lies initially in its painterliness and in the intensity of its brushwork. The rich darkness of the layered tones contrasts dramatically with the white of the figure and the white highlights in other parts of the composition. None of these white areas is solid; instead, the gesture of the brush is visible throughout, making the painter's action a vital element in the experience of the work. The occasional white of the canvas emphasizes the fact that paint has been applied and denies the suggestion of narrative. It focuses our attention on the act of painting.

In spite of Baselitz's focus on expressive form, the motif of *White Woman* has great significance. The figure is inspired by a photograph that appeared in the German journal *Stern* in 1979 that showed a Russian girl supervising German women in the streets surrounded by ruins after World War II. The prisoner had become the victor who was now in charge of those for whom she previously had had to work. The painting is also known as *Woman of the Rubble*, an imperfect translation of the German term "Trümmerfrau,"[1] a term that was used in Germany for those women who were instrumental in cleaning up the destroyed cities in Germany and who worked hard to keep their families alive immediately after the war, when most of their men were either dead or had not yet returned home. These humble, tireless workers played a vital role in the rebuilding of Germany after World War II.

When Baselitz used the figure of the girl in his paintings and called it "Trümmerfrau," he was reversing the roles allotted in his photographic source, giving his inversion of the motif added significance. The painting comments on the contradictions and tragedies of war. It evokes memories of the difficult existence and perseverance of those who had to construct new lives for themselves after a war that consumed everything. Baselitz reflected on these issues in a highly sophisticated painting in which the gestural brushwork supports the content as much as it remains autonomous. *White Woman* is a sophisticated response to a complicated situation and a different view from the painful uproar and desperation visible in the *Picture for the Fathers*, painted some fifteen years earlier. C. H.

Saint Louis Art Museum, Funds given by Mrs. Alvin R. Frank, Bruce and Kimberly Olson, and Mr. and Mrs. Thomas K. Langsdorf 7:2003

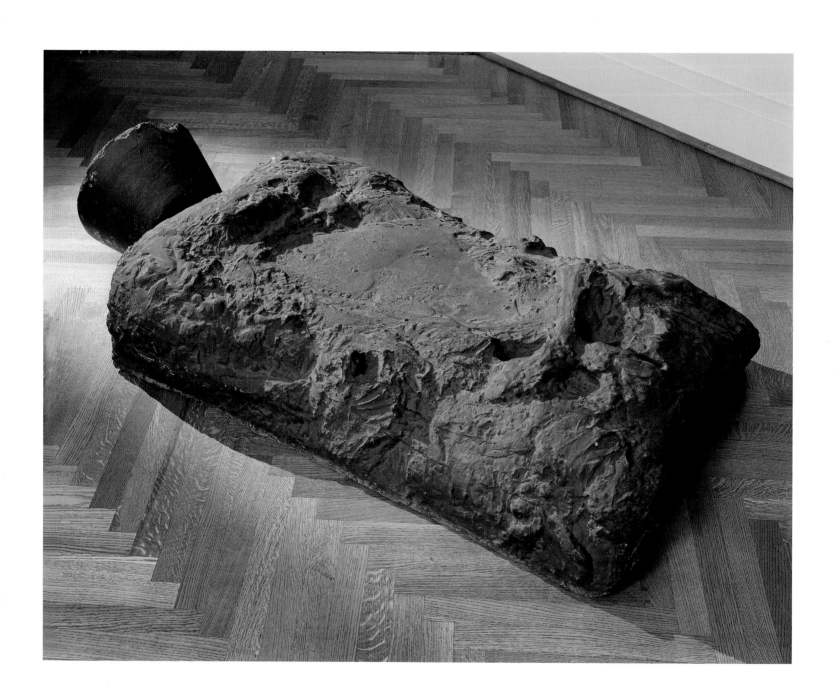

Mountain King (Tunnel), 2 Planets

Bergkönig (Tunnel), 2 Planeten, 1958/1972
Bronze, 2 pieces, edition 3/3
14³/₁₆ × 33⁷/₁₆ × 64³/₁₆ in. (36×85×163 cm)

Joseph Beuys
Beheaded King
Enthaupteter König, 1959
Watercolor and
silver-aluminum on paper
Collection van der Grinten,
Bedburg-Hau

Three casts of *Mountain King (Tunnel), 2 Planets* exist, one made in 1969, a second cast in 1971, and the version included in the present exhibition, which was made in 1972. The sculpture's complex title reflects Beuys's strong interests in mythology, cosmology, and the metaphorical resonances of the natural sciences.[1] The two-part sculpture was cast from two earlier works: *Two Planets* (1958; also called *Large Saturn*) and *Val* (1961). The larger element was understood by Beuys to reference both a landscape ("mountain") and a human torso (the body of a "king"), while the "two planets" (one circular element nestled inside another) function both as celestial bodies and as the head of the king.

On the topic of his melding of landscape and figurative modes, Beuys said, "what interested me was the psychology embedded in the physiology."[2] The mountain/torso was cast as a hollow form, which, the artist explained, was also integral to its meaning:

> The tunnel character suggests the activities of man, the will to penetrate the surface, mining, tunneling, and channeling. This is the cave aspect where legends and folklore of the mountain start. The legend continues in the drawing of the *Beheaded King*, where the heart jumps out to continue an independent existence.[3]

Two contradictions inherent in Beuys's connection of *Mountain King (Tunnel), 2 Planets* with *Beheaded King* illuminate important aspects of his broader oeuvre. One is the notion of a story, or "legend," which falls outside linear concepts of time – strictly speaking, the drawing, which was made in 1956, could not "continue" the sculpture made in 1972, even if one considers the genesis of its original elements, created in 1958 and 1961. Yet Beuys continually drew upon his previous work to create both new objects and new narratives. Indeed, his autobiography, which was honed and codified in many retellings, was one of his great symbolic fictional works.[4] A second contradiction, or contrast, is between the delicately rendered work on paper and the scarred and lumpy bulk of the cast-bronze sculpture. It is typical of Beuys to explore a theme through a broad range of materials. His mediums included not only wood, stone, clay, bronze, and pencil on paper: he also incorporated plastics, steel, string, wire, rubber, fat, felt, wax, animals (both living and dead), and his own body in performance. The trope of a beheaded king who transcends his condition through suffering is one manifestation of Beuys's chosen role of the artist as shaman. R. C.

Saint Louis Art Museum, Friends Fund and funds given by Mr. and Mrs. Donald L. Bryant Jr. 3:2003a, b

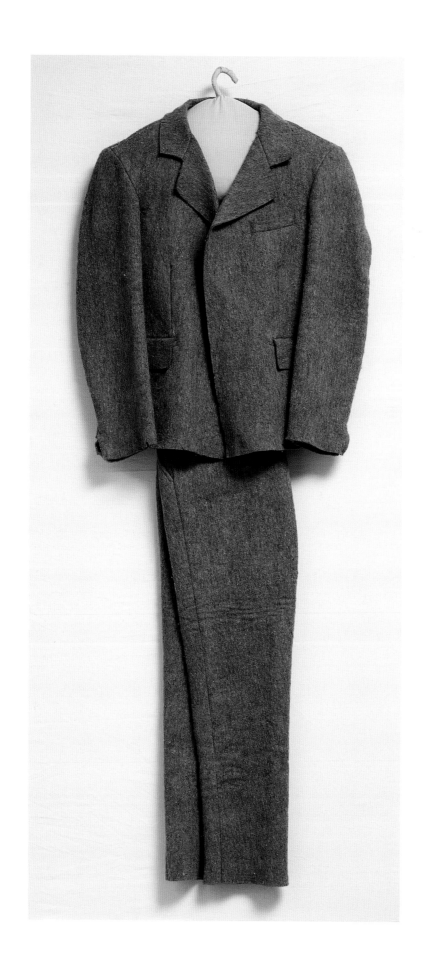

Felt Suit

Filzanzug, 1970
Felt
66¹⁵/₁₆ × 23⁵/₈ in. (170×60 cm)
Edition 27/100

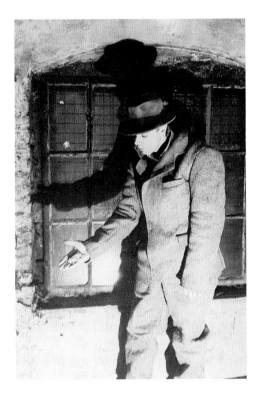

Isolation Unit
Joseph Beuys's anti-Vietnam
War action performed in
conjunction with Terry Fox at
the Staatliche Kunstakademie
Düsseldorf, October 4, 1971
Photograph by Ute Klophaus

Felt Suit occupies the intersection of two important aspects of Beuys's populist practice, performance and editioned art works. While the ephemerality of performance is somewhat contradicted by the production of souvenir sculptures based on props used during the event, the fleeting experience embodied in the performance and the relative affordability of editioned artworks both subordinate the preciousness of the art and privilege viewer experience.[1] Beuys wore a felt suit in an action with the artist Terry Fox. *Isolation Unit*, which took place in the cellar of the State Art Academy (Staatliche Kunstakademie), Düsseldorf, on October 4, 1971. Themes of death and rebirth were explored through the manipulation of object and sound for this performance, which was billed as an anti-Vietnam War event.[2] In the course of it, Fox burned a cruciform-shaped window frame, Beuys (wearing the suit) cradled a dead mouse in his hand, Fox burned a candle next to a naked lightbulb while banging repeatedly on an iron pipe, and Beuys caused a silver bowl to gently ring by spitting seeds into it.

Each visual and audio component of *Isolation Unit* has a value within Beuys's complex cosmology, none more resonant than the felt used to make his costume for the performance. For Beuys, felt carries a range of symbolic associations, including its ability to insulate (retain heat) and to isolate (muffle sound). When asked about the meaning and possible uses for the suit, Beuys replied:

> The suit is meant to be an object which one is not supposed to wear. One can wear it but in a relatively short time it'll lose its shape because felt is not a material which holds a form … it's an extension of the felt sculptures I made during my performances. There, felt also appeared as an element of warmth … not even physical warmth is meant. If I had meant physical warmth, I could just as well have used an infrared light in my performances. Actually I meant a completely different kind of warmth, namely spiritual or evolutionary warmth or the beginning of an evolution.[3] R. C.

Saint Louis Art Museum, Museum Shop Fund 46:1993a–d

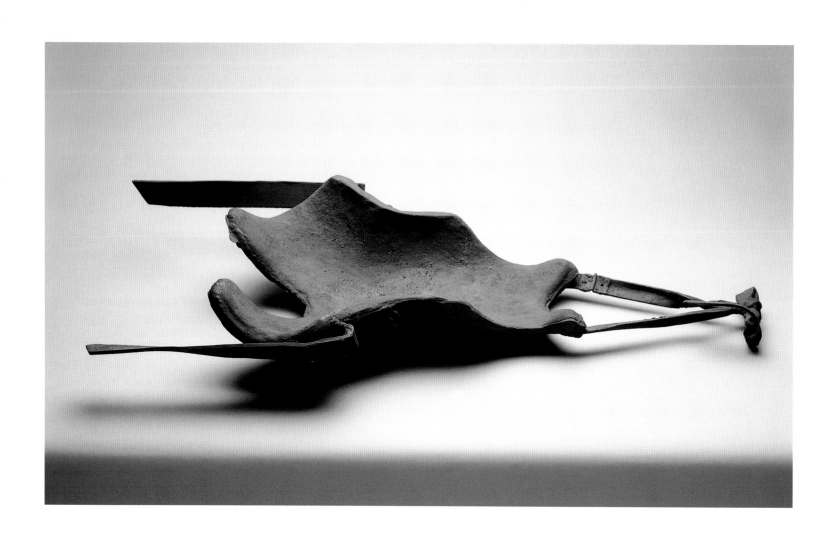

Joseph Beuys
Val (spine side of *Mountain King*), 1961
Bronze
Hessisches Landesmuseum,
Darmstadt, Ströher Collection

Backrest of a Fine-limbed Person (Hare-type) of the 20th Century AD

*Rückenstütze eines feingliedrigen Menschen
(Hasentypus) aus dem 20.Jahrhundert p.Chr.*, 1970–72
Cast iron
5¾ × 38 × 17 in. (14.6×96.5×43.2 cm)

With its evocation of the human spine, *Backrest of a Fine-limbed Person (Hare-type) of the 20th Century AD* is related to *Mountain King (Tunnel), 2 Planets* (cat. 6), whose final cast also dates to 1972. The "torso" section of the *Mountain King* features stacked vertebrae on what has become the obverse of the sculpture (see figure at left). By virtue of its massiveness and its reference to landscape, *Mountain King* represents the strength of the backbone, while the *Backrest* speaks to the vulnerability of the spine. An iron sculpture cast from a plaster backrest for weak or injured patients, the piece embodies a contradiction, since any back in need of support could hardly bear the weight of this metal prosthesis.

The physical properties of iron also contain a duality: in a pristine state, iron is among the most durable materials, yet it is also prone to rusting, and through this degradation it loses its structural integrity. Although he was born a century before Beuys, the Victorian art critic John Ruskin made the following comment on iron, which is directly applicable to Beuys's practice: "We may say that iron rusted is living; but when pure or polished, Dead."[1] The rusting surface of *Backrest of a Fine-limbed Person (Hare-type) of the 20th Century AD* evidences decay, but its efflorescence also signifies change and in that sense represents a life force.

The "hare-type" in the work's title may describe a frail person, or it may refer to the sculpture itself, which resembles a running hare with legs outstretched. Rabbits played an important symbolic role in the work of the artist, who drew them and incorporated them into some of his staged events, or "actions" (*Aktionen*). For example, Beuys cradled a dead hare in his arms for the famous 1965 action called *How to explain pictures to a dead hare* (see figure, p. 49). Although it was indeed dead, the hare symbolized both fertility and a close relationship with the earth in the context of Beuys's performance. The vitrine in which *Backrest of a Fine-limbed Person (Hare-type) of the 20th Century AD* is displayed was designed by Beuys and is integral to the piece. This presentation, together with the organic qualities of the object, suggests an archaeological display in a natural history museum, reflecting Beuys's interest in the integration of art and science.[2] R. C.

Saint Louis Art Museum, Funds given by Anabeth Calkins and John Weil, Mr. and Mrs. Donald L. Bryant Jr., the Siteman Contemporary Art Fund, the Henry L. and Natalie Edison Freund Charitable Trust, Museum Purchase, the Honorable and Mrs. Thomas F. Eagleton, Eleanor J. Moore, Gary Wolff, Nancy Singer, and Bequest of Helen K. Baer, by exchange 17:1999

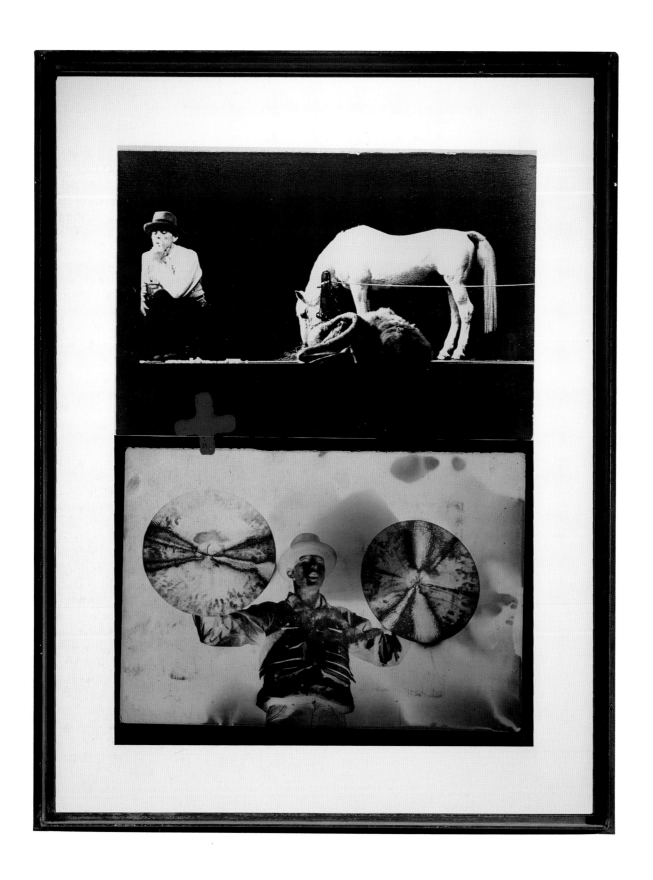

Iphigenia / Titus Andronicus

Iphigenie / Titus Andronicus, 1985
Photographic transparency and negative
with oil paint in steel, glass, and felt frame
28×21¼×2 in. (71.2×54×5.1 cm)

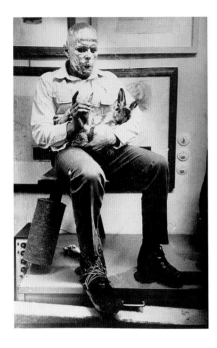

Joseph Beuys performing
**How to explain pictures
to a dead hare**
Photograph from action,
Galerie Schmela,
Düsseldorf, 1965
Photograph by Ute Klophaus

Beuys's activities as a teacher, political agitator, and performer were part and parcel of his artistic work. He understood all of these elements to be social sculpture, strategies for molding and shaping the world in which we live. Insofar as each person understands the process of living as a creative act, Beuys famously declared, everyone is an artist.[1] His resolve to act as a sort of shaman for postwar German society has been faulted by some critics as retrograde and self-serving,[2] but all agree that his performances were extremely influential. A key example is *How to explain pictures to a dead hare*. His 1965 performance was closed to the public but recorded for television and also visible from the street. Beuys, his head coated with honey and gold leaf, mysteriously whispered to the body of a dead hare he cradled in his arms.

Another important performance was *Iphigenia/Titus Andronicus*, which was part of the Frankfurt theater festival *experimenta 3* in May 1969. Having been invited to stage Goethe's *Iphigenia* and Shakespeare's *Titus Andronicus*, Beuys offered to stage them simultaneously. Tapes of the scripts for both plays were broadcast over loudspeakers while Beuys performed on stage. The side of the stage devoted to *Titus Andronicus* (which represented English realism, according to Beuys) was empty; the side devoted to *Iphigenia* (representing German idealism) featured Beuys and various props including a live white horse, chalkboards with diagrams, sugar lumps, fat lumps, and cymbals that Beuys periodically clashed.[3] Playwright Peter Handke recalled that the performance initially made him indignant, because Beuys's gestures were insistently repetitive. In retrospect, however, Handke decided that the performance was so "painfully beautiful that it becomes Utopian, and that means political."

Sixteen years after the performance, Beuys decided to make a photographic work based on documentation by Ute Klophaus, who photographed many of Beuys's performances. *Iphigenia/Titus Andronicus* comprises a photographic negative superimposed on a positive. Where their edges meet, a cross has been applied in red oil paint. The images are sandwiched between two sheets of glass, which are held together by a metal frame. Lengths of felt are wedged between the front and back of the frame as if to suggest that the metal conducts a form of energy released from the pictures. This editioned work (forty-five were made, in addition to five artist's proofs) functions both as documentation of the 1969 performance and also as a ritual object created by the artist a year before his death in 1986. R. C.

Saint Louis Art Museum, Gift of the Honorable and Mrs. Thomas F. Eagleton 596:1998

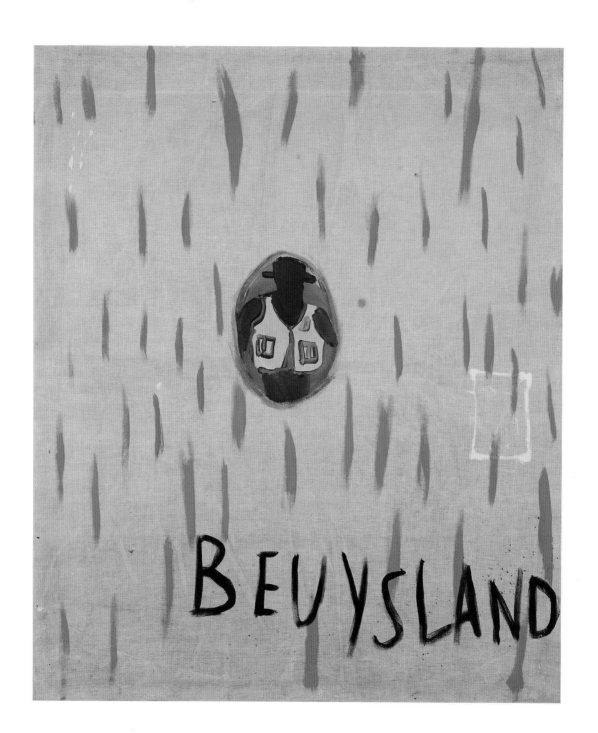

Beuysland
1965
Oil on canvas
49³/₁₆ × 41⁵/₁₆ in. (125 × 105 cm)

Jörg Immendorff in his
Beuysritter outfit, 1965
Courtesy Michael Werner,
New York and Cologne

Jörg Immendorff was barely eighteen years old when he became a student at the prestigious State Art Academy in Düsseldorf. After three semesters with the stage designer Teo Otto, he was told to leave or find a different professor to work with. He entered the class of Joseph Beuys and became one of his favorite students. Beuys was a formidable influence, who taught Immendorff not only great freedom in artistic expression, but also showed him the importance of social and political engagement. Initially with Beuys, but increasingly independently, Immendorff developed paintings and performances that questioned and criticized existing political structures and the conservative position of the Art Academy.[1]

In the mid-1960s Immendorff addressed his close early relationship with Beuys in a number of paintings, among them *Beuysland*. The work acknowledges Beuys's leadership role and iconic position in the German art scene of the 1960s and expresses both Immendorff's admiration for his teacher and his ironic assessment of Beuys's influence. The raw canvas of *Beuysland* is covered with a loose pattern of uneven red brushstrokes. In the center a medallion encloses the silhouette of Beuys, easily recognizable in his felt hat and fisherman's jacket, which he wore like a uniform. Photos of Beuys and a sample of his vests are still hanging in Immendorff's studio today as mementoes of his teacher. The central position of Beuys's image and the work's title inscribed on the canvas underline the subject's importance but also his limitations. Beuys's "land" is a stretch of bare canvas with a minimum of color. Beuys often told his students that painting was dead, but Immendorff found painting to be a crucial part of his artistic identity. While Beuys's approach to making art was crucial for Immendorff, he also recognized that Beuys's position was too restricting for his own development. From the 1970s onward, Immendorff has found his artistic identity in an expressive, narrative style of painting far removed from Beuys's work. C. H.

Saint Louis Art Museum, Friends Fund 4:2003

4 Muses
4 Musen, 1980
Acrylic on canvas
122¹/₁₆ × 98⁷/₁₆ in. (310 × 250 cm)

Jörg Immendorff
Position, 1979
Painted lime wood
Collection Garnatz, Cologne

Four men who are artists, friends, and rivals are shown in this large painting. Immendorff represented himself in the company of Georg Baselitz, Markus Lüpertz, and A. R. Penck, offering commentary on their art, their ambitions, and his own political and artistic beliefs. As with *Beuysland*, this work is a celebration of friendship and artistic achievement that is put into perspective with an infusion of irony. It is, however, less a programmatic statement than a multifaceted commentary by a mature artist.

Closest to the foreground of the composition is Baselitz, seated at a massive table looking at himself in a mirror. He seems to stare with surprise at his image, which is wearing a crown so big that it has slipped down to his shoulders. An upside-down nude makes reference to his work, in which he inverts his imagery. The table legs are upside-down figures as well; the nearest represents a bound eagle, an image that Baselitz and his friends used repeatedly in their work as a symbol of power and an emblem referring to Germany. Here, however, its potency is rather dramatically reduced, being strapped down and inverted.

In the background on the left, Lüpertz has turned away from a table with a mirror to gaze into an oversize looking glass. He is contemplating his own coronation, for which he himself has assumed the responsibility, like Napoleon. It might have been Lüpertz's well-known attitude of self-assurance that inspired Immendorff to use this imagery. On the right side of the composition, Penck is shown with his back to the viewer, seated at the edge of his table playing the guitar. His bearded face stares back at us from a mirror while sheets of his drawings are scattered around. His table is supported by men in uniform, a reference to the soldiers of East Germany, the country he was leaving in 1980 when this painting was made.

Immendorff himself is barely visible in a mirror, adorning himself with jewelry, part of his outfit at the time. The legs of his table consist of heads blindfolded with cloths having the colors of the German flag. On top of the table a sign protesting against atomic power alludes to the artist's political position, as does the huge figure in the background carrying an atomic energy symbol on its head. The Russian bear in front of the Kremlin and the figure of Lenin, among others, proclaim Immendorff's communist leanings.

This painting incorporates the imagery that Immendorff employed in other works to express his political convictions and his conception of the artist's role. It also makes references in paint to actual sculpture in the form of furniture that Immendorff had created earlier (see figure at left).[1] Most importantly, however, it celebrates the friendship and common concerns of the four artists depicted. As much as they differed in their art making, they all were intricately linked to the political situation in Germany: Immendorff had grown up on the border between East and West Germany, Baselitz and Lüpertz had lost their homeland in the East and had come to the West, while Penck was just then turning his back on the GDR because he could not work there any longer as an artist. Their awareness of their roots was as much a part of their personalities as of their art making. C. H.

Saint Louis Art Museum, Funds given by The Jordan Charitable Foundation 5:2003

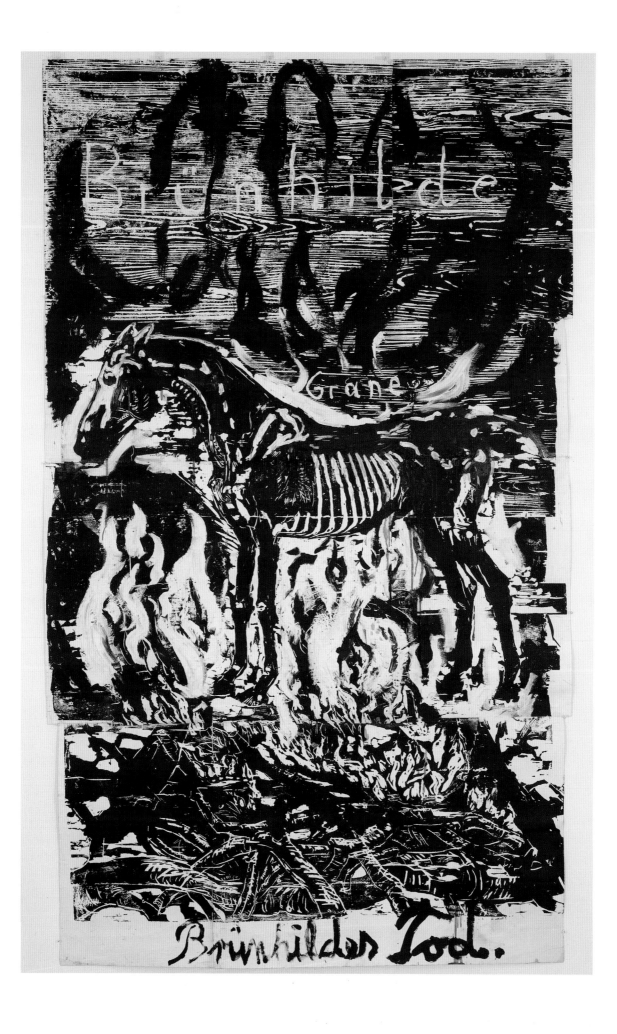

Brünhilde Grane, Brünhilde's Death

Brünhilde-Grane, Brünhildes Tod, 1978
Woodcut with oil
103 × 62¾ in. (261.6 × 159.4 cm)

One of the themes that Anselm Kiefer has used repeatedly as an inspiration for his work is the saga of the Nibelung. Its portrayal of good and evil, love and jealousy, and the battle for power and wealth is a German myth recounted many times and made famous by Richard Wagner in his operas of the *Ring* cycle. Wagner and his music, together with the myths they addressed, were appropriated by the Nazi regime, which was keen to establish a glorified German identity. When Kiefer chose this subject matter, he was well aware of both the long tradition of the heroic tales as a part of German culture and their more recent use in the ominous context of National Socialism.

Brünhilde's Death relates specifically to Wagner's final opera of the *Ring* cycle, *The Twilight of the Gods*. Siegfried, the brave hero, has not only found the gold of the Nibelungs but has also awakened the Valkyrie Brünhilde, who had been asleep in a circle of fire protecting her from lesser mortals. The two swear eternal love for each other, and Siegfried gives Brünhilde the magic ring from the hoard of the Nibelungs. In an attempt to gain the treasure, King Gunther tricks Siegfried into drinking a magic potion that makes him forget Brünhilde and fall in love with Gunther's sister instead. When Brünhilde hears of his betrayal, she swears vengeance and helps Siegfried's murderer. In the end Brünhilde learns that they both have been deceived. She orders Siegfried to be immolated on a funeral pyre and rides her horse Grane into the flames. As a result of these tragic events, the Rhine overflows, the treasure of the Nibelungs is lost again, and the fire reaches heaven, where it burns Valhalla and brings an end to the power of the gods.[1]

Brünhilde's Death is one of a series of very large woodcuts that Kiefer made in 1978, each unique through added painting and writing. It shows the horse Grane standing amid the flames that spread dangerously toward the heavens. Brünhilde appears only in her written name, as if she, together with her strength and love, have evaporated in the clouds of smoke. The emphasis on the horse's skeleton, together with its quiet pose of suffering, suggest its imminent destruction. In contrast to some other versions of the composition, which take the form of a crucifix, this work focuses all its energy on the prominent form of the horse amid the leaping flames. Kiefer's choice of the woodcut medium to represent a log fire is strangely appropriate. It also suggests the forests of Germany in which much of the mythical action takes place. Kiefer enriched and altered the print with paints of various intensities and thicknesses, thus suggesting pictorially the many ways the story has been understood and used. In the myth, the image symbolizes the end of the world, but considered historically, it also alludes to the misuse of power in Nazi Germany and the resulting destruction of a country and its culture. C. H.

Collection of Anabeth and John Weil

Burning Rods

Brennstäbe, 1984–87
Oil, acrylic, emulsion, and shellac on canvas
with ceramic, iron, copper wire, and lead
130×219×11¹³/₁₆ in. (330.2×556.3×30 cm)

A student of Beuys, Kiefer reflects in his work his teacher's interest in recent German history as well as his use of unconventional materials. Yet Kiefer is known primarily as a painter of epic, almost environmental works, despite Beuys's dismissal of painting as a viable contemporary medium. *Burning Rods* is a monumental work in three parts. The canvas on each panel has been scorched and the surface built up in a dense accumulation of materials, including paint, tar, sand, straw, and molten lead, as well as found objects including an old ice skate. In places the lead peels away from the canvas in rough scrolls projecting a foot or so in front of the painting. The total work weighs nearly 700 pounds (318 kilograms).

The painting's imposing physical bulk is matched by its ambition in addressing the problems facing western civilization in the latter half of the twentieth century. Soon after its completion in 1987, *Burning Rods* was featured in the eighth Documenta, the important quadrennial exhibition of contemporary art held in Kassel, Germany. It was exhibited with five of Kiefer's other works, including *Osiris and Isis* (1987). *Burning Rods* depicts a landscape ravaged by nuclear disaster, while *Osiris and Isis* refers to the Egyptian myth of Osiris, a god whose body was dismembered and scattered across the earth, only to be gathered again by Isis and rejuvenated. Both are massive works addressing apocalyptic moments, one imagined in the distant past and the other in the near future.

The theme of *Documenta 8* was loosely framed as "art and society." It was organized by Manfred Schneckenburger, who praised Kiefer not only as a painter but also as a philosopher who was not afraid to confront Germany's recent historical trauma.[1] In an otherwise highly critical review of the exhibition, American art historian Dore Ashton concurred, calling *Burning Rods* "more subtle and far more disquieting" than other works in the exhibition.[2] With this work Kiefer successfully shouldered the twin, if unequal, burdens of a horrific national history and the legacy of an overwhelmingly charismatic and important teacher. R. C.

Saint Louis Art Museum, Gift of Mr. and Mrs. Joseph Pulitzer Jr., by exchange, 108:1987a–c

Breaking of the Vessels

Bruch der Gefässe, 1990
Lead, iron, glass, copper wire,
charcoal, and aquatec
149×135¹/₁₆×57 in. (378.5×343×144.8 cm)

This massive sculpture consists of a three-tiered iron bookcase that is filled with folio-sized lead books. The books, made from thin sheets of lead, appear crammed into the shelves and are interspersed with panes of glass. Some of the glass has fallen and shattered on the floor in front of the bookcase. The imagery in this work is inspired by the Jewish mystical writings of the Lurianic Kabbalah. There, the creation of the world is described as beginning with God, who was *Ain-Sof*, "without end." In order to make room for creation, God contracted himself, withdrawing himself from His creation. What remained was God's light, and from it emanated the first man, Adam Kadmon, from whose nose, ears, and eyes streamed the light of *Ain-Sof*. This is the light of the *Sefirot*, which are God's attributes, the matrix of the world. The light emanating from Adam Kadmon's eyes was too strong for the vessels that were to contain it. As a result, the vessels of the six lower *Sefirot* were broken and the godly light returned to its source. Only small parts of it remained and mixed with particles of evil. Prior to the creation of the world, evil had been part of God's power; now it received its own identity and became manifest in the world. This process is called *Shvirat Hakelim*, the breaking of the vessels.[1]

Kiefer reflected this tradition in his sculpture by suspending a glass pane above the bookshelf inscribed with the phrase *Ain-Sof*. From the sides of the shelves extend leaden signs, which represent the six lower *Sefirot* that scattered. The broken glass in front of the sculpture suggests the remaining shards of the vessels. On a more general level one can read the work as a commentary on the fragility and imperfection of human life and experience. The massiveness of the sculpture alludes to the long history and richness of Jewish culture and its powerful impact on the development of European history. The signs of destruction recall the many times when this tradition has been threatened, and refer in particular to the persecution of Jews in Nazi Germany. In 1938 Jewish-owned shops and synagogues were destroyed in the infamous *Kristallnacht*, a night during which the streets of German cities were littered with the glass of smashed Jewish storefronts, a public display of brutality that signaled a further step in the effort by the National Socialists to annihilate the Jews. In this context Kiefer's sculpture becomes a towering monument to one of the darkest chapters of German history. C. H.

Saint Louis Art Museum, Funds given by Mr. and Mrs. George Schlapp, Mrs. Francis A. Mesker, Henry L. and Natalie Edison Freund Charitable Trust, Helen and Arthur Baer Charitable Foundation, Marilyn and Sam Fox, Mrs. Eleanor J. Moore, Mr. and Mrs. John Wooten Moore, Donna and William Nussbaum, Mr. and Mrs. James E. Schneithorst, Jain and Richard Shaikewitz, Mark Twain Bancshares, Inc., Mr. and Mrs. Gary Wolff, Mr. and Mrs. Lester P. Ackerman Jr., the Honorable and Mrs. Thomas F. Eagleton, Alison and John Ferring, Mrs. Gail K. Fischmann, Mr. and Mrs. Solon Gershman, Dr. and Mrs. Gary Hansen, Mr. and Mrs. Kenneth Kranzberg, Mr. and Mrs. Gyo Obata, Jane and Warren Shapleigh, Lee and Barbara Wagman, Mr. John Weil, Museum Shop Fund, the Contemporary Art Society, and Museum Purchase; Dr. and Mrs. Harold J. Joseph, Estate of Alice P. Francis, Fine Arts Associates, J. Lionberger Davis, Mr. and Mrs. Samuel B. Edison, Mr. and Mrs. Morton D. May, Estate of Louise H. Franciscus, anonymous donor, Miss Ella M. Boedeker, by exchange 1:1991

Pergola – Dithyrambic
Pergola – dithyrambisch, 1970
Distemper on canvas
78 3/4 × 116 1/8 in. (200 × 295 cm)

In 1970 Lüpertz received a fellowship that enabled him to work for a year in Florence. For the first time the northerner experienced the bright sunlight and intense colors of southern Europe and saw the extraordinary art treasures of Italy. He had a studio and a large terrace with a pergola covered by vines.[1] The artist made a series of paintings that look up into this pergola. At first glance, the present work appears to be almost an abstract painting; only slowly do the supporting wooden poles and patches of blue sky emerge within the dense canopy of leaves. Lüpertz captured the rich shades of the green vines and used the wooden rods as if they were visual elements rather than structural supports.

The word "dithyrambic" in the painting's title refers to Lüpertz's proclamation of the dithyramb as his personal invention and art form. The term *dithyramb* is derived from the cult of the ancient god Dionysus and signifies a song of praise; for the artist it had associations of intoxication, enthusiasm, and inspiration. In 1968 he published a manifesto, *The Grace of the Twentieth Century is Made Visible by the Dithyramb, Which I Invented*, whose title is not only a display of superb self-confidence by an artist who purposefully promotes himself as a genius, but also suggests that Lüpertz as a painter felt the need to contribute something uniquely his own to the field of painting. He argued that the dithyramb was his "unique and unscientific contribution to abstraction. Abstract not in the sense of non-representational, but as invention, of a nonsensical object."[2] Lüpertz invented a term that allowed him to define for himself a form of painting in which the object and the act of painting could be unified.[3]

In the case of *Pergola*, the term could be applied almost literally. The artist's enthusiasm can be felt in the celebration of painting that the work seems to express. It is felt in the Dionysian delight taken by the artist in his experience of Italy's intense colors, lush vegetation, and bright sunlight. In a more general context, paintings like these reflect the discovery of the northern artist who for the first time encounters the southern climate. For centuries, painters and writers from northern Europe were drawn to Italy for exactly the experience that Lüpertz is celebrating in his painting. C. H.

Saint Louis Art Museum, Friends Fund 8:2003

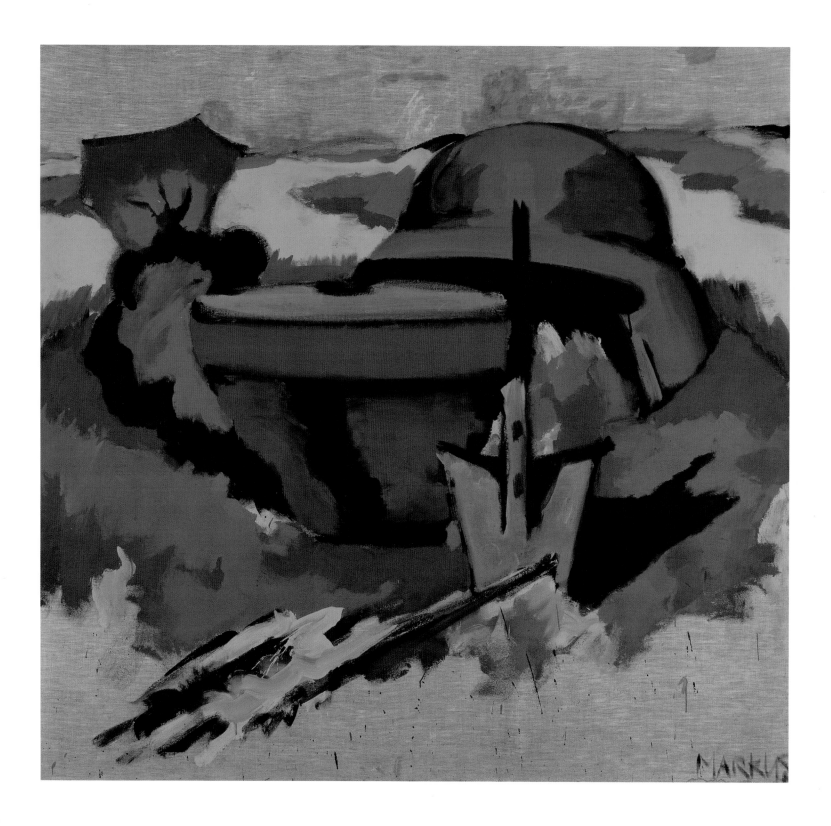

German Motif – Dithyrambic III
Deutsches Motiv – dithyrambisch III, 1972
Distemper on canvas
78¾ × 78¾ in. (200×200 cm)

During his sojourn in Italy, Lüpertz saw an Italian movie that showed the stereotypical German soldiers of the Nazi era. Unable to follow the conversation in Italian, he concentrated on the visual effects and was struck by the endless row of helmets moving along the horizon. This experience initiated a series of paintings that used imagery related to World War II and the Nazi regime.[1] *German Motif – Dithyrambic III* is an important example of this series. A still life appears to have been set up in a landscape, consisting of a helmet, a flowerpot, a spade, and a sheaf of wheat. At first glance, it seems a rather innocuous arrangement of unrelated objects. However, the sheaf of wheat, the spade, and, more obviously, the helmet, all represent loaded imagery within the context of German history. For anyone growing up in Germany during World War II, the sheaf of wheat and the spade would recall a Nazi organization called the *Reichsarbeitsdienst* (RAD), in which young people between eighteen and twenty-five years of age had to work for a minimum of half a year, essentially without pay. It was intended to indoctrinate the young generation with Nazi ideals. Members of the group wore a uniform, and their emblems were the sheaf of wheat and the spade, reflecting the Nazi *Blut und Boden* (blood and soil) ideology. This imagery is contrasted strangely with the flower pot, which appears banal in this context and serves to emphasize the symbolic weight of the other objects. The impact of the work is intensified by the composition and materials. The still life is centered on the canvas, which is otherwise left bare. At the time Lüpertz used distemper, a cheap paint easily available to him on the construction sites where he worked at the time. He preferred its rough, earthy quality to the fine art associations of oil paint. The artist also wanted to achieve a density of tone, as in the yellow areas of this painting, which could serve as an autonomous, abstract element within the composition.[2]

While the painterly impact of the work was just as important to Lüpertz as the content he depicted – in line with his concept of the dithyrambic – he was well aware of the meaning of his imagery.[3] The German public, however, was not ready to face this material in 1972. Eager to forget their recent past and focused on the astonishing recovery of their economy, German viewers were unable to accept this engagement with the past and the responsibilities that went with it. Initially misunderstood as a celebration of Nazi ideology, Lüpertz's work was rejected instead of being seen as an artist's confrontation with the burden of history. C. H.

Saint Louis Art Museum, Funds given by Anabeth and John Weil 9:2003

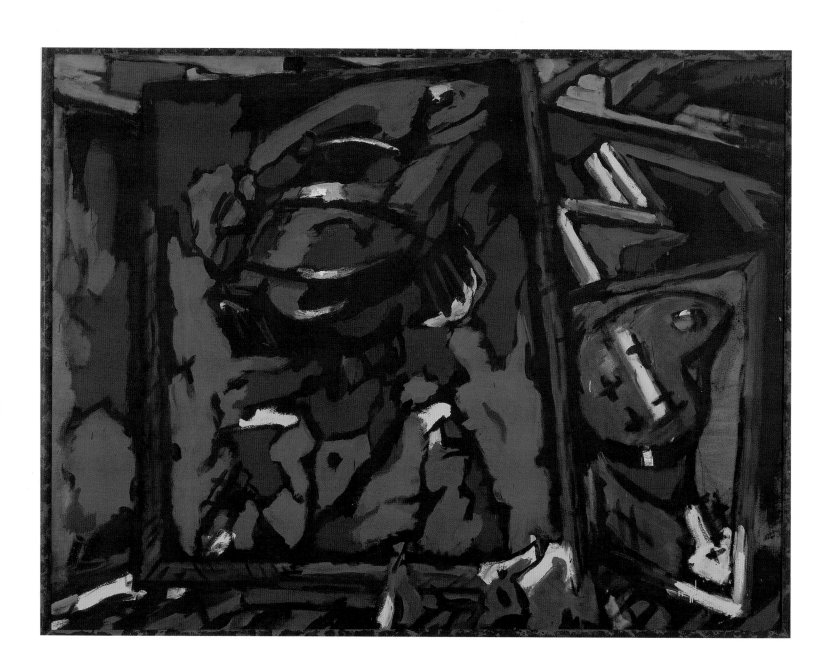

Interior III
Interieur III, 1974
Distemper on canvas
76¾ × 101³⁄₁₆ in. (195×257 cm)

Max Beckmann
Studio Corner
Atelierecke, 1946
Oil on canvas
Saint Louis Art Museum

Interior III shows an area of the artist's studio where finished canvases are stacked in front of and next to each other. Here the results of the painter's work are waiting, ready to be shown to the public. More even than palette and brushes, such a studio corner represents the identity of the artist and has a long tradition in the history of art. Lüpertz, an artist who is consciously seeking a place in the tradition of great painters, was well aware of his models. Max Beckmann, one of the artists he admires and one who is certainly a prominent member of the pantheon, also used such imagery, as for example in his 1948 *Studio Corner* in the collection of the Saint Louis Art Museum.

Interior III goes beyond this display of the artist's metier and awareness of artistic tradition. The imagery refers to another more threatening type of history. The most prominent canvas shown in the composition depicts a uniformed figure with a huge cap and the upper part of an army coat. Further inspection reveals that there is no human being inside the uniform. Instead of a face, there seems to be only the huge visor. The uniform is an empty shell, representing the insignia of an army without a human presence, implying an anonymity that is frightening. Lüpertz highlights the absence of the individual, but also the powerful dehumanization of a large group. The empty uniform suggests a soldier who has no personality or will of his own and does not connect with his surroundings or opponent. In a German context such an image evokes memories and raises questions regarding the army's role in World War II.

The canvas reproduced in the painting is one that Lüpertz painted as part of a series of three with the same subject. The canvas depicted to the right of it, showing the painter's palette, is also part of a series by Lüpertz. It seems as if the artist is not only confronting his viewers with the question of collective responsibility, but is also trying to define his own position. What is the painter's role in the face of history? How can an artist who had no part in the war respond to this history, which is so much part of his heritage? Lüpertz confronts the German past through layers of meaning, using the motifs of the uniform and the artist's palette in paintings that he then depicts again in a composition that deals with artistic identity as much as the experience of history. The artist thus introduces a level of abstraction that is not related to the non-representational, but to a conceptual way of approaching the act of painting. C. H.

Saint Louis Art Museum, Friends Fund 10:2003

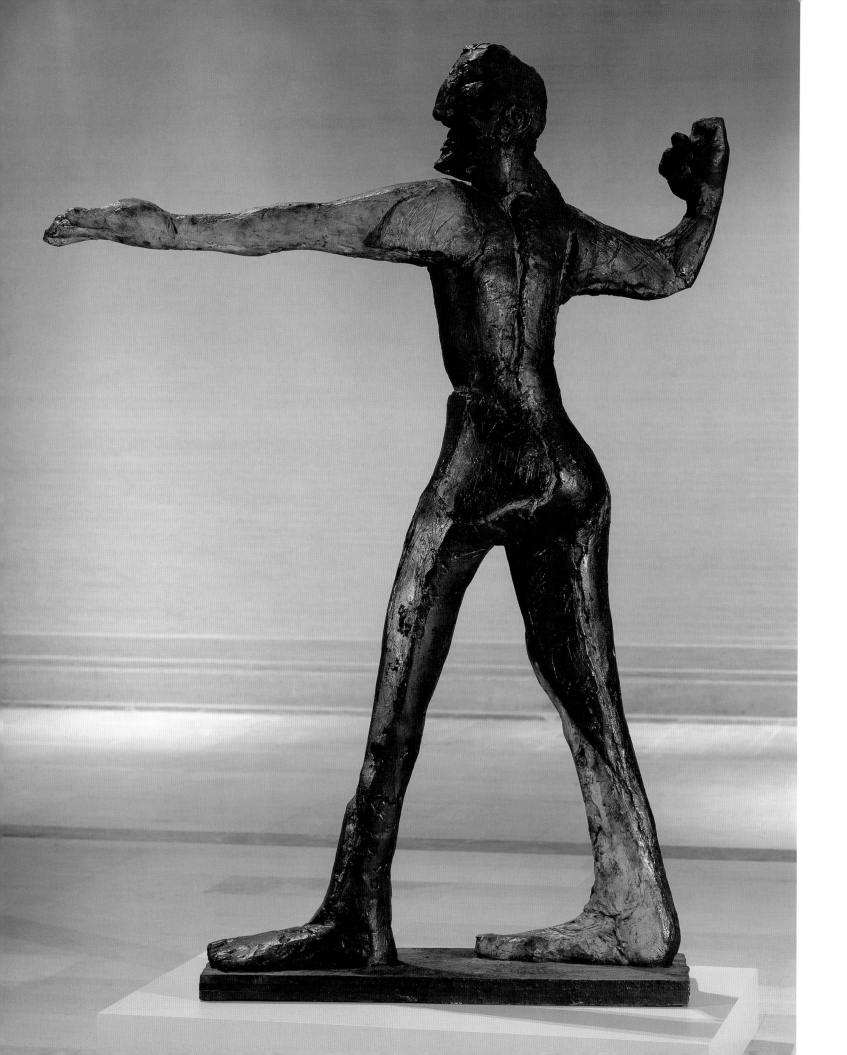

Titan
1986
Painted bronze
98³/₈ × 76¹/₂ × 17³/₄ in. (249.9 × 194.3 × 45.1 cm)
Edition 5/6

In around 1980 Lüpertz began making sculpture. In contrast to Baselitz, who presented his first wooden sculptures in 1980, Lüpertz chose bronze as his medium. Many of his figures are inspired by antiquity, both in terms of content and form. He was fascinated by the perfect balance of ancient sculpture, which he considers a starting point for his own work. The model for *Titan* is the figure of Zeus from Cape Artemision, now in the Athens National Museum. Lüpertz repeated the pose of the god throwing what was most probably a spear or a bolt of lightning, emphasizing the thrust of the throwing arm and the firm balance of the other. The body exudes power and strength: legs are firmly planted on the ground, the body is tense in preparation for action. Lüpertz's sculpture shows nothing of the graceful beauty of his Greek model, however. His figure is rough in form and surface, showing little detailing in the face and body parts. The face seems like a rough mask, the nose is jutting forward. As a result, the work appears much more aggressive than the antique Zeus, but this impression is softened by the seemingly incongruous fact that Lüpertz turned upwards the outstretched hand of his sculpture in a gesture of pleading or supplication.

Like ancient sculptures in their original state, Lüpertz painted his bronze. As with the modelling, he did not aim for delicate detail but used color to complement the roughness of his forms. Incisions highlighted in red suggest muscles or body parts and emphasize the angularity of the figure. One leg is painted a greenish-blue, as if clad in partial armor. The outstretched arm has the same color, and together they create an extraordinary impression of balance that has an abstract quality. The artist called his figure *Titan*, not *Zeus*. According to Greek mythology, Zeus fought and defeated the Titans in a battle for control between the forces of the earth and the gods from Olympus. This sculpture shows the strength of the Titans, ready to fight and defend their power. Titan's upturned hand, however, could suggest that he knows he will not win his final battle. C. H.

Saint Louis Art Museum, Funds given by Kenneth and Nancy Kranzberg in honor of their children, Lily and David Dulan and Mary Ann and Andrew Srenco 11:2003

Zeus
found in the sea
near Cape Artemision
c. 460–450 BC
Bronze
National Archaeological
Museum, Athens

Fritze
1975
Acrylic on canvas
112³/₁₆ × 112³/₁₆ in. (285 × 285 cm)

Ralph Winkler, who assumed the alias A. R. Penck in 1968, had decided
to live and work in East Germany where he was born and develop his art
within the political framework of the GDR. Self-taught, he created a pictorial
sign language, which he called *Standart*.[1] He attempted to develop a visual
sign system that offered a new approach to understanding the world but
could function independently of any ideological tendencies. His work
found resonance only in the West, however, where Michael Werner gave
Penck a first gallery show in 1968. Officials in the GDR looked at Penck and
his work with distrust. He had applied to become a member of the VBK,
the official artists' organization in East Germany, without which he could
not be recognized or function as an artist, but he was turned down in
1969. In 1972 Penck declared that *Standart* had failed. He developed a
new artistic language using the alias Mike Hammer, referring both to the
detective of American fiction and to Michael Werner, and then continued
with signing his canvases T. M., for Tancred Mitchell or Theodor Marx.
By the mid-1970s Winkler had had a number of important exhibitions in
western Europe and his financial situation had improved as well. He
developed a new freedom and energy in his large-scale works, which
are characterized by an unprecedented use of color and expressiveness.

Fritze, signed T. M., is a celebration of color and expressive painting.
Its large size reinforces the dramatic impact of the brushwork. Different
from the gestural expressiveness of Abstract Expressionism, Penck's
shapes seem on the verge of bursting apart at the seams, but are
nevertheless contained within the framework of an outline. Seemingly
abstract at first glance, the work actually has representational content:
narrow shoulders and a vast head rise from the colorful background like
a caricature, created out of bright green, red, and blue. In the upper right
corner a form could be interpreted as the Brandenburg Gate in Berlin. The
title also hints at narrative content: "Fritz" was a pejorative nickname for
the German soldier in World War II. The figure rises like a huge specter,
but also dissolves in a riot of colors and forms. Penck had experienced
the bombing and subsequent burning of his hometown, Dresden, when
he was a child. His memories of the war and its destruction were vivid
and immediate. The Brandenburg Gate, formerly a sign of Germany's
strength, had become a symbol for the loss of identity and the separation
of Germany into East and West. Shortly before he painted this canvas,
Penck had to perform his military service, an experience that might also
have suggested the imagery of this work. *Fritze* takes on the artist's
memories and shows the immense creative powers of the painter. In
presenting the soldier as a dissolving, dripping figure, Penck seems to
assume an ironic distance from his own life experiences as well as the
menace of military power. C. H.

Saint Louis Art Museum, Funds given by the Honorable and Mrs. Thomas F. Eagleton 13:2003

Tulb
1976
Acrylic on canvas
112³/₁₆ × 112³/₁₆ in. (285 × 285 cm)

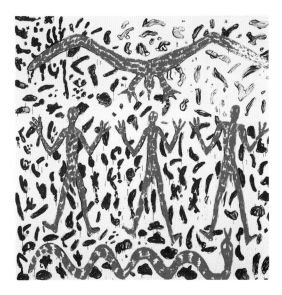

A. R. Penck
Standart 3, 1974
Acrylic on canvas
Fukuoka Art Museum

The image of the eagle appears frequently in Penck's work, both in writing and in painting. He shares it with other artists, among them Immendorff and Baselitz. For Penck the eagle is primarily a symbol of strength within any conceptual structure. He has employed the image in different contexts and styles, often placing it within his investigations of contemporary society. In his 1974 text *Eagle*, he investigated the fact that the bird is used as a symbol in many different societies and mythologies, often with different meanings and attributes, but always as a symbol of power.[1]

In *Tulb* the eagle has a powerful presence and it can be read as a symbol for Germany. The word inserted in the lower part of the composition mirrors the German word for "blood." The eagle is flying over a rugged landscape. The reference to Germany's recent past is evident and the work raises the question of reflection on the terrors and bloodiness of World War II. The painting is executed with an expressive brushwork that seems to be structured only by the separation of blue and black areas. The glorious blue of the sky stands in dramatic contrast to the heaving darkness of the earth beneath. Using the eagle in such a naturalistic form, Penck makes a connection to other artists of his generation who were also his friends. In 1976, when this painting was made, Penck started to work on an exhibition project with Immendorff, who often used the eagle as a symbol in his commentaries on Germany. Penck's decision to use the mirror image of "Blut" also allowed him to connect ironically with Baselitz, who inverts imagery in his paintings. The two artists have known each other since the 1950s, and it was Baselitz who helped Penck to make connections in the West. In the early 1970s Penck also met Lüpertz, who had just completed his series *German Motifs,* in which he dramatically confronted Germany with its own history. *Tulb* is a powerful composition that established for Penck a relationship with his western colleagues at a time when life was becoming increasingly difficult for him in the GDR. It reflects on the responsibility of Germany as a whole toward its history rather than the separation between East and West. C. H.

Saint Louis Art Museum, Funds given by Florene M. Schoenborn in honor of her father, David May, by exchange, and Friends Fund 14:2003

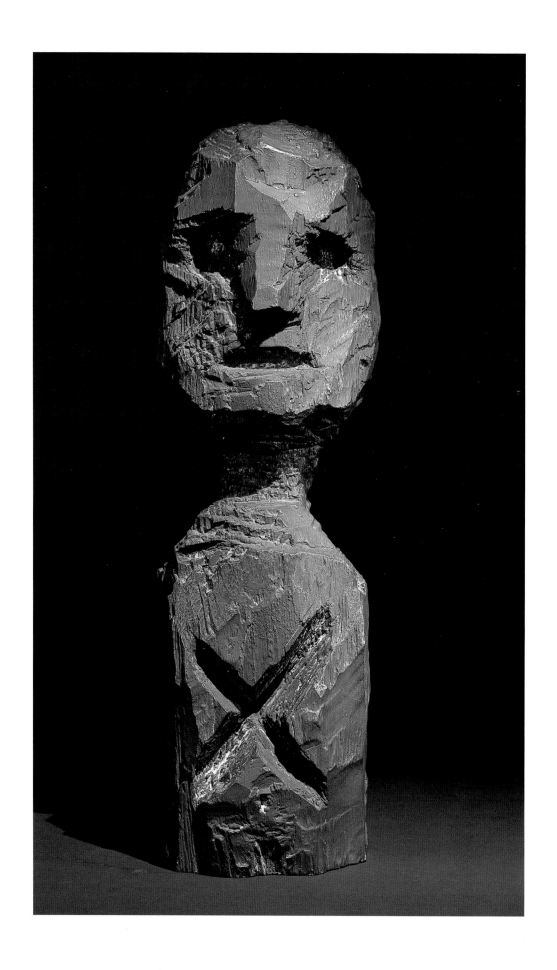

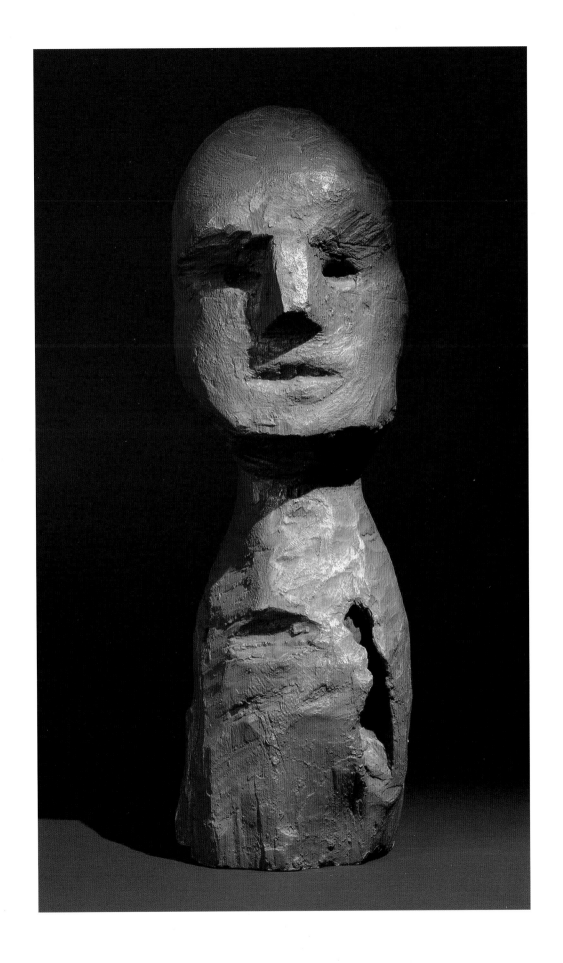

Self Head I

Selbstkopf I, 1984
Bronze
23⅝×7⅞×8¼ in.
(60×20×21 cm)

Head W

Kopf W, 1984
Lead and paint
26¾×9¹/₁₆×9¹/₁₆ in.
(68×23×23 cm)

Alongside working as a painter, Penck has often been engaged with sculpture. Initially using a variety of everyday materials such as cardboard, plaster, plastic, or aluminum foil, he began cutting wood sculptures in 1977. Starting out as a way to escape from a personal crisis, they became more prominently part of his oeuvre in the following years. In the 1980s Penck began to have his wood sculptures cast in bronze. In part, this was a way to make them more durable, but it was also the artist's response to the consumerism that he found in West, which he had experienced differently during his life in the GDR. The small editions in bronze were less a response to increased demand for his work than Penck's reaction to a capitalist system. He commented ironically on the contradiction between the West's obvious commitment to market forces and the art world's pretended indifference to this economic context.

These two heads illustrate particularly well Penck's approach to materials. The artist took great care to retain the feeling of the original texture in the cast. Roughly hewn surfaces show the traces of the cut wood; in *Head W* a hole in the tree trunk he had used becomes part of the aesthetic experience of the final sculpture. "I was fascinated to have a surface that looked like wood, but was as hard as iron. That led me to cast wooden sculptures, because I could achieve an effect that was estranged from its original."[1]

The two heads, one a self-portrait, the other a portrait of Michael Werner, Penck's dealer and friend, do not show great resemblance to their models, but are dramatically different from each other. The self-portrait is a frontal image, marked with an X on the torso, as if the artist were facing the world like a prisoner before a firing squad. He presents himself head-on, bracing himself for the impact of the public's response to his work. In Michael Werner's portrait, the high forehead has a pensive curve to it, contemplative and observing. It exists in different types of casts and coatings, and its red patina either shines brightly or, as in this case, has a muted tone. In this version it is cast in lead instead of bronze, which not only makes it exceedingly heavy, but also suggests an interesting connection to the use of lead by other German artists, for example, in some of Kiefer's work. The two sculptures are rather personal statements by an artist who generally chooses more abstract forms. Penck's ability to survive as an artist, especially during his time in East Germany, was tied closely to Werner's support and willingness to break through the restrictions that the GDR placed on Penck's art. As signs of a long friendship, these two works seem very appropriate. C. H.

Self Head I: Courtesy Michael Werner, New York and Cologne
Head W: Saint Louis Art Museum, Friends Fund and funds given by Florene M. Schoenborn in honor of her father, David May, by exchange 12:2003

Totem for Cologne	**Mi-Cla-Ma**
Totem für Köln, 1989	1986
Bronze	Bronze
119⅛ × 11⁷/₁₆ × 11⁷/₁₆ in.	96⁷/₁₆ × 4⁵/₁₆ × 3⅛ in.
(302.5 × 29 × 29 cm)	(245 × 11 × 8 cm)

Many of Penck's sculptures function as memorials. They commemorate aspects of German history, such as his *Memorial for an Unknown East German Soldier* (1984), or address topics on a more personal level, as in *Emigrant* (1987), which points to an experience that Penck shared with many others. His memorials often take the form of totems, as with *Totem for Cologne*. Penck's connections to this city are deep and manifold. It was the place of his first exhibition in the West in 1968, and it is the place where Michael Werner has been active as a friend and supporter. It was Penck's first home when he came to the West, and for a long time it has been a center for artists and the German art market. *Totem for Cologne* has the long vertical form of a totem pole. Its undulating form rises into the air from a base that clearly shows the roughly hewn surface of the wooden model from which the work was cast. The form suggests an interesting parallel to the emblem of Cologne, the cathedral whose spires rise majestically above the city. The traditions of art making and the old roots of the city, going back to the Roman period, add a timeless quality that extends the work's significance beyond Penck's personal experience.[1]

Mi-Cla-Ma has a similar format with a base that is even more prominent, lifting the open and closed shapes of the sculpture's upper part high into the air. In this case Penck used the solemn format of the totem with a heavy dose of irony. The title seems abstract and suggests a contemplative quality that evaporates, however, when one learns that "Mi-Cla-Ma" is short for "middle-class man." The sculpture's loftiness seems incongruous and slightly ridiculous in the face of such a title. Penck had moved to London in 1983 and used the title most probably to reflect his experiences of western social structures. The awareness and broad acceptance of class distinctions would have struck Penck, who came from a communist environment where only one class of people was supposed to exist. *Mi-Cla-Ma* celebrates this difference and at the same time satirically questions the nature of western capitalist society. C. H.

Courtesy Michael Werner, New York and Cologne

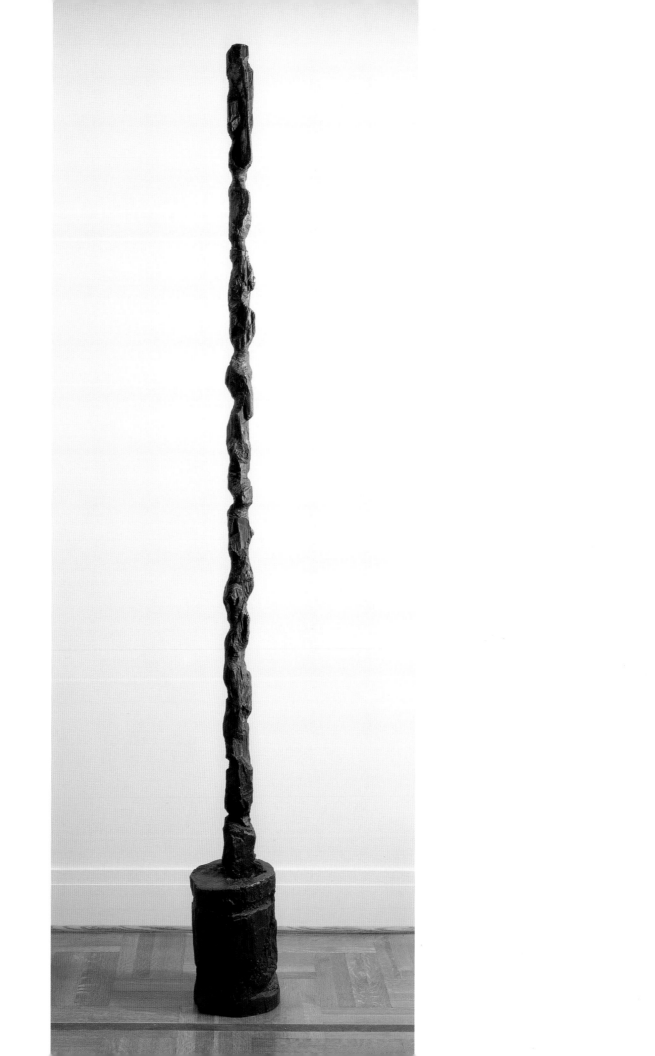

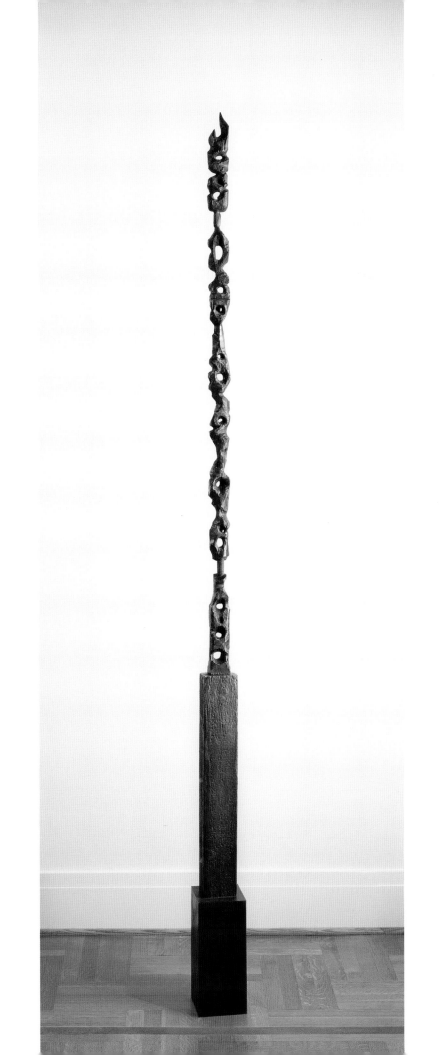

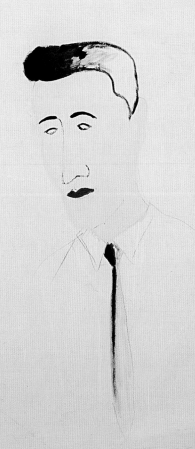

Why Can't I Stop Smoking?
1964
Dispersion and charcoal on canvas
66¹⁵/₁₆×47⁷/₁₆ in. (170×120.5 cm)

Polke's childhood in an impoverished East Germany and emigration to a more affluent and socially mobile West Germany is often cited, along with the impact of American Pop Art, as an important influence on his work of the mid-1960s. Following an apprenticeship as a glass painter, Polke enrolled in the State Art Academy in Düsseldorf, where he studied from 1961 to 1967. *Why Can't I Stop Smoking?* was made during a time when the traditions of German art academies were contending with challenges both from without and within. The anarchist aims of Dada resurfaced in the form of Fluxus, which erupted in several events in Düsseldorf, including "Neo-Dada in Music" at the Düsseldorf Kammerspiele in 1962 and "Festum Festorum Fluxus" at the Staatliche Kunstakademie in 1963. The international cast of Fluxus artists shared an interest in performance and ephemeral actions expressed through music, food, the spoken word, and the element of surprise. Polke's work from this period interweaves the spontaneity and irreverence of Fluxus with the visual vocabulary and cultural criticism of Pop.

Thinly painted on unprimed canvas, *Why Can't I Stop Smoking?* is rendered in an offhand manner consistent with the deadpan delivery of the text that is block lettered in English across the top of the painting. Polke has started fleshing out a figure at the base of the painting; he has gone so far as to outline a head and shoulders, secure a collar and tie, and begin filling in a strange, wiglike hairpiece, but he seems to have lost interest midstream. Although the figure's mouth (longing for the cigarette) is colored a fulsome, deep red, the figure's eyes are vacant and his tie cascades down a barely suggested torso. In contrast to the compulsive urgency suggested by the title, the painter hardly seems able to muster enough enthusiasm to complete his picture. At this moment Polke abuses both the craft tradition in which he initially trained and the conventions of fine artistry to which he once aspired at the academy by using cheap paints on cheap supports as well as borrowed imagery and a text from down-market popular culture. Yet, if Polke's everyman can't seem to stop smoking, Polke himself can't seem to stop painting, in spite of the notion in some avant-garde circles that painting had become exhausted as a means of expression. Although he went on to test its boundaries, both physically and conceptually, Polke has remained in thrall to painting throughout his long and influential career. R. C.

Saint Louis Art Museum, Funds given by Mr. and Mrs. Donald L. Bryant Jr., the Gary Wolff Family, and Friends Fund 15:2003

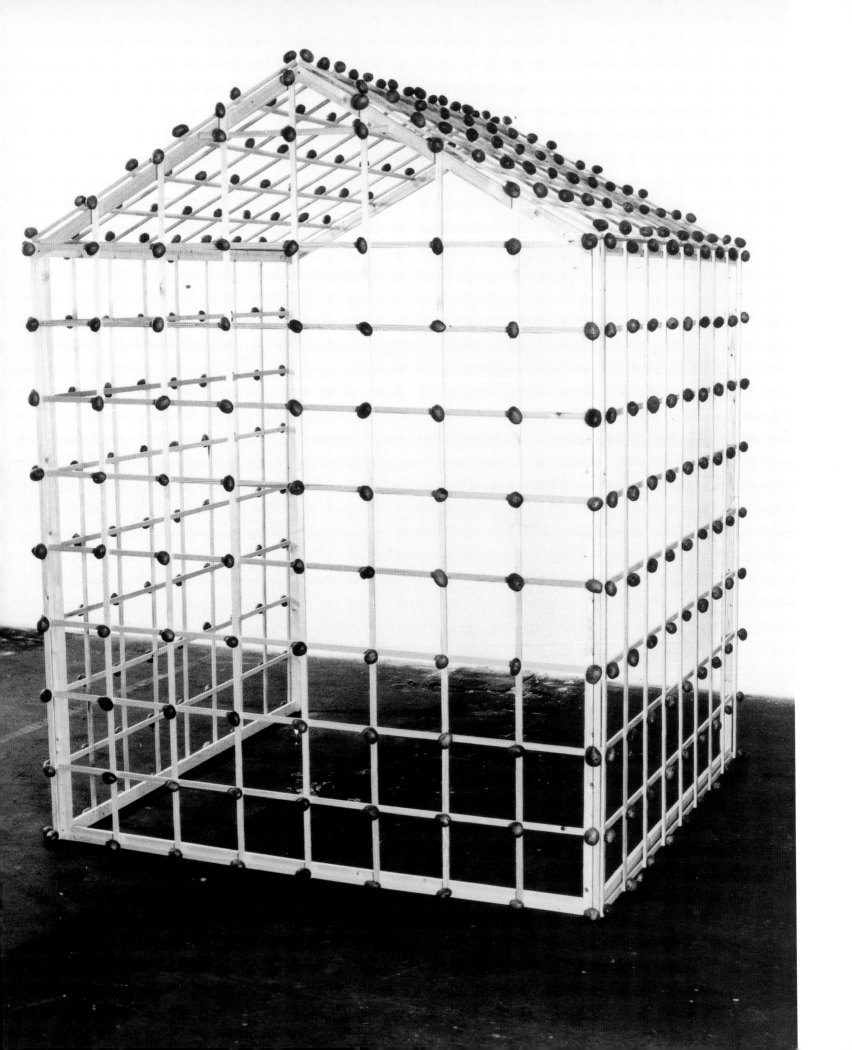

Potato House

Objekt Kartoffelhaus, 1967
Wood and potatoes
99³/₁₆ × 78³/₄ × 78³/₄ in. (252 × 200 × 200 cm)

Sigmar Polke
**Potato Pyramid in
Zwirner's Basement**
*Kartoffelpyramide in
Zwirners Keller*, 1969
Felt-tipped marker and pen
Private collection

Potatoes occur repeatedly in Polke's work from the 1960s. In his series *Potato Heads*, he used potatoes with generic shapes as a vehicle for ironic comments on social and political relationships. When he constructed *Potato House*, he transferred the concept of raster image dots from his paintings onto a three-dimensional art work. The house is constructed of wooden trellises, with three walls and a tilted roof. A fourth side is open and big enough for a visitor to walk in. On the outside of the house a potato is attached at each point where the latticework intersects.

The little house calls to mind the small allotment gardens in towns all over Germany, which were especially popular in the 1950s and 1960s. Those who lived in the city and had no garden would have the opportunity to enjoy the outdoors and grow vegetables and flowers. Often these little gardens had a tool shed or even a summerhouse, whose simple shapes resemble those of *Potato House*. The regular placement of potatoes on the trellis recalls the potatoes and other vegetables grown in these gardens, whose orderly rows reflect the cliché of the German obsession with orderliness. Dishes made with potatoes were of course popular in Germany, but potatoes also were closely associated with the years of severe hunger immediately after the war, when they were a mainstay of the German diet. In the 1960s, the potato implied normality and boring regularity. Polke's house reflects ironically on the yearning for middle-class normality among many people in the first decades after World War II. *Potato House* also suggests that this daydream, in which the horrors of the recent past were erased, was as ludicrous as this structure. Germany had not yet faced its past, and Polke, like many of his contemporaries who grew up after the war, used his art to confront his viewers with this fact. Appropriately for the artist, his method was an ironic approach in which the banality of his subject matter underscores the seriousness of his commentary. C. H.

Courtesy Michael Werner, New York and Cologne

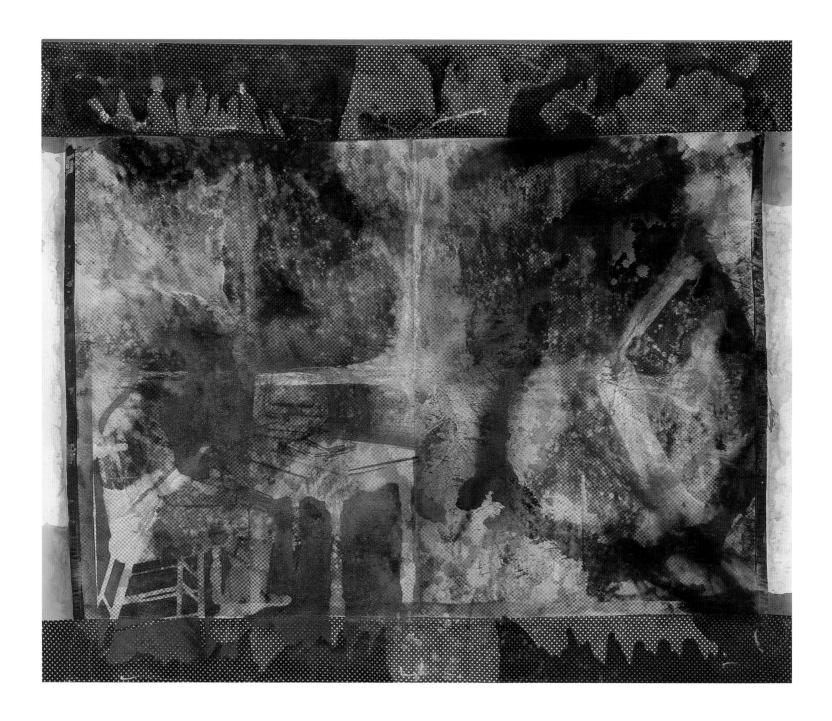

The Computer Moves In
1983
Mixed media with manganese on fabric
102½×122½ in. (260.4×311.2 cm)

George Segal
The Computer Moves In
Shown on the cover
of *Time* magazine,
January 3, 1983

The Computer Moves In is painted onto ten strips of fabric that have been sewn together to create one large canvas. The seams are not altogether straight; some appear machine sewn, while others were perhaps stitched inexpertly by hand. Polke has exchanged the traditional painter's problem of how to address a blank canvas with the challenge of beginning with a ground preprinted in red and blue patterns. *The Computer Moves In* is not Polke's first foray into painting on patterned fabric; an early example of this is *The Palm Painting* (*Das Palmen-Bild*; 1964), and works rendered in even more complex crazy-quilt patterns include *Alice in Wonderland* (*Alice im Wunderland*). However, *The Computer Moves In* is unique in its distinctly American subject matter: part of the imagery, and the title, have been lifted from the cover of the January 3, 1983 issue of *Time* magazine. Typically, *Time*'s new year's issue names a man or woman of the year, but in 1983, the computer was named "Machine of the Year." *Time* commissioned George Segal to make a work about the sudden omnipresence of the computer in American life. Perhaps it was the strangeness of Segal's stark and melancholy image that inspired Polke to appropriate it for this painting.

Along with the printed fabrics and transfer of Segal's image, Polke has incorporated stains and glittering manganese shavings in his multi-layered surface. The entire composition echoes the form of a computer screen in the way the fabric strips at the perimeter seem to frame a central image and also in the way that the dots of the fabric patterns and the shimmering of the metallic spray both recall the pixels of video. Polke's focus on American media in this work coincided with his new prominence on the American art scene at this moment, his first solo exhibition in New York having been seen at Holly Solomon Gallery in 1982. R. C.

Saint Louis Art Museum, Funds given by Dr. and Mrs. Alvin R. Frank and Friends Fund 262:1995

Helena's Australia

Helenas Australien, 1988
Synthetic resin and acrylic on fabric
118⅛ × 88⁹⁄₁₆ in. (300×225 cm)

Sigmar Polke
Quetta, Pakistan, 1974 / 1978
Gelatin silver print with paint
Froehlich Collection, Stuttgart

During the 1970s and 1980s, Sigmar Polke continued to experiment with unorthodox materials and a variety of formal idioms. This multiplicity of approaches became a hallmark, if not exactly the identifiable style, of his work. During these years Polke traveled to destinations including Pakistan, Afghanistan, Mexico, Brazil, Papua New Guinea, and Australia, making works in response to his experiences there. In a series of photographs shot in opium dens in Quetta, Pakistan, Polke evoked the hallucinatory properties of opium by hand-coloring oversized prints in brilliant hues, inscribing them with mysterious calligraphic lines.[1] The layering of images, patterns, and colors in these photographs resonates with strategies Polke also used in his paintings during this period.

Although the sources for *Helena's Australia* are not as obvious as those for the Quetta pictures, this work also makes use of nontraditional methods and materials. The support for the painting is two strips of polyester fabric joined by a seam running diagonally from the top to the bottom of the canvas. Polke laid the stretched canvas face down and poured synthetic resin on the back. Where the resin saturated the fabric, it became translucent. The artist then created abstract patterns on the front of the canvas using acrylic paints. One can see at least three layers when looking at the resulting imagery: the skeins and drips of paint on the surface, the fabric, and the supporting stretchers, which are visible through the translucent passages of the painting. Like *The Computer Moves In* (cat. 27), this work can be linked to Polke's early training in a glass studio. The shifting planes and strange effects of light also lend this picture some of the otherworldly qualities developed in Polke's photographic work during the 1970s. R. C.

Saint Louis Art Museum, Friends Fund and funds given anonymously 16:2003

Cityscape Sa 2

Stadtbild Sa 2, 1969
Oil on canvas
49¼ × 49¼ in. (125.1 × 125.1 cm)

Gerhard Richter
Cityscape TR
Stadtbild TR, 1969
Oil on canvas
3 panels
Frieder Burda Collection

Sol LeWitt
Modular Structure (floor),
1966
Painted wood
Courtesy of the artist

The influence and complexity of Richter's work stem partly from his simultaneous engagement with contemporary art movements, such as Pop and Minimalism, and with the political conditions of Germany after World War II.[1] The *Stadtbild* (which may be translated as "cityscape" or "townscape"), a recurring subject in Richter's work during the later 1960s, is a case in point. As a group, these paintings form a microcosm of Richter's famous stylistic heterogeneity: some are loosely, almost crudely brushed, while others are so rigid in their geometry and so crisply articulated as to resemble arrangements of machine parts. One of the most elaborate cityscapes is a triptych, which departs from the square format of most of the cityscapes by comprising three abutting vertical canvases to create one horizontal work. Focusing on the aesthetic qualities of this particular painting, Richter commented, "I put the paint on very thickly in black and white, creating with the two a gray. It was quite musical, almost like a fugue."[2]

Cityscape falls somewhere in the center of this stylistic spectrum. Like all of the cityscapes, it is done in grisaille, a technique that looks back to Renaissance panel painting and also references the tonality of the black-and-white magazine reproductions on which the paintings are actually based.[3] The simplified geometry of the buildings resonates formally with the contemporaneous sculpture of American artists such as Donald Judd and Carl Andre, whose work Richter knew through art publications before their first exhibitions in Germany. The geometric forms in the painting are echoed by the square format of the canvas itself, which can be read almost as legibly in any orientation. A tension develops between the sensuous application of paint on the surface of the canvas and its composition, which refers to a more clinical science. The deadpan presentation of aerial imagery evokes the anonymity of surveillance photography and alludes to sinister military applications. By infusing the language of Modernism with charged political content, Richter creates works that function in multiple registers and confound exclusive interpretations. R.C.

Saint Louis Art Museum, the Siteman Contemporary Art Fund and partial gift of John and Sally Van Doren and Mr. and Mrs. Ronald K. Greenberg; Friends Fund and Museum Purchase 67:2001

Ölberg
1986
Oil on canvas
118⁷/₁₆ × 98½ in (300.9 × 250.2 cm)

With its concentrations of work by German modernists including Max Beckmann, Lovis Corinth, Erich Heckel, Ernst Ludwig Kirchner, Max Pechstein, and Karl Schmidt-Rottluff, the Morton D. May Bequest of 1983 made the Saint Louis Art Museum one of the major public collections of modern German painting. This generous gift inadvertently raised the issue of how German art had developed after World War II, a question which began to be answered with the acquisition of Gerhard Richter's *Ölberg*, the first major postwar German painting to enter the Saint Louis Art Museum's collection.

Ölberg can be read as a luscious, brilliantly colored abstract painting in the tradition of American Abstract Expressionism, or as a wry commentary on the notion of heroic, emotive tendencies in both German and American art.[1] By creating an accomplished painterly canvas that is also self-reflexive, Richter preserves multiple avenues for interpretive entry into (and escape from) the painting. In an interview with Michael Shapiro, Richter explained how this painting and others like it were made.[2] The stretched canvas was placed on his studio floor, and boldly colored pigments (yellow, orange, red, green, and blue) were brushed onto the gessoed surface. To make the subsequent layers of the painting, Richter mounted the canvas on a wall and applied additional paint in vertical strokes with a broad spatula. Richter's control of this technique is such that he can make abstract passages appear photographic. Quotations of the photographic and the appearance of spontaneity in an abstract picture that has in fact been laboriously composed render opaque both Richter's intentions and the painting's content. Like the both/and approach of Richter's technique, knowledge of specific details about the work (the painting's title, for example, refers variously to a street that Richter's relatives live on, to a mountain near Bonn, and to the Mount of Olives mentioned in the New Testament) opens a broad field of tantalizing interpretations but brings one no closer to a definitive answer. R. C.

Saint Louis Art Museum, Purchase 107:1987

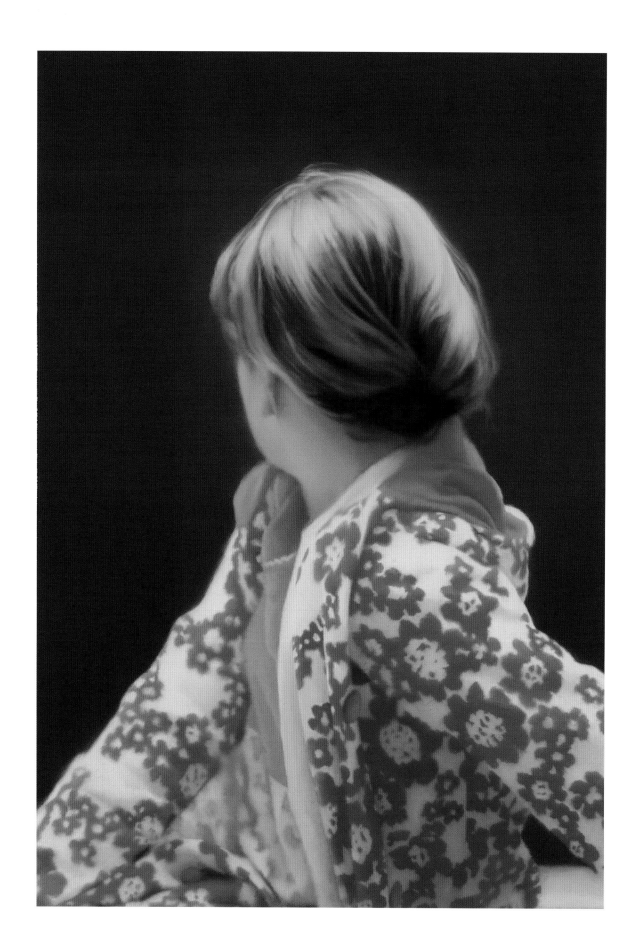

Betty
1988
Oil on canvas
40¼ × 28½ in. (102.2 × 72.4 cm)

The image of a young girl is captured in the act of turning away from the viewer, or perhaps toward an object in the distance. It is a posture both intimate and withholding; while her face is averted, the figure actually leans precipitously forward. The sharp angle of her turning away implies that this condition is only temporary, and that the dramatically torqued body will soon relax and once again face the viewer.

The formal elegance and psychological ambiguity of this painting combine to make it one of the most riveting in Richter's oeuvre. The technique and composition of the work are partly informed by venerable art historical sources; several authors have remarked on the similarity between Betty's pose and that of the model in Ingres's *Bather of Valpinçon* (1808), a photograph of which Richter kept in his studio. It is also likely that the radiant yet soft focus of the painting owes a debt to Vermeer (one might think, for example, of *The Lute Player*, 1663–64). If Richter's attention to works by these earlier masters is evident in this painting, so too is his engagement with abstraction. The dark expanse into which Betty seems to gaze is a rendering of one of Richter's own gray monochrome paintings. Indeed, *Betty* embodies Richter's insistence on a practice that weds, without blurring, the abstract and the representational.

Richter painted *Betty* from a photograph he took of his daughter in 1978, when she was eleven years old.[1] He waited ten years, until she was a grown woman, to paint the picture and then chose not to exhibit it publicly for another three years. As a color portrait of a close family member, *Betty* is a rare phenomenon within Richter's oeuvre. It falls into a small group of paintings that also include *Ema (Nude on a Staircase)* (1966; see fig.) and *Reading* (1994). *Ema* depicts Richter's first wife, Marianne (Ema) Eufinger; the model for *Reading* was the artist's third wife, Sabine Moritz. All painted from photographs, these pictures at first seem accessible, almost documentary, but the distance at which each figure is caught never lessens, and over time the atmospheric haze of nostalgia and memory, suggested by soft brushstrokes, contributes to a mounting sense of uncertainty. In spite of, or perhaps because of, their physical and emotional proximity to Richter, each of the figures is portrayed looking away from him. On some level, the question of what these images represent is as unanswerable for Richter as it is for us. R. C.

Saint Louis Art Museum, Funds given by Mr. and Mrs. R. Crosby Kemper Jr., through the Crosby Kemper Foundation, Arthur and Helen Baer Charitable Foundation, Mr. and Mrs. Van-Lear Black III, Mr. John Weil, Mr. and Mrs. Gary Wolff, Senator and Mrs. Thomas F. Eagleton; Museum Purchase, Dr. and Mrs. Harold Joseph, and Mrs. Edward Mallinckrodt, by exchange 23:1992

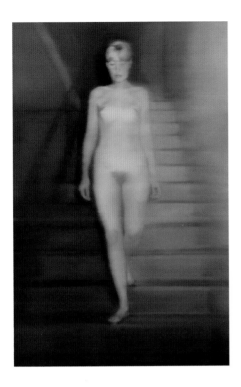

Gerhard Richter
Ema (Nude on a Staircase)
Ema (Akt auf einer Treppe), 1966
Oil on canvas
Museum Ludwig, Cologne

January *Januar*, 1989, **December** *Dezember*, 1989,
November *November*, 1989
Oil on canvas
Each panel 126×78¾ in. (320×200 cm)
in each of three diptychs

These three very large abstract paintings speak eloquently of temporal progression and motion, concepts that are conveyed through the reverse chronological order of the paintings' titles, their diptych format, and especially the dramatic vertical and horizontal movements that define these abstractions.[1] This sets them apart from Richter's main figurative subjects during the 1980s – landscapes and still lifes that underline one of photography's innate qualities: the arrest of time and space. They are conceptually linked to Richter's fifteen-part painting cycle *October 18, 1977*, which was completed just before he began to work on these diptychs. The *October* paintings commemorated the deaths in a high-security prison of members of a notorious German terrorist organization, the Red Army Faction. In those paintings, the artist used various formal devices to counter the morbid spectacle of the forensic and media images on which the paintings were based. Abstraction functioned as a distancing device that successfully held the spectacular at bay and diffused the emotional impact of the photographic images through a process of estrangement. Paradoxically, abstraction achieves the opposite effect in *January*, *December*, and *November*, which have an unsettling emotional effect, even though they are void of representational imagery.[2] Despite their dramatic impact, these paintings are not the result of a spontaneous, bravura performance but the product of a semi-mechanical painting process. Richter achieved the sweeping vertical and horizontal movements by dragging enormous squeegees across the canvas, uncovering previous layers each time he applied new paint. The results are heavily worked surfaces that register like curtains and smudged shadows, seemingly silencing previously existing images.

One clue to a possible interpretation of these paintings comes from their titles, which suggest a direct link to the seismic political events that took place during these winter months. On November 9, 1989, forty years of history collapsed as the disintegrating East German government gave in to mass demonstrations and opened the Berlin Wall, the first in a series of steps that eventually led to the reunification of the two German states. Since Richter had left East Germany a few months before the Wall was built in 1961, the recent turn of events would have struck a very personal note. November and December 1989 and January 1990 witnessed tourists and locals chipping away on the city's physical divider and moving freely from one sector to another. While a celebratory mood prevailed in the streets and in the media, it appears as if Richter condensed the emotional and political uncertainty surrounding these events, and the historical questions arising from them, into these three enormous canvases in which past, present, and future seem submerged in layers of paint. C. M.

January: Saint Louis Art Museum, Funds given by Mr. and Mrs. James E. Schneithorst,
Mrs. Henry L. Freund and the Henry L. and Natalie Edison Freund Charitable Trust; and Alice P. Francis,
by exchange 28:1990a, b
December: Saint Louis Art Museum, Funds given by Mr. and Mrs. Donald L. Bryant Jr.,
Mrs. Francis A. Mesker, George and Aurelia Schlapp; Mr. and Mrs. John E. Simon, the Estate
of Mrs. Edith Rabushka in memory of Hyman and Edith Rabushka, by exchange 29:1990a, b
November: Saint Louis Art Museum, Funds given by Dr. and Mrs. Alvin R. Frank and the Pulitzer Publishing
Foundation 30:1990a, b

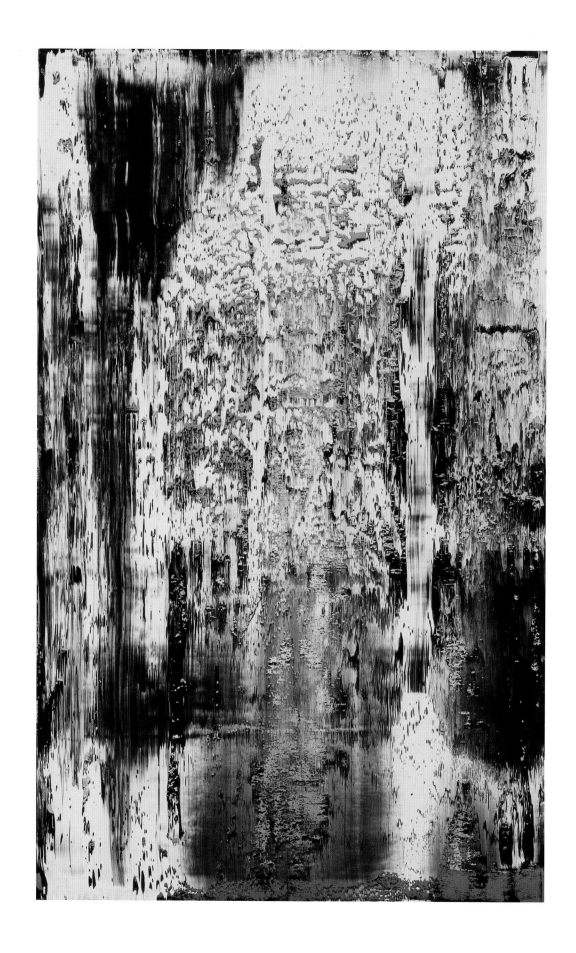

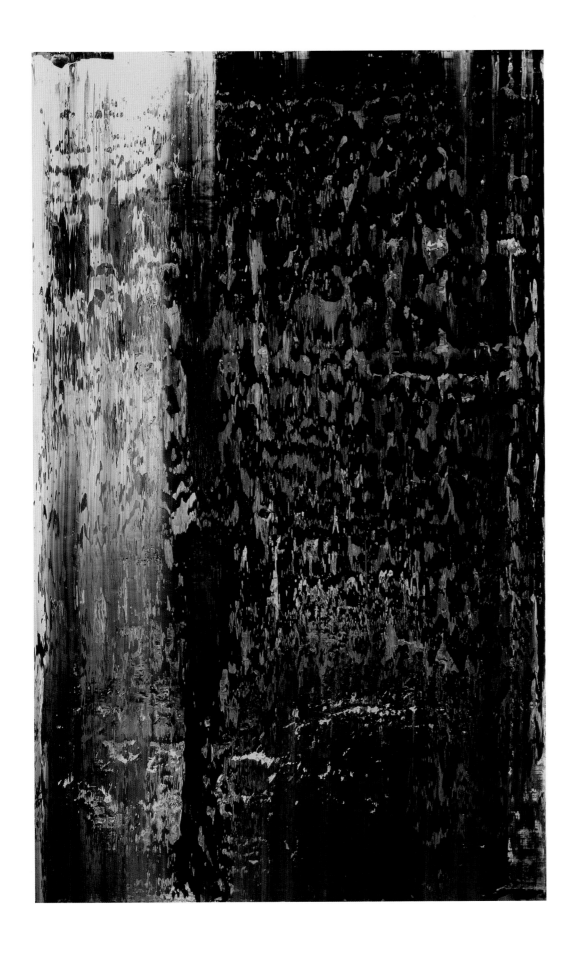

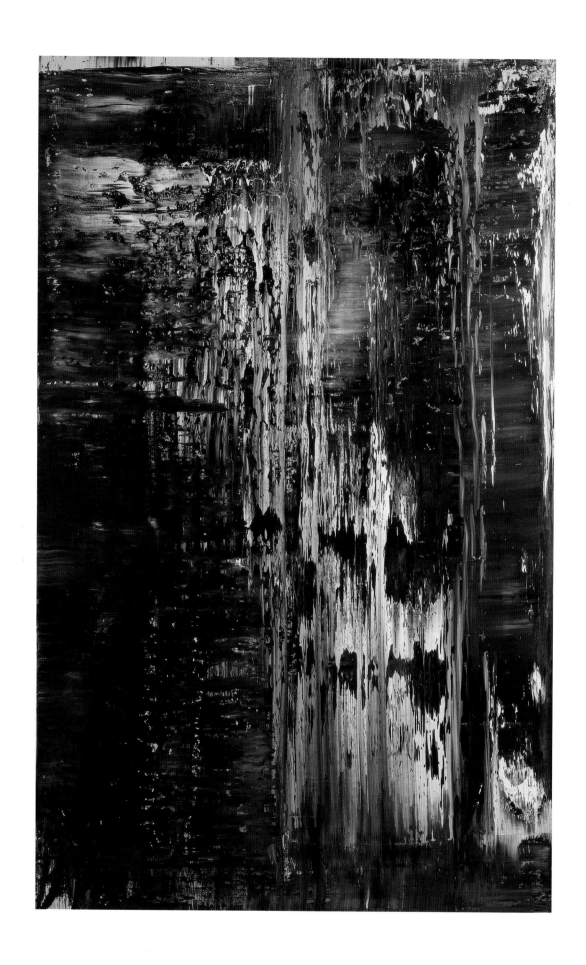

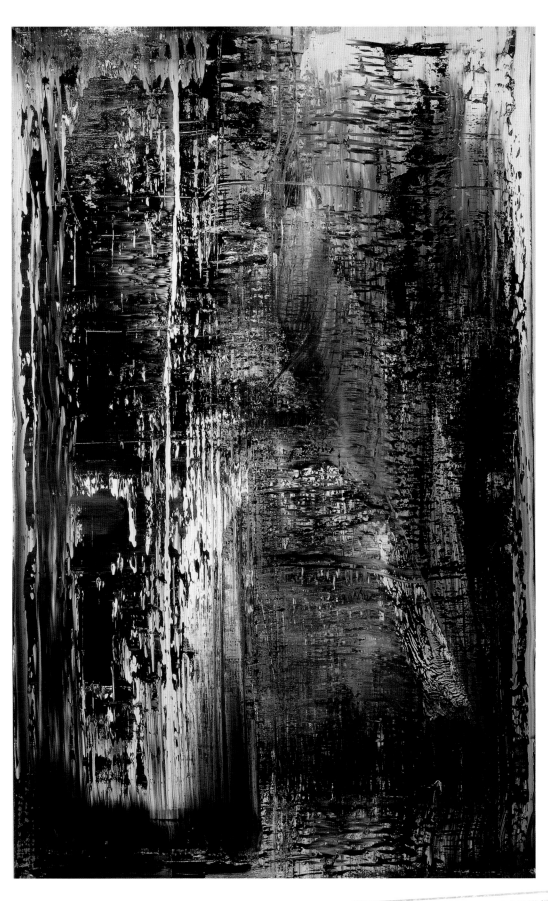

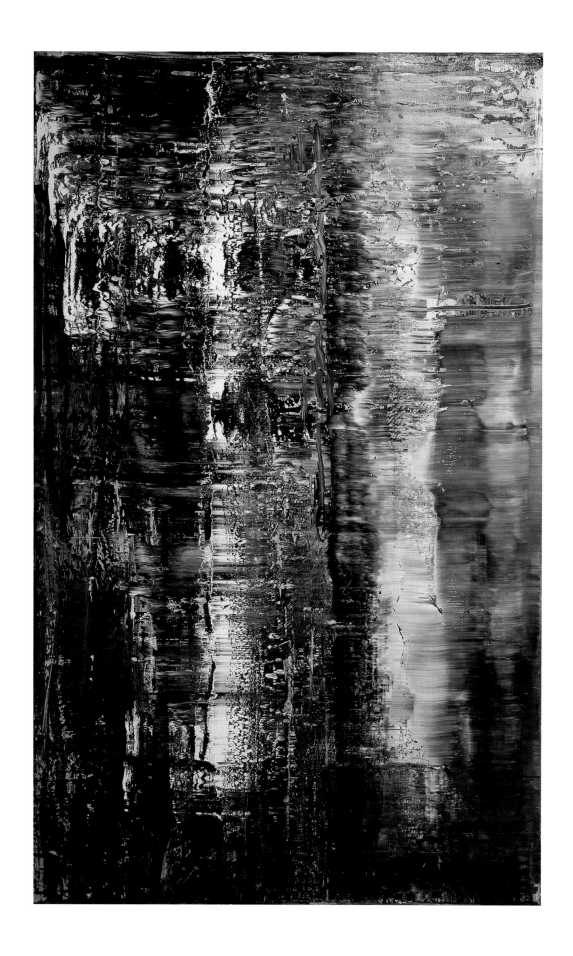

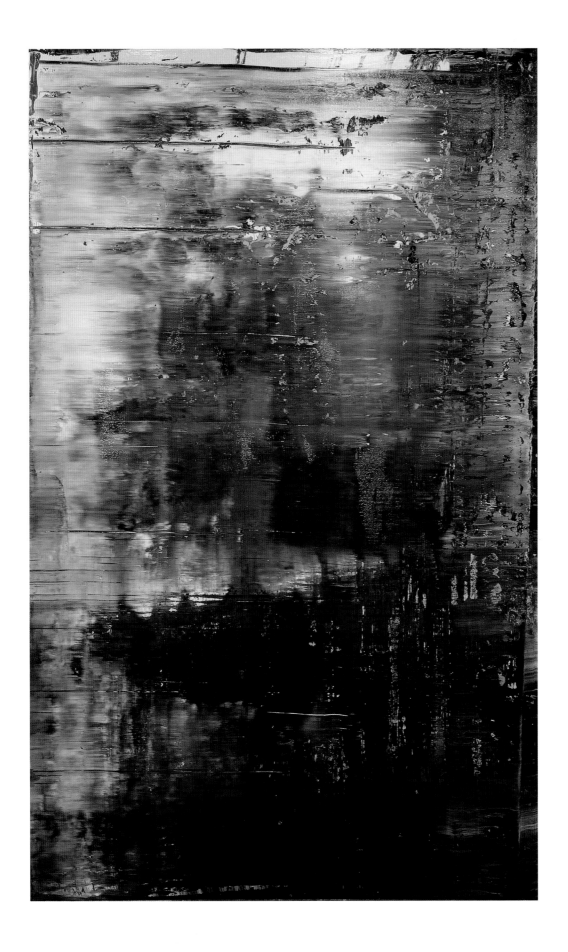

Gray Mirror

Grauer Spiegel, 1991
Glass, enamel, and paint
each 118⅛ × 68⅞ in. (300 × 175 cm)
Richter cat. raisonné 751/1-4

Richter's *Gray Mirror* followed on the heels of his large abstractions in the late 1980s and addressed his interest in representation by referencing painting, photography, and sculpture. It is fitting that this work should belong to the same collection as Richter's *Betty* (cat. 31), which depicts the artist's eldest daughter as she is turning away from the viewer and looking at an opaque, dark gray surface that is probably meant to depict one of Richter's gray paintings from the 1970s.

Ever since his first photo-based painting in 1962, Richter has explored the relations between illusion and abstraction. While the seductiveness of the photographic image lies in its seeming transparency, Richter's painterly translations of newspaper and magazine clippings re-encoded the photographic reproduction through the rhetoric of painting. His method of "un-painting" eliminated one of photography's most prized characteristics – the rendition of minute details – and suspended the instant recognition afforded by most straight photographic images.[1] The result was a slowing of the viewing process, a demand that viewers ask new questions about the nature of representation. However, the application of paint to the back of a glass panel constitutes an inversion of painting and deflects attention from the materiality of paint. Instead of being the image's constituting matter, the gray paint becomes the ground for subsequent reflections. As viewers move around the gallery, they find ephemeral images of themselves, the surrounding architecture, and art objects reflected in the monochrome panels. In this respect, Richter's dark mirrors could be said to resemble large-scale photographic plates with an endless exposure.

Although the artist began to create a variety of gray and colored mirrors in 1991, there are two important precursors that date back to 1977. The two *Window Panes* (*Glasscheiben*) were freestanding structures, each holding a horizontal glass plate in a metal frame, one side of the glass being covered by gray paint. The artist's titles are often conceptual rather than illustrative, and thus *Window Panes* is not transparent, but instead presents viewers with the flat materiality of an opaque surface on one side, and on the other a faint illusionistic image with the suggestion of perspectival space.[2] Richter's *Gray Mirror* of 1991, installed almost flush against the wall, entirely denies painterly materiality in favor of illusion – an illusion that is of a different register than the painted image in *Betty*. C. M.

Saint Louis Art Museum, Gift of Gerhard Richter 734:1991a–d

Gerhard Richter
Window Panes
Glasscheiben, 1977
Glass and gray paint
Private collection

Georg Baselitz

Picture for the Fathers

1 Georg Baselitz and Eugen Schönebeck, *Pandemonium 1* (1961), translated in Jo-Anne Bernie Danzker, *Georg Baselitz* (exh. cat.), Vancouver: Vancouver Art Gallery, 1984, p. 13.

Three Stripes, Cows

1 Conversation with the artist in Derneburg, June 7, 2002; see Diane Waldman, *Georg Baselitz* (exh. cat.), New York: Solomon R. Guggenheim Museum, 1995, p. 57.

2 Heinz Peter Schwerfel, *Georg Baselitz im Gespräch mit Heinz Peter Schwerfel*. Cologne: Kiepenheuer & Witsch, 1989, p. 56.

Landscape with Pathos

1 Schwerfel, *Georg Baselitz*, pls. 52, 56. Compare also J. Gachnang, "Ein Gespräch mit Georg Baselitz," in Jürgen Schilling, *Georg Baselitz* (exh. cat.), Braunschweig: Kunstverein Braunschweig, 1981, p. 71.

2 Conversation with the artist in Derneburg, June 7, 2002.

3 Ibid.

Seated Male Nude – Morocco

1 A few years earlier the artist had even made finger paintings in which he had experimented with different effects of paint application.

2 Conversation with the artist in Derneburg, September 12, 2002.

White Woman (Woman of the Rubble)

1 In 1978 Baselitz completed another work with the same title.

Joseph Beuys

Mountain King (Tunnel), 2 Planets

1 At the time that Beuys made *Two Planets* and *Val*, he was overcoming what he described as a long period of illness and artistic crisis. He recalls immersing himself in the study of natural science, which was facilitated by obtaining a studio next to the zoo in Kleve and by his marriage to Eva Wurmbach, the daughter of a prominent zoologist. Götz Adriani, "Joseph Beuys, Biographical Information,"

in *Joseph Beuys: A Private Collection*. Munich: Artforum Munich, 1990, pp. 16–17.

2 Beuys quoted in Caroline Tisdall, *Joseph Beuys*. New York: Solomon R. Guggenheim Museum, 1979, p. 66.

3 Ibid.

4 In "Joseph Beuys: Life Course/Work Course" the artist describes his birth as the "Exhibition of a wound drawn together with plaster"; Tisdall, *Joseph Beuys*, p. 9.

Felt Suit

1 *Felt Suit* was published in an edition of 100. In an interview on the subject of multiples, Beuys said, "It's more important to speak of distribution, of reaching a larger number of people"; and also, "It's sort of a prop for the memory." Jörg Schellmann and Bernd Klüser, "Questions to Joseph Beuys," in Jörg Schellmann, ed., *Joseph Beuys, The Multiples: Catalogue raisonné of multiples and prints*, 8th ed. Cambridge, Mass.: Busch-Reisinger Museum, Harvard University Art Museums; Minneapolis: Walker Art Center, 1997, p. 9.

2 For an account of the event, see Tisdall, *Joseph Beuys*, p. 168. As a political action, *Isolation Unit* can also be understood in the context of Beuys founding the Organization of Direct Democracy through Referendum five months earlier in Düsseldorf.

3 Schellmann and Klüser, "Questions to Joseph Beuys," p. 16.

Backrest of a Fine-limbed Person

1 John Ruskin, "The Work of Iron in Nature, Art and Policy," in *The Two Paths: Collected Essays*, p. 160, is cited by Andrea Duncan, "Rockets Must Rust: Beuys and the Work of Iron in Nature," in David Thistlewood, ed., *Joseph Beuys: Diverging Critiques*. Liverpool: Liverpool University Press, 1995, p. 90.

2 At the artist's urging, the collector Karl Ströher loaned his major collection of Beuys's work to the Hessisches Landesmuseum Darmstadt, where Beuys installed it. Beuys took an ongoing interest in this self-curated retrospective, which he periodically supplemented with additional

works. The museum houses both art and natural history collections. For more on this subject, see David Galloway, "Beuys and Warhol: Aftershocks," *Art in America* (July 1988), p. 112.

Iphigenia/Titus Andronicus

1 "My objects are to be seen as stimulants for the transformation of the idea of sculpture, or of art in general. They should provoke thoughts about what sculpture can be and how the concept of sculpting can be extended to the invisible materials used by everyone: Thinking Forms – how we mould our thoughts or Spoken Forms – how we shape our thoughts into words or Social Sculpture – how we mould and shape the world in which we live: Sculpture as an evolutionary process; everyone an artist." Beuys quoted in Tisdall, *Joseph Beuys*, p. 7.

2 Benjamin Buchloh, "Twilight of the Idol, Preliminary Notes for a Critique," *Artform* (January 1980), pp. 35–43.

3 See Tisdall, *Joseph Beuys*, pp. 182–89.

Jörg Immendorff

Beuysland

1 The concept of his Lidl actions is especially significant. For a detailed discussion see Johannnes Gachnang et al., *Immendorff* (exh. cat.), Zürich: Kunsthaus Zürich, 1983.

4 Muses

1 A selection of these works was exhibited in *Jörg Immendorff: Position-Situation*, Galerie Michael Werner, Cologne, 1979.

Anselm Kiefer

Brünhilde Grane, Brünhilde's Death

1 For further information on Kiefer's woodcuts of this series, see Nan Rosenthal, *Anselm Kiefer: Works on Paper in The Metropolitan Museum of Art* (exh. cat.), New York: The Metropolitan Museum of Art, distributed by Harry N. Abrams, Inc., 1998.

Burning Rods

1 Manfred Schneckenburger et al., *Documenta 8*. Kassel: Weber & Weidmeyer GmbH & Co, 1987, p. 122.

2 Dore Ashton, "Document of what?" *Arts Magazine* (Sept. 1987), p. 20.

Breaking of the Vessels

1 For this explanation see Doreet LeVitté-Harten, "Bruch der Gefässe," in *Anselm Kiefer* (exh. cat.), Berlin: Nationalgalerie Berlin, Staatliche Museen Preussischer Kulturbesitz, 1991, pp. 20–28 (my translation).

Markus Lüpertz

Pergola – Dithyrambic

1 Conversation with the artist, Düsseldorf, June 9, 2002.

2 Heinz Peter Schwerfel, *Markus Lüpertz im Gespräch mit Heinz Peter Schwerfel*. Cologne: Kiepenheuer & Witsch, 1989, p. 30 (my translation).

3 Ibid, p. 30. See also a detailed discussion in Armin Zweite, "Dithyramben und anderes," in Armin Zweite, *Markus Lüpertz: Gemälde, Skulpturen* (exh. cat.), Düsseldorf: Kunstsammlung NRW; Ostfildern-Ruit: Cantz, 1996, pp. 14–16.

German Motif – Dithyrambic III

1 The first painting of this group is *Helme sinkend – dithyrambisch*, 1970, Museum Ludwig, Cologne.

2 Conversation with the artist, Düsseldorf, June 9, 2002.

3 For details on the concept of the dithyramb, please compare text and notes of *Pergola – Dithyrambic*.

A. R. Penck

Fritze

1 *A. R. Penck: Gemälde, Handzeichnungen* (exh. cat.), Cologne: Josef-Haubrich-Kunstalle, 1981. For detailed discussions of Penck's concept of *Standart*, see *A. R. Penck* (exh. cat.), Berlin: Die Nationalgalerie; Zurich: Das Kunsthaus, 1988. See also A. R. Penck, "Standart. Einführung eines Begriffes" (1970), in *A. R. Penck* (exh. cat.), Cologne.

Tulb

1 A. R. Penck, "Der Adler," in *Interfunktion* (1974).

Self Head I, Head W

1 Quoted in *A. R. Penck* (exh. cat.), Berlin, p. 61.

Totem for Cologne

1 Detlev Gretenkort and Ulrich Weisner, *Raumbilder in Bronze: Per Kirkeby, Markus Lüpertz, A. R. Penck* (Bielefeld: Kunsthalle Bielefeld, 1986).

Sigmar Polke

Helena's Australia

1 For a comprehensive study of Polke's photographic work, see the essays by Maria Morris Hambourg and Paul Schimmel in *Sigmar Polke Photoworks: When Pictures Vanish*. Los Angeles: The Museum of Contemporary Art, 1995.

Gerhard Richter

Cityscape Sa 2

1 One prominent art historian argues that "Richter is – after Beuys, if not against Beuys – the quintessential artistic figure in which the needs and interests of a German postwar public were most clearly articulated" (Benjamin Buchloh, *Gerhard Richter: Painting After the Subject of History*, Ph.D. diss. [City University of New York, 1994], p. xiii); while, for another, "Richter's sensibility, although in many ways carefully unpolitical, is a product of this endlessly idealistic, endlessly disillusioned Germany" (Neal Acherson, "Revolution and Restoration: Conflicts in the Making of Modern Germany," in Sean Rainbird et al., *Gerhard Richter*. London: Tate Gallery, 1991, p. 38).

2 Quoted in Rainbird et. al., *Gerhard Richter*, p. 126.

3 In his *Atlas*, an archive of photographic and other imagery that Richter has assiduously compiled and used as source material for his paintings, there are about one hundred aerial photographs of cities in addition to images of models for housing developments. Comparison of the photographs with the related paintings shows that Richter often cropped and rotated the images, removing telling details to defamiliarize the city views. See Armin Zweite, "Gerhard Richter's Album of Photographs, Collages, and Sketches," in B. H. D. Buchloh et al., *Photography and Painting in the Work of Gerhard Richter: Four Essays on Atlas*. Barcelona: Museu d'Art Contemporani de Barcelona, 1998, pp. 76–77; and also Armin Zweite, *Gerhard Richter Atlas*. Munich: Verlag Fred Jahn, 1989, pp. 66–73.

Ölberg

1 The critic Roberta Smith points out that Richter "can be taken, pure and simple, as a late and quite decorative Formalist," while the curator Bernard Blistène has observed, "following Polke's example, Richter creates an inventory of the emblematic signs around which the history of abstraction was constituted. Virtuosity is held at a distance and antagonisms pushed to their paroxysm; the trace of the brush is opposed to geometric flatness." See Roberta Smith, "Art at Two Galleries, Gerhard Richter Works," *The New York Times*, March 13, 1987, and Bernard Blistène, "Mechanique et manuel dans l'art de Gerhard Richter," *Galeries Magazine* (April–May 1988), p. 91.

2 Michael Edward Shapiro, "Gerhard Richter: Paintings, Prints, and Photographs in the Collection of the Saint Louis Art Museum," *The Saint Louis Art Museum Bulletin* (summer 1992), pp. 16–17, 30–31.

Betty

1 Richter archived this photograph in his *Atlas*. See Armin Zweite, *Gerhard Richter Atlas*. Munich: Verlag Fred Jahn, 1989, p. 215.

January, December, November

1 Richter's catalogue raisonné indicates that the paintings were created in the order *January*, *December*, *November*. Although they are catalogued individually, they should be regarded as a group. See *Gerhard Richter* (exh. cat. and catalogue raisonné), Bonn: Kunst- und Ausstellungshalle, 1993.

2 By subjecting a series of forensic and media images to a painterly treatment, Richter's *October 18, 1977* paintings posed questions of history and commemoration by eroding the evidentiary abilities of the photographic medium. It is helpful to consider that the series had originally encompassed more than the current fifteen paintings and that some of the extras had been turned into abstractions or semi-abstractions. For further information see Robert Storr, *Gerhard Richter: October 18, 1977*. New York: The Museum of Modern Art, 2000, pp. 95–96.

Gray Mirror

1 In 1972, the artist coined the term "un-painting" (*Vermalung*) for a series of near-monochrome canvases that showcased painterly gesture. Rather than an act of creation, *Vermalung* alludes to the undoing or un-painting of an already existing image and situates itself critically in relation to 1950s-style gestural abstraction.

2 The 1977 *Window Panes* was followed by two similar works, all of them alluding to the *Four Panes of Glass* (*Vier Glasscheiben*) of 1967. The panes of glass in the 1967 piece were transparent and installed in such a way that they could be turned around a central axis. In a recent essay, Benjamin Buchloh reconsidered this installation as Richter's reflection of the Minimalist challenge in painterly terms. See Benjamin H. D. Buchloh, "Gerhard Richter's *Eight Gray*: Between *Vorschein* and *Glanz*," in *Gerhard Richter: Eight Gray*. New York: Solomon R. Guggenheim Foundation, 2003, pp. 13–28.

The Architecture of Images: Photographic Perspectives

Photography's move from the margins to the center of artistic production in Europe and the United States was a gradual process that began in the 1960s. The impetus for this development was a critical review of the Modernist model of art making and a rejection by artists who emerged during this decade of individual expression and style as the hallmarks of artistic innovation. Contributing to this were Jasper Johns's and Robert Rauschenberg's rejection of the transcendental abstraction of the 1950s and an embrace of everyday culture. This development was epitomized by Pop Art and accompanied by a shift toward mechanically produced and serial imagery, notably in Andy Warhol's screenprints. The subsequent displacement of Pop by Minimal art was described by the artist Dan Graham as a change in the artwork's "contextual frame of reference," Pop being oriented toward the "surrounding Media world of cultural information," while Minimal art referenced the "gallery's interior cube."[1] Minimal art introduced industrial materials and processes in combination with serial installations and provided viewers with a spatial experience. Along with Fluxus, performance, and Conceptual art, Minimalism explored new artistic possibilities that entailed rethinking the role of the artist, artistic methods, and objectives.

In Germany, as elsewhere in Europe and in the United States, these fundamental changes in artistic sensibilities, which emerged during the second half of the 1960s, laid the foundation for a re-evaluation of photography. Jean-François Chevrier, who surveyed the field in 1993, noted that any discussion of photography in contemporary German art hinges on Düsseldorf.[2] Given that developments in photography were intimately linked to those of avant-garde art generally, and considering Düsseldorf's position as the most important center for contemporary art in Germany, this comes as no surprise. Indeed, without the innovative artistic climate of the greater Düsseldorf area and the unique contributions of a number of local artists in the 1960s, German photography's bright future may have never materialized, or might have taken an entirely different course.[3] Beginning in the early 1960s, one can trace at least three main currents that had profound implications for photography's future in Germany: the pioneering work of Hilla and Bernd Becher and the latter's subsequent career as professor of photography at the Düsseldorf State Art Academy (Staatliche Kunstakademie); Gerhard Richter's and Sigmar Polke's employment of the photographic medium to critically rethink representational strategies; and the legacy of the Fluxus movement and Joseph Beuys's activities. Beuys's performances and process-oriented art practice, centered on social interaction, inspired a number of his students to turn to photography (as well as video and film) at various points in their careers. Lothar Baumgarten, Bernd Blume, Anselm Kiefer, Katharina Sieverding, Klaus Rinke, and Reiner Ruthenbeck are some of Beuys's students who helped to define an artistic approach that relied on photography as a device with which to reflect upon temporal and historical processes, systemic relationships, narratives and counter-narratives.[4]

The collection of postwar German photographs at the Saint Louis Art Museum is a small but exquisite group that brings together key works by Bernd and Hilla Becher and some of the most celebrated of their students who emerged in the 1980s: Andreas Gursky, Candida Höfer, Thomas Ruff, and Thomas Struth. As such, the collection is closely related to the legacy of the first of these three Düsseldorf currents. For lack of a better term, this younger generation of photographers has sometimes been labeled the "Becher school," which gives the somewhat misleading impression that their work developed in a contained photographic environment that stood apart from other artistic activities, when in fact multiple factors contributed to the development of their ideas. The following discussion will highlight some of the departures in the 1960s and early 1970s that were instrumental for the future development of these artists, and trace the impulses that led to a photographic practice in the 1980s and 1990s that gelled around the architecture of pictorial space.

When Bernd and Hilla Becher began photographing industrial structures such as winding towers,[5] water and gas tanks in 1959, their photographic project was unique inasmuch as their subject and approach were diametrically opposed to the influential currents of the day. Otto Steinert's "subjective photography," inspired in part by Informel painting, celebrated expressive and

quasi-abstract tendencies in photography and was considerably influential during the 1950s.[6] Retrospectively, one can discern that the Bechers' work was perched ambiguously at an intersection of divergent genres and practice: it shared aspects of documentary photography; Minimalist installation art, in its serial presentation; and an archival method bordering on the conceptual.[7] They worked as an artistic team; Bernd Becher had just begun exploring the possibilities of the photographic medium when he joined forces with Hilla Becher, who was an accomplished photographer. The gradually increasing technical sophistication of their images placed them in the photographic tradition of straight photography, but their standardized method and serial presentation eclipsed the Modernist convention of limited edition art photography. Although these factors initially made it difficult for the Bechers to find acceptance in photographic circles, they uniquely positioned the artists to play an influential role in the artistic climate of the late 1960s.

The Bechers' main aim was to make their images of industrial structures comparable, which required the selection of "ideal viewpoints" and the suppression of elements that would establish relative scale, which they achieved by tightly framing each structure.[8] As the Bechers explained, "Our special interest in this subject is that buildings serving the same function appear in manifold forms. We are attempting, with the help of photography, to categorize these forms and make them comparative. To this end, the objects must be

freed from their environment, from associations – as it were, neutralized."[9]

The resulting photographs, arranged in typological grids, transformed the gritty industrial structures into iconic objects. Typology had been a popular comparative tool in nineteenth-century scientific studies (notably in biology and physiognomy, but also in architecture), and the Bechers returned to this ordering principle in the early 1960s to map the multitude of forms of a set of industrial types.[10] The consistency of the Bechers' artistic vision and their reliance upon a comprehensive photographic archive form the basis for an achronological practice that entails the reprinting and recombination of images in ever-new typological constellations.

As in France and the United States, vehement student demonstrations against the Vietnam War marked the German political landscape between 1966 and 1969. While the German student movement was galvanized by the protests, it was also fuelled by an opposition to the conservative domestic political establishment and its administrative hierarchies, which were seen as an inheritance from the country's fascist past. One of the ideological offspring of the political demonstrations that engulfed most major German cities at the time was an increasingly insistent demand by artists, such as Joseph Beuys and his students, for an art reflecting upon social and political conditions. In the context of highly visible and often provocative artistic interventions in the heyday of student activism at the

Düsseldorf State Art Academy – which included the establishment of Jörg Immendorff's alternative Lidl-academy in the hallways of the existing art school – the Bechers' photographs seemed comparatively uncontroversial and remained in the shadows of the main artistic currents.[11]

This finally began to change as hope for radical political activity faded. The 1968 Documenta at Kassel had bestowed a final stamp of approval on Pop Art and, by implication, legitimized the use of photography and reproductive techniques in glamorous silkscreens and paintings. By 1969 Minimal and Conceptual art were gaining visibility through a series of influential exhibitions such as *When Attitudes Become Form* in Bern and *Op Losse Schroeven* (*Square pegs in round holes*) in Amsterdam, which included anonymous and bland photographic images.[12] In the early 1960s, the Los Angeles-based painter Ed Ruscha had pioneered deliberately factual, non-aesthetic photographs in his artist books. "Above all," Ruscha declared in 1965, "the photographs I use are not 'arty' in any sense of the word. I think photography is dead as a fine art."[13] Instead, Ruscha offered deliberately bland images of subjects such as gas stations, apartment buildings, and vacant parking lots. His early conceptual use of the photographic image opened an avenue for artistic exploration in the second half of the decade, examples of which could be found at the 1969 Bern and Amsterdam exhibitions.

Here photographs served various new functions. They appeared in form of "site

Fig. 1
Dan Graham
Homes for America, 1969
Photo offset reproduction
of layout for magazine article
Originally published in
Arts Magazine (December
1966–January 1967)

documents," in conjunction with maps and written notes; as tools that helped to map relations between visible and non-visible processes; and as markers of space–time relations. In addition, photography provided documentation of actions and performances, and served as a self-reflexive tool with which to deconstruct the medium's presumed objectivity and traditional modes of representation.[14] Needless to say, the boundaries between such categories were fluid. Yet, as a general trend, one

finds that artists such as Vito Acconci, Jochen Gerz, John Baldessari, Robert Barry, Mel Bochner, Jan Dibbets, Dan Graham, Hans Haacke, Anselm Kiefer, Joseph Kosuth, Sol LeWitt, Bruce Nauman, Klaus Rinke, and Reiner Ruthenbeck began utilizing photography as a mode of inquiry in the late 1960s in contrast to aesthetic compositions that had been the hallmarks of the Modernist period. The Bechers greatly benefited from the aesthetic shift marked by these shows. Their solo exhibition at the Kunsthalle Düsseldorf in 1969 was planned to coincide with a traveling exhibition of Minimal art in adjacent galleries, which included serial installations by Carl Andre, Sol LeWitt, and many others. In subsequent years, their photographs began to be met by increasing interest in the art community, followed by invitations to international exhibitions such as *Information* at The Museum of Modern Art, New York, in 1970, and *Documenta 5* in 1972.[15]

Despite the increasing visibility of works that incorporated photography in the late 1960s, the new functions of the medium mostly remained below the radar of critical attention. Christopher Phillips appropriately termed the emerging photographs during this period the "phantom image," precisely because the medium became ubiquitous and yet deflected attention from itself in the linguistic disguises of model, information, document, and tool.[16] Statements denouncing any aesthetic qualities in photography were symptomatic. Thus Douglas Huebler declared that he used "the camera as a 'dumb' copying

device that only serves to document whatever phenomena appear before it through the conditions set by a system. No 'esthetic' choices are possible." Ed Ruscha characterized his photo books as "collection of facts."[17] In Germany, photography started to come to prominence in the early 1970s. The 1971 Prospect, an annually occurring art fair dedicated to contemporary art since 1968, was solely interested in photography, film, and video, though the latter two far outweighed the photographic contributions.[18] A year later, Gerhard Richter's *Atlas*, an open-ended compendium of photographs, clippings, and sketches, collaged and assembled into standard-size frames, was shown in Utrecht, while Marcel Broodthaers's most famous incarnations of his *Museum of Modern Art*, with the subtitle "The Eagle from the Oligocene until Today," was mounted at the Kunsthalle Düsseldorf. Issues of representation were at stake in both Richter's and Broodthaers's work, although *Atlas* was discursive, reflecting upon middle-class consumer culture and the conflation of public and private spheres, whereas Broodthaers's ironic installation focused specifically on the eagle as an iconographic symbol of the western powers and juxtaposed mythological and political subjects with everyday ephemera.

The most influential show of the year was undoubtedly the 1972 Documenta. Subtitled "Inquiry into Reality – Image Worlds Today," it was an encyclopedic survey of everyday visual culture, including

Fig. 2
Hans-Peter Feldmann
Image from
9 Pictures, Streets
9 Bilder, Strassen, 1972
(detail one of nine)
Berlinische Galerie,
Photographische Sammlung

advertisements, film, political propaganda, science fiction, and ephemera as well as artistic production and projects. Neither photography nor film and video were the primary subjects of the exhibition, yet their presence could be felt at every turn. Photography's changing role was perhaps most prominent in the exhibition's "Idea" section, organized by the art dealer Konrad Fischer and the curator Klaus Honnef, where the presentation of American and European Minimal and Conceptual art included an extensive installation of Becher typologies, the photo books of Ed Ruscha, and photo-based works by John Baldessari, Victor Burgin, Jan Dibbets, Hamish Fulton, Douglas Huebler, and William Wegman.

The impact of this international show was almost immediately perceptible as the following years saw the proliferation of photography exhibitions and publications throughout Germany. Since art photography had previously occupied a marginalized niche within the arts, curators and art critics began to survey the field, and many of their efforts tended toward the creation of a historical continuum between the pre- and postwar photographic traditions, which helped to legitimize the new photographic works. In order to distinguish the new artistic uses of the medium from modernist "aesthetic" photography, terms such as "photography as art" sprang up during the 1970s and continued to be used well into the following decade. This expression seems to derive from a distinction made by Walter Benjamin: "It is significant that the debate [about photography] becomes stubborn

chiefly where the esthetics of *photography as art* are involved, while for example the much more certain social significance of *art as photography* is hardly accorded a glance. And the effect of photographic reproduction of works of art is of much greater importance for the function of art than the more or less artistic figuration of an event which falls prey to the camera."[19]

While Benjamin's formulation "art as photography" meant the photographic reproduction of artworks, curators and critics in the 1970s used the phrase to characterize a new approach to photography.[20] This led to confusion rather than clarification, since the need to justify these photographic works as "art" seemed to signal a return to nineteenth-century arguments.

The second half of the decade witnessed the medium's further popularization in German art magazines, where entire issues were devoted to topics such as narrative and documentary photography.[21] The gradual move toward photography's academic enshrinement in the second half of the 1970s is reflected in the appointment of Bernd Becher as the first professor of photography at the Düsseldorf State Art Academy in 1976, the emphatic celebration of the medium at the 1977 Documenta, and the 1979 publication of Wolfgang Kemp's three-volume work on theories of photography.[22]

Even a cursory glance at exhibition catalogues and essays reveals that narrative strategies of every stripe accompanied the myriad of photo-based works in the

1970s. Artists interested in topics having to do with anthropology, sociology, gender, myth, and politics often included photography in their work. In Germany, artists such as Lothar Baumgarten, Bernhard Blume, Johannes Brus, Jochen Gerz, Rebecca Horn, Jürgen Klauke, Astrid Klein, and Katharina Sieverding were among those who incorporated the medium in their artistic practice. Joseph Beuys and Sigmar Polke continued to be influential, as did other, non-German, European artists, notably Gilbert and George, Urs Lüthi, the Viennese Actionists, Valie Export, and Christian Boltanski, not to mention the many American artists active during that decade. The articulation of conceptual ideas with the help of photography, which had been an important aspect of artistic practice since the late 1960s, found its most hermetic form in Hanne Darboven's serial installations.

Despite photography's growing importance as an artistic medium, the new market for photography seemingly collapsed at the beginning of the 1980s. "Only historical works or images by photographers who had already been accepted into the art world – for example, the Bechers – continued to sell," stated the photography curator Thomas Weski. "The reason for this shift was the appearance of neo-expressionist painting."[23] While German painters such as Georg Baselitz, Jörg Immendorff, Markus Lüpertz, and Anselm Kiefer did indeed become stars in the international art world, a critical re-examination of the narrative and process-oriented

Fig. 3
Louise Lawler
Monogram, 1984
Cibachrome
Courtesy of the artist

depiction of architectural details and interior furnishings in the work of Gursky, Höfer, Ruff, and Struth, as well as Axel Hütte and Jörg Sasse, seem to derive from a Minimalist sensibility and aesthetic such as the Bechers'. Without wanting to diminish the catalytic role played by the artist couple, one should consider other national and international impulses contributing to this development. Apart from Ed Ruscha's photo books, Dan Graham's early color photographs, perhaps best known through his text–image collage *Homes for America* (Fig. 1, p. 107), offered an alternative aesthetic with which German artists would have been familiar.[25] Graham trained his camera on the modular units of suburban tract housing, which gain the appearance of minimal structures in his photographs, ironically contrasting the promotion of individuality by real estate agents and the monotony of mass-produced housing developments. Like other conceptual artists at the time, Graham "exhibited" his *Homes for America* in an art magazine, a decision meant to circumvent a gallery system that was itself reliant upon magazines for the circulation of information. Unlike Graham, the Becher students were uninterested in a 1960s critique of the art object, nor were they opposed to the commercial mechanisms of the art world. They instead combined a minimal photographic aesthetic akin to Graham's with highly sophisticated photographic prints of an increasingly large scale.

If American tract houses blighted the American postwar landscape, bland postwar apartment buildings defined the inner cities and middle-class suburbs in Germany. The Bechers began photographing the façades of such apartment buildings in their characteristic iconic fashion in the 1970s, while entire stretches of inner city streets were also recurrent subjects in Hans-Peter Feldmann's artist books, which would have been familiar to Becher's students.[26] Feldmann, himself a Düsseldorf-based artist, utilized small, grainy reproductions for his conceptual photo books, which bore as titles the number of images included in each one. His perplexingly banal black-and-white views (Fig. 2, p. 108) find an echo in some of Struth's early photographs of empty city streets, although the latter's non-serial, large-scale images and technically accomplished prints turned them into something altogether different.[27] The Becher students' preoccupation with space and architecture was clearly informed by the visual vocabulary of Minimalism, but it also dovetailed with the German debate on art in public space (*Kunst im öffentlichen Raum*), which began to dominate the cultural and artistic landscape in the second half of the 1980s.[28] Although these discussions largely hinged on the function of art in site-specific urban contexts, the emerging photographers made architecturally-defined space their point of departure. Thus Thomas Ruff trained his eye on middle-class interiors in the early 1980s, Gursky photographed such unlikely locations as a path below a concrete bridge pillar and the new brutalist portico of the university in Bochum in 1988, and Höfer, who had started her photographic

strategies of the previous decade's art resulted in photographers distancing their work from those conventions as well as from the neo-expressionist tendencies in painting.

It has become a common practice to relate the emergence of the banal architectural photographs during the early 1980s in Germany almost exclusively to the subject matter and photographic style of Bernd and Hilla Becher.[24] Indeed, the cool appearance and serial

Fig. 4
Andreas Gursky
Paris, Montparnasse, 1993
Photograph on paper
on perspex
Tate, London

career in the 1970s photographing the life of Turkish workers in Germany, began investigating the subtle incongruities between architecture and interior furnishings in public buildings.[29]

The articulation of space in photography occurred not only in contemporary German art but figured prominently in the work of other international photographers with postmodern leanings, for instance Cindy Sherman and Jeff Wall. In their images, however, architecture and space are inflected by the pictorial conventions of film and usually serve as "stage sets" for a cast of characters. Hiroshi Sugimoto's photographs of old movie theaters eliminated human figures. Here the movie screen, framed by the surrounding architecture, acts as a site of memory and ephemeral reflection.[30] In contrast to such film references, Louise Lawler's poignant and quietly

deconstructive images of museum displays and private collections seem closer to the visual sensibilities and cultural and historical concerns expressed by the emerging Düsseldorf photographers. Lawler perfected the art of the carefully chosen view (Fig. 3, p. 109), and her color photographs frame incongruous arrangements of diverse objects, a theme that recurs with different emphases in Thomas Ruff's private middle-class interiors, where a claustrophobic personal and cultural history seems to be inscribed in each depicted item, and especially in Candida Höfer's interior views of public institutions.[31] Painterly qualities and subjects are reflected in many photographs of the Becher students, in contrast to those by their American and Canadian counterparts.[32] These are not the painterly concerns of the neo-expressionists, but the pictorial rhetoric seen, for example,

in Gerhard Richter's paintings. It comes as no surprise to learn that Thomas Struth began his career as a painter and studied for several years with Richter before joining Bernd Becher's photography class.[33] One senses that Richter's critical engagement with photography, and the reflection of Minimalism in many of his photo-based paintings, were not only significant for Struth but for his peers as well. Paradoxically, Richter decided in 1962 to use non-artistic photographs as models for his paintings with the declared intent of getting away from questions regarding composition, while Becher students such as Ruff and Gursky seemingly reconsidered photographic compositions through the rhetoric of Richter's paintings.[34] The continuing dialogue between abstraction and representation in Richter's work resurfaces, for instance, in Gursky's *Paris,*

and Höfer's photographs, the references are less subject-specific. Instead, Struth's museum photographs and Höfer's interiors have the pictorial quality of painterly tableaux and also reinterpret painterly genres such as the devotional painting and the still life in postmodern terms.

During the 1990s the importance of photography to contemporary artistic practice was celebrated in countless exhibitions and theoretical studies. Today the works of the first generation of Becher students have already become classics – a status measurable not only in museum retrospectives and teaching appointments but manifested in the realization that their subjects and sensibilities have contributed to something like an "international style" in photography. Fuelled by a range of artistic ideas, they successfully created compelling images that confidently proposed their photographs as equivalent to painting. Within the pluralist fabric of the contemporary German art world, the Bechers and their students articulated a surprisingly coherent photographic vision that occupies a central and influential place, though it represents just one among a number of artistic possibilities. In the last decade the photographic vocabulary and approaches have grown exponentially: Gursky and Ruff began to utilize digital processes; Reinhard Mucha integrates photographs into larger installations; while Thomas Demand takes the inverse approach and turns installations into photographs. His large prints of sterile office interiors, archives,

and even vegetation strike an alienating note until the viewer realizes that the depicted "realities" are paper constructs.

At the opposite end of the spectrum stands an artist like Wolfgang Tillmans (Fig. 5), whose unframed pictures of club culture signal not only a return to the individual but move away from the Becher students' single, grand image in favor of kaleidoscopic installations. With the battles over photography's legitimacy a thing of the past, the medium no longer enjoys the special status of the new but finds itself so well established that it has, for some, become the standard to be subverted.

Montparnasse (Fig. 4, p. 110), which recalls Richter's color charts, or in his untitled photograph of a gray carpet that evokes Richter's gray paintings from the 1970s.[35] Likewise, Thomas Ruff's portrait series seems to invert the strategy of Richter's *48 Portraits*: within the parameters of a serialized presentation, Richter's paintings had returned a degree of individual expression to the anonymous reproductions of cultural figures, while Ruff's photographic portraits of friends and acquaintances turn the sitters into a homogeneous group whose façade-like faces remain impenetrable and reveal nothing but surfaces. In Struth's

1 Dan Graham, "My Works for Magazine Pages: 'a history of conceptual art,'" first published in 1985. Quoted in Alexander Alberro and Blake Stimson, eds., *Conceptual Art: A Critical Anthology*. Cambridge, Mass., and London: The MIT Press, 2000, p. 419.

2 Jean-François Chevrier, "Zwischen den bildenden Künsten und den Medien. Das deutsche Beispiel," in *Photographie in der deutschen Gegenwartskunst*. Cologne: Gesellschaft für Moderne Kunst am Museum Ludwig Köln; Stuttgart: Edition Cantz, 1993, p. 26.

3 In the early 1960s, the Fluxus movement took hold in the Rhine region and Joseph Beuys was appointed professor for monumental sculpture to the Düsseldorf State Art Academy in 1961. Art dealers such as Alfred Schmela and Jean-Pierre Wilhelm had been instrumental in promoting the postwar French and German avant-gardes in the area since the 1950s, and Schmela became one of Joseph Beuys's staunchest promoters. For more information about the artistic climate of the Düsseldorf area see *Brennpunkt Düsseldorf. Joseph Beuys, die Akademie, der allgemeine Aufbruch 1962–1987*. Düsseldorf: Kunstmuseum Düsseldorf, 1987.

4 One approach to the artistic developments in postwar Germany has been along the fault lines of the country's fascist past and the intellectual, emotional and political dislocation following the country's division in 1949. The war and immediate postwar experience informed many German artists' work and found reflection in the novels of Heinrich Böll, the films of Rainer-Werner Fassbinder, and the artistic practices of Joseph Beuys, Georg Baselitz, Jörg Immendorff, Anselm Kiefer, Markus Lüpertz, Gerhard Richter, A.R. Penck, and Sigmar Polke. Although the German past continued to be a subject of critical reflection in the 1970s and 1980s, indeed until today, new identity questions arose in the context of the student movement and gender emancipation in the late 1960s and 1970s. Kai-Uwe Hemken's study on Gerhard Richter's painting cycle *October 18, 1977* includes an insightful discussion of German artists' approaches to history in the 1970s and 1980s. Hemken distinguishes between a play with mythical associations that one encounters in the work of Kiefer or Lüpertz, and Richter's dual reflection of historic events and the conditions and possibilities of commemoration. In addition, the author considers the "history debate" between Jürgen Habermas and the conservative German historian Ernst Nolte as a significant factor in Richter's decision to paint the October cycle in 1988–89. See Kai-Uwe Hemken, *Gerhard Richter: 18. Oktober 1977*. Frankfurt am Main and Leipzig: Insel Verlag, 1998.

5 "Winding-towers are to be found above mine-shaft openings. Their function is to bring the raw-materials of the mines to the surface." Bernhard and Hilla Becher, *Anonyme Skulpturen: Eine Typologie technischer Bauten*. Düsseldorf: Art-Press Verlag, 1970, n.p.

6 Steinert organized a series of influential "New Subjectivity" exhibitions in 1951, 1953, and 1954. The German photography curator Thomas Weski has considered Steinert to be "by far the most influential teacher of photography in Germany [in the '50s and '60s], first in Saarbrücken and later at the Folkwangschule in Essen." See Thomas Weski, "People and Ideas. Point of View: A Photo Map of Germany," *Aperture* (spring 1991), p. 88. Ludger Derenthal has recently argued that German photography circles in the second half of the 1950s were also significantly influenced by the *Family of Man* exhibition that had been organized by the Museum of Modern Art in New York and traveled to Munich and West Berlin in 1955. See Ludger Derenthal, "Versuchte Neuanfänge: Konstellationen künstlerischer Photographie in Deutschland von 1945 bis 1960," in *Positionen künstlerischer Photographie in Deutschland seit 1945* (exh. cat.), Berlin: Martin Gropius Bau, 1997, p. 12.

7 In the 1950s and 1960s, German art academies did not offer specializations in photography. Traditionally, aspiring photographers applied for apprenticeships in commercial photography studios. When Hilla Becher came to the Düsseldorf State Art Academy she was already an accomplished photographer. She considered her acceptance to the academy an unusual exception since she was not interested in studying painting or sculpture, but wanted to take advantage of various programs and events. She speculated that her ability to photograph the professors' paintings and sculptures may have been a practical consideration that led to her acceptance and she subsequently set up the first darkroom at the academy. (Hilla and Bernd Becher in conversation with the author, March 17, 2001.)

8 The Bechers use a view camera, which renders even minute features in excruciating detail. In order to avoid perspective distortion, the artists photograph the structures from an elevated viewpoint and prefer to photograph during the cold months when skies are overcast and surrounding trees are free of foliage. See Michael Köhler, "Interview mit Bernd und Hilla Becher," in Bernd and Hilla Becher, *Künstler: Kritisches Lexikon der Gegenwartskunst*, 7th ed. Munich: Weltkunst und Bruckmann, 1989, p. 14.

9 Bernd and Hilla Becher, "Anonyme Skulpturen" in: *Anonyme Skulpturen, Kunst-Zeitung Nr. 2*, ed. Hans Kirschbaum and Eugen Michel. Düsseldorf: Verlag Michelpresse, 1969, n.p.

10 The Bechers arrived at their characteristic typological arrangements as early as 1963, yet the term became synonymous with their work with the publication of their first artist book *Anonyme Skulpturen: Eine Typologie technischer Bauten* in 1970. Apart from the subject matter, the search for a tool that best enabled formal comparisons distinguishes the Bechers' arrangements from Andy Warhol's grids of consumer items such as his Campbell's soup cans, which were emblematic of the serially produced image and, with the exception of printing irregularities and small alterations, were often based on the same photographic image.

11 In reaction to the death of the student Benno Ohnesorg during a political demonstration in Berlin, Joseph Beuys initiated the "German Student Party." In the late 1960s and early 1970s, Joseph Beuys together with a number of his students aimed to undermine the restrictive enrollment policies at the Düsseldorf State Art Academy and aided the creation of a subsidiary academy (Immendorff's Lidl-academy) with open enrollment inside the existing Art Academy, ultimately resulting in the removal of Beuys by the state's minister of culture in October 1971.

12 Both shows traveled to the Museum Folkwang in Essen, and *When Attitudes Become Form* was subsequently on view at Museum Haus Lange in Krefeld and the Institute of Contemporary Art in London.

13 John Coplans, "Concerning Various Small Fires: Edward Ruscha Discusses His Perplexing Publications," in *Ed Ruscha, Leave Any Information at the Signal: Writings, Interviews, Bits, Pages*, ed. Alexandra Schwartz. Cambridge, Mass. and London: The MIT Press, 2002, pp. 23–24. Originally published in *Artforum* (February 1965).

14 For a detailed analysis of the photographic trajectory in the late 1960s and early 1970s see Christopher Phillips, "The Phantom Image: Photography within Postwar European and American Art," in *L'Immagine Riflessa* (exh. cat.), Prato: Museo Pecci, 1995, pp. 142–52.

15 The Bechers had their first New York solo exhibition at Sonnabend Gallery in 1972, and Carl Andre's discussion of their work in *Artforum* brought to bear his own Minimalist sensibilities and did much to link their photographs to contemporary artistic developments. See Carl Andre, "A Note on Bernhard and Hilla Becher," *Artforum* (December 1972), pp. 59–61.

16 Phillips, "The Phantom Image," pp. 142–52.

17 Douglas Huebler, cited from "Information 2," in Donald Karshan, *Conceptual Art and Conceptual Aspects* (exh. cat.), New York: The New York Cultural Center, 1970, p. 42. Coplans, "Concerning Various Small Fires", p. 26.

18 See Konrad Fischer, Jürgen Harten, Hans Strelow, *Prospect 71: Projection*. Düsseldorf: Art-Press Verlag, 1971.

19 Emphases by Walter Benjamin. See Walter Benjamin, "A Short History of Photography" (1931), quoted in Alan Trachtenberg, ed., *Classic Essays on Photography*. New Haven, Conn.: Leete's Island Books, Inc., 1980, p. 211. The German original can be found in Walter Benjamin, *Das Kunstwerk im Zeitalter seiner technischen Reproduzierbarkeit: Drei Studien zur Kunstsoziologie*. Frankfurt: Suhrkamp Verlag, 1977, p. 60.

20 Some examples include Volker Kahmen, *Fotografie als Kunst*. Tübingen: Verlag Ernst Wasmuth, 1973, Helmut R. Leppien, *Kunst aus Fotografie – Was machen Künstler heute mit Fotografie*. Hannover: Kunstverein Hannover, 1973), and *Medium Fotografie: Fotoarbeiten bildender Künstler von 1910 bis 1973*. Leverkusen: Städtisches Museum Leverkusen, Schloss Morsbroich, 1974. The photographer Floris Neusüss had initiated a series of photography exhibitions during the 1970s, which culminated in his publication *Fotografie als Kunst – Kunst als Fotografie: Das Medium Fotografie der bildenden Kunst Europas ab 1968*. Cologne: DuMont Buchverlag, 1979, which placed emphasis on performance and narrative strategies in the photographic works of the previous decade.

21 For examples see Margarethe Jochimsen, "Story-Art: Text – Foto – Synthesen," *Magazin Kunst* (1974), pp. 43–55; 58–73. On the occasion of the 150th anniversary of photography *Kunstforum International* published a special issue on photography; see *Kunstforum-Sonderband: Die Fotografie*. Mainz: Kunstforum International, 1976. In subsequent years the magazine dedicated space to more specific topics, see *Kunstforum International* (1979) subtitled "Text – Foto – Geschichten: Story Art/Narrative Art," and *Kunstforum International* (1980) dedicated to documentary photography.

22 Stefan Gronert has observed that the Bechers' presentation of their photographs began to change in the late 1970s and was "reflected in an increase in the formal strategies of their photos' pictorial language," such as a stronger isolation of objects. (Stefan Gronert at a lecture held at the City University of New York,

Graduate Center, 2000.) One might add to this that the Bechers also moved from the presentation of typologies in a single frame (where the images were rather small) to individually framed photographic prints that emphasized the technical sophistication of the prints and lent each image a greater object character. It seems plausible that this development was partly influenced by the new status that the medium had achieved at that time.

23 Weski, "People and Ideas," p. 89.

24 For example see Anne Wauters, "Realist Photographs, Ordinary Buildings," *Art Press* (summer 1996), pp. 40–47.

25 In 1970, the first solo show of Ed Ruscha's artist books was mounted by the Galerie Heiner Friedrich in Munich, and, as noted above, his books were introduced to a broader public at the 1972 Documenta. Bernd Becher seemed to recall that "Every Building on the Sunset Strip" was shown at the Düsseldorf State Art Academy in the late 1960s, although it should be added that the academy does not have a record of such a display. (Hilla and Bernd Becher in conversation with the author, March 17, 2001.) Stefan Gronert, who knows many of the Becher students personally, confirmed that the artists were well aware of Ruscha's work. Dan Graham's *Homes for America* of 1966–67 originally appeared in *Arts Magazine* (December 1967), and was subsequently published in the German avant-garde art magazine *Interfunktionen* (1971). Other works by Graham were introduced in subsequent issues.

26 Bernd Becher has acknowledged that his interest in industrial structures such as blast furnaces, mine heads, and water towers was in part a reaction to the supposedly functional yet anonymous architecture that began to fill the bombed-out German cities in the 1950s and 1960s. (Hilla and Bernd Becher in conversation with the author, March 17, 2001.) For examples of Feldmann's photographs of this subject see Hans-Peter Feldmann's art books *9 Bilder, Strassen* (1972) and *Eine Stadt: Essen*. Essen: Museum Folkwang, 1977.

27 Peter Galassi recently noted that both Gursky and Struth were familiar with

Feldmann's work and compared Struth's early city images to nineteenth-century documentarians such as Charles Marville. "If this achievement is heresy to the avant-garde, it is all the more apposite here, for Gursky would commit the same sin, and would do so, at first and in part, by following Struth's lead." See "Gursky's World," in Peter Galassi, *Andreas Gursky*. New York: The Museum of Modern Art, 2001, p. 19. Although Galassi is right to point out the gap that separates the artistic objectives of a conceptualist such as Feldmann from those of the Becher students, including their high degree of compositional sophistication, the evocation of nineteenth-century documentary photography is misleading. As part of a postmodern generation of artists, Gursky, Höfer, Ruff, and Struth bring a different sensibility to their work. They are keenly aware of past and present pictorial strategies and incorporate and reflect on them as they explore new pictorial possibilities.

28 The debate was in part inflected through questions regarding historic commemoration and the function of public monuments. For example, see *Denkmal – Zeichen – Monument: Skulpturen im öffentlichen Raum heute*. Munich: Prestel-Verlag, 1989. Although monuments, counter-monuments, and artistic interventions in public spaces had been an important subject for artists such as Claes Oldenburg and Daniel Buren since the 1960s, the subject found new resonance and new interpretations in the cultural climate of the 1980s and early 1990s. For a discussion of artistic interventions in public spaces at that time see Michael Hübl, "Kunst im öffentlichen Raum: Am Rand und mittendrin," *Kunstforum International* (November/December 1991), pp. 340–47.

29 Like Hilla Becher, Candida Höfer was an accomplished photographer when she decided to enroll at the Düsseldorf State Art Academy in 1973. Roughly ten years senior to Gursky, Ruff, and Struth, she initially joined Ole John's film class. Höfer's early photographs of Turkish workers (a joint exhibition with Gerard Osborne) were exhibited at Konrad Fischer's Düsseldorf gallery in 1975.

30 Beginning in 1977, Sugimoto recorded the screening of entire films in single black-and-white images with the paradoxical result that the moving images vanished in the final photographs. What remained was a luminescent, blank, white screen framed by the surrounding architecture.

31 Struth's museum photographs of the early 1990s go one step beyond Lawler's project. Here in the interaction between modern-day museum patrons and figurative paintings of earlier periods, the moments of contemplation become the subject of his work.

32 Hans Belting, *Thomas Struth: Museum Photographs*. Munich: Schirmer/Mosel, 1993.

33 Gerhard Richter had joined the faculty of the Düsseldorf State Art Academy in 1971.

34 In one of his notes, Richter explained, "My first Photo Picture?… I had had enough of bloody painting, and painting from a photograph seemed to me the most moronic and inartistic thing that anyone could do." Gerhard Richter, "Notes, 1964," in Hans-Ulrich Obrist, *Gerhard Richter. The Daily Practice of Painting: Writings 1962–1993*. Cambridge, Mass.: The MIT Press; London: Anthony d'Offay Gallery, 1995, p. 22. Richter began making photographic editions in 1965 and in the following years assembled his collection of photographs and newspaper clippings in standard-size panels, which subsequently became known as the compendium *Atlas*.

35 Peter Galassi has traced the significance of Richter's work for Andreas Gursky in his essay "Gursky's World," in Galassi, *Andreas Gursky*.

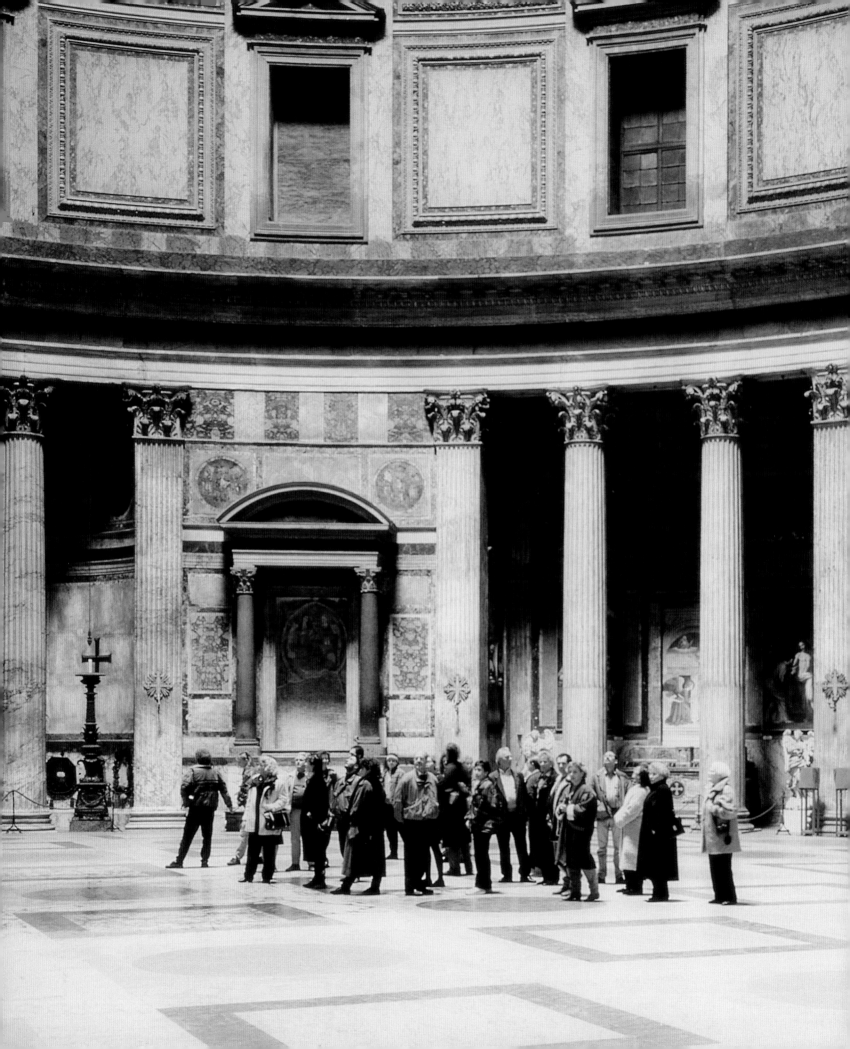

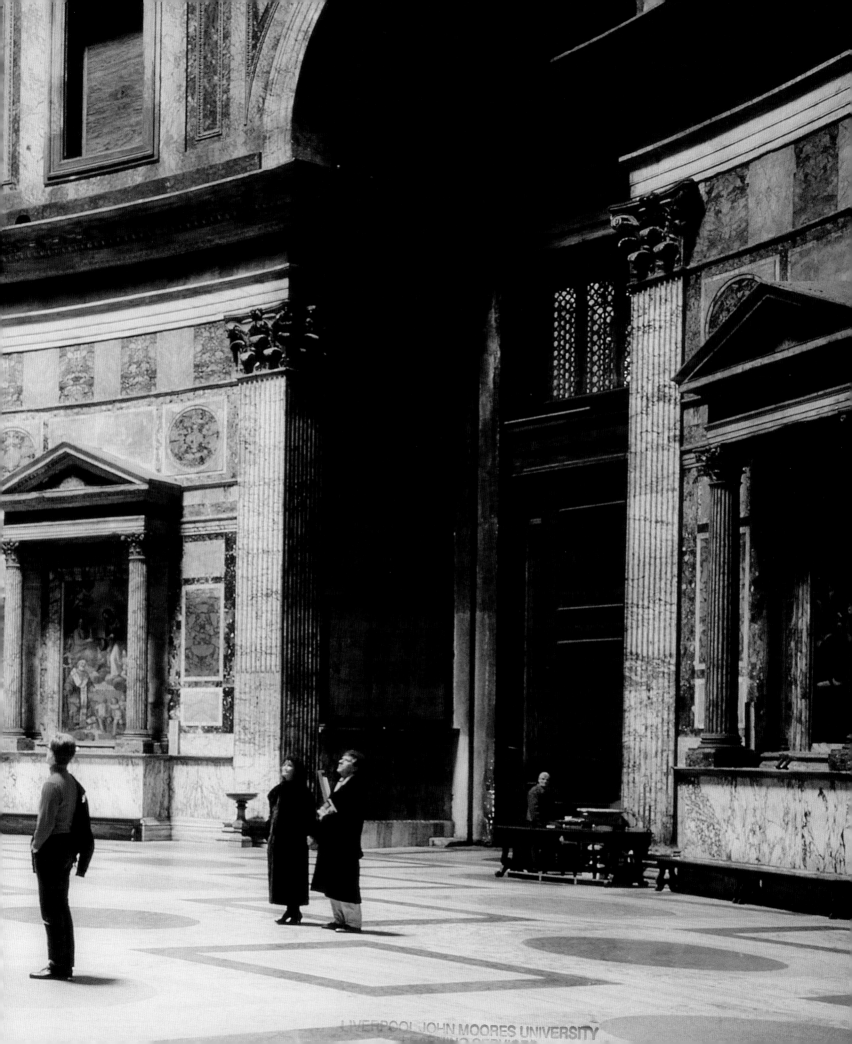

Photographs

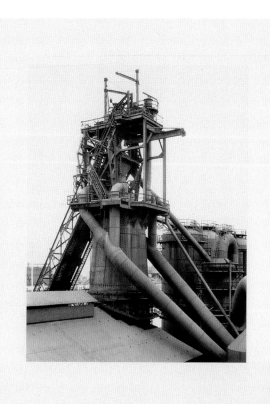

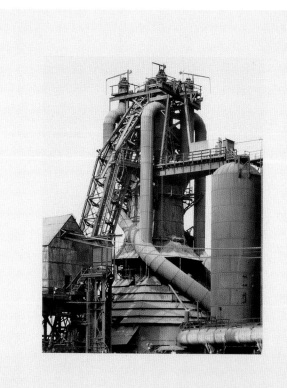

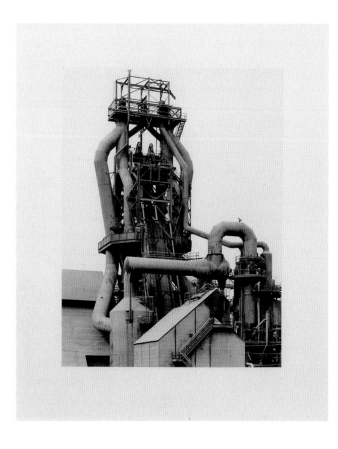

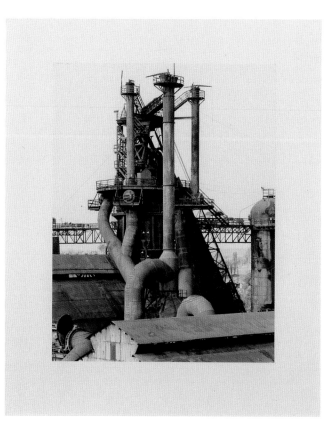

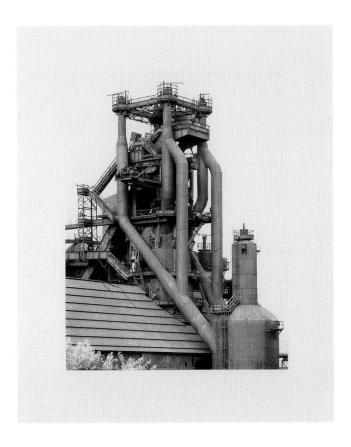

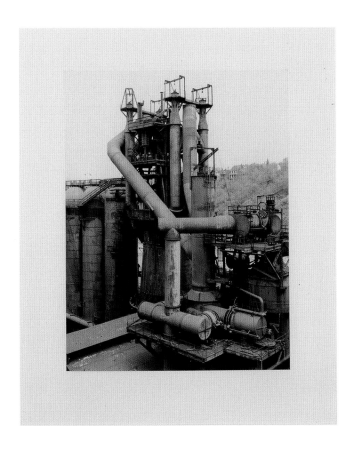

Blast Furnaces, U.S.A.

Hochöfen, U.S.A., 1979–86
printed 1992
24 gelatin silver prints (detail of 6)
Each image: 15 ¹⁵/₁₆ × 12³/₁₆ in. (40.5 × 31 cm)
Each sheet: 21³/₄ × 18 ¹/₄ in. (55.3 × 46.3 cm)

Over a period of forty years, the Bechers have accumulated an enormous photographic archive of images of industrial structures. It speaks for the consistency of their aesthetic vision that they are able to reprint and recombine old and new images in ever-changing constellations. The Bechers' characteristic typological arrangements collapse time and space: *Blast Furnaces, U.S.A.* brings together structures from different locations in the United States; the individual photographs, taken over a period of seven years, were printed in 1992.

Blast furnaces, which are used to extract crude iron from iron ore, are undoubtedly the most complex of the Bechers' many subjects. The furnaces are typically found in sprawling industrial complexes, but the artists' photographic prints successfully isolate their subjects and render the chaos of hoists and pipes as a coherent view of an architectural type that serves a specific industrial function. In order to depict the variations of this specific industrial type, the Bechers employ a photographic formula that entails a carefully selected, elevated "ideal viewpoint" and tight cropping of the image. The consistent application of this method combined with the vastly reduced scale of the furnaces in the photographic prints isolate the enormous structures so that they gain the quality of sculptures and, through the uniform scale of the prints, become comparable.

The Bechers' project is frequently, and somewhat misleadingly, called documentary because of the artists' seemingly objective mode of depiction, together with the fact that they set out to photograph their subjects at a moment when the "old economy" industries, which built them, were in crisis. In fact, many of the industrial structures photographed by the artists were subsequently demolished.[1] Yet the Bechers' photographs are not documents in an archival sense, for despite the most excruciating articulation of photographic detail, even initiated viewers will be hard-pressed to determine with certainty if they are looking at twenty-four different furnaces or twenty-four views of several structures.[2] While the documentary photographer is expected to be comprehensive in approach, and methodical and minute in presentation, the views and groupings chosen by the Bechers are instead synthetic and guided by aesthetic objectives. Despite their fascination with the functionality of these structures, the typological arrangement of images like those in *Blast Furnaces, U.S.A.* emphasizes sculptural qualities rather than a production process. Though the photographs reveal little about how these furnaces function and do not illuminate their various social and economic contexts, they nevertheless testify to the clarity of a compelling artistic vision. C. M.

Saint Louis Art Museum, Funds given by the Contemporary Art Society and by the John R. Goodall Trust, Mr. S. Lee McMillan, Mr. and Mrs. Fielding Lewis Holmes, Mr. and Mrs. James Lee Johnson Jr., Mrs. Francis A. Mesker, Mr. Thomas F. Schlafly, Mr. and Mrs. William H. T. Bush, Dr. and Mrs. William H. Danforth, Dr. and Mrs. Louis Fernandez, Mr. Jack Ansehl, Mr. and Mrs. Lawrence E. Langsam, and other donors to the 1990 and 1991 Annual Appeals 4:1993a–x

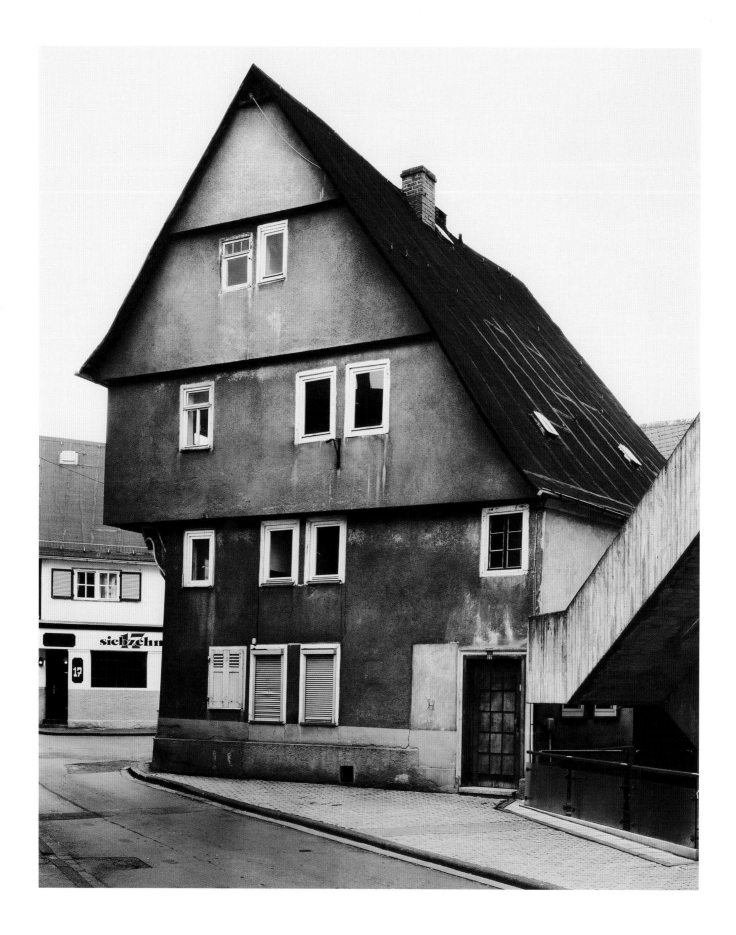

Bernd and Hilla Becher
Typology of Framework
Houses
Typologie von
Fachwerkhäusern,
1959/1974
9 gelatin silver prints
Museum Ludwig, Cologne

Dillenberg, Hessen, Germany
Dillenberg, Hessen, Deutschland, 1989
Gelatin silver print
Image: 24×19¹³/₁₆ in. (61×50.4 cm)
Sheet: 24 ×19¹³/₁₆ in. (61×50.4 cm)

This single black-and-white photograph of a traditional half-timbered house is a more recent pendant to the photographs of mass-produced half-timbered workers' houses, built in the Siegen mining district in the late nineteenth century, which were one of the Bechers' earliest subjects. Unlike some of the industrial structures they photograph, the Dillenberg building with its asymmetrical façade depicts not a readymade "type" but an idiosyncratic design for this particular location.

Despite the unusual subject, the image demonstrates the artists' characteristic preference for obsolete and under-appreciated buildings, in this case not a representative example of traditional craftsmanship but a nondescript, banal view of a house façade like many others in the region. It is the detailed, high-resolution image taken with their view camera that guides the viewer's attention to alterations made to the house over the years—the mismatched windows, the cheap tar roofing, and a façade covered with a gritty, aged layer of plasterwork that covers the underlying half-timbered construction. The projection of the upper stories and the profile of a curved timber beam supporting them are the only tangible indicators of the house's underlying structure.[1]

The Bechers' earliest photographs of mass-produced half-timbered houses pointed to a dialectical relationship between a façade's surface and the building's supporting structure, emphasizing the modifications made to the standardized models through time and drawing attention to the haptic qualities of the building materials. The Dillenberg photograph is no exception, although the viewer has to look harder to discern the structural clues. Unlike the Bechers' earlier photographs of houses, where the façades are aligned with the photographic frame, the diagonal view chosen for this image shows the building in the context of its immediate surroundings, which are marked by traces of modernization. The concrete stairway to the right and the brightly renovated building in the background may be harbingers of a transformation of the area that will ultimately result in the renovation or demolition of this house, whose present appearance will thus be as ephemeral as the graffiti seen beside its entrance. C. M.

Saint Louis Art Museum, Museum Shop Fund 614:1991

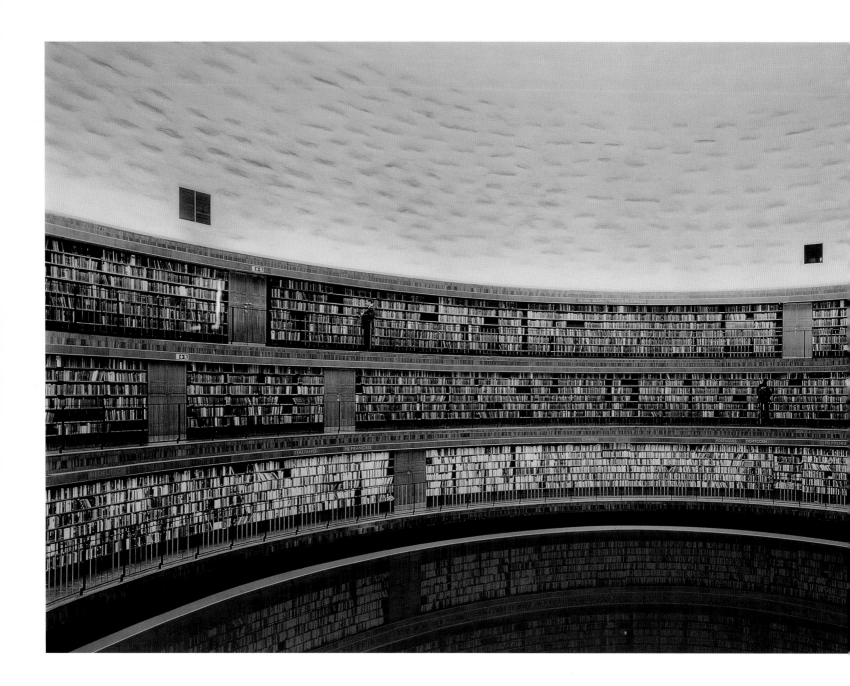

Library

Bibliothek, 1999
Color coupler print
Image: 62³/₈ × 126¹/₂ in. (158.4 × 321.3 cm)

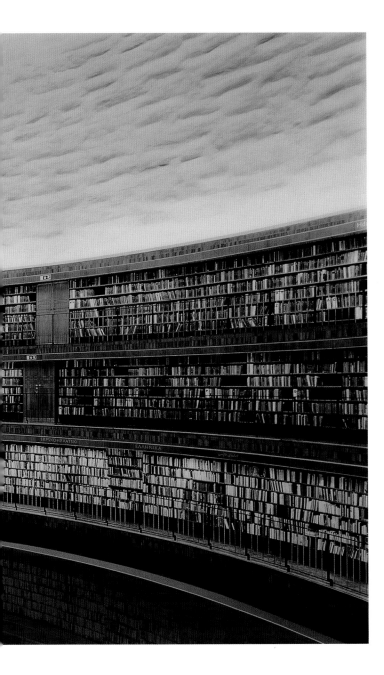

Like most images he has made since the mid-1990s, Gursky's panoramic *Library* is not an objective photographic record of an actual interior but a digitally altered image or a composite of several images. In this case the final photograph depicts stacks at the Gunnar Asplund Public Library in Stockholm.[1] Only close scrutiny reveals the subtle inconsistencies within the formally stringent, symmetrical composition. The main clue to the digital nature of the photograph is provided by signs above certain sections of bookshelves indicating the range of titles to be found on them. A viewer may decipher the first headings on the lower floor with relative ease: "Hf Deutsch," "Italiano," "Hj Français," "Español," and "Portugues," which are followed by headings in Eastern European and Middle Eastern alphabets. The arbitrary inclusion of portions of catalog number prefixes in the German and French sections ("Hf" and "Hj") and the omission of similar codes in others reveal the library's presumably rigorous shelving system to be peculiarly arbitrary.

In Gursky's photograph the library's space is virtual, floating between a dark, semicircular field at the bottom, which reflects two floors of stacks, and a light-infused ceiling vaguely recalling the dome of the Pantheon in Rome. The aura emanating from this totalizing, virtual space in which the books are contained seems to enshrine knowledge, alluding to a humanist belief in the transforming potential of learning. The shelves' reflection in the "pool" below seems but a further narcissistic confirmation of an established and revered order, in which the individual is merely inscribed as a detail. Yet this idealist vision is punctuated by air vents, emergency exits, and inconsistent signage that mark such totalizing notions as fallacious.

In the wake of postmodern critiques in the 1980s and 1990s, the library as a cultural institution and sign of collective knowledge has been critically re-evaluated by a number of artists.[2] Gursky's *Library* can be seen as a key example within this body of work, his digital alterations forcefully and succinctly deconstructing the library's seductive power and revealing a system of organization as subjective and fragmentary as the photographic print itself. C. M.

Saint Louis Art Museum, Funds given by the Honorable and Mrs. Thomas F. Eagleton 59:2000

German National Library, Frankfurt am Main IV
Deutsche Bibliothek Frankfurt am Main IV, 1997
Color coupler print
Image: 23^{13}/$_{16}$ × 23^5/$_8$ in. (60.5×60 cm)
Sheet: 33^9/$_{16}$ × 33^9/$_{16}$ in. (85.3×85.3 cm)

Höfer's *German National Library* is, unlike Andreas Gursky's virtual *Library* (cat. 38), comparatively intimate in scale and not concerned with totalizing notions of knowledge, but rather a dialogue between objects in a specific space. The artist works in thematic series, each photograph gaining descriptive insistence from the absence of people, and the attention to the appearance of individual objects. The stark geometry of Höfer's library is relieved only by two chairs pushed back from the table and several desk lamps, the necks of which have the appearance of line drawings in front of the blank concrete wall. Formally, the image is an inversion of the natural history display (cat. 40), inasmuch as the viewpoint is from within a box rather than outside a boxlike structure. The notion of being in a box is underlined by a moveable ladder attached to the bookshelves, which ascends toward what appear to be clerestory windows, giving the impression of a room without an exit.

Höfer photographed a number of library interiors in 1997–98, some of them famous, such as the reading room of the Bibliothèque Nationale in Paris, spaces that have acquired a "patina of use" or are furnished with recent utilitarian furniture incongruously placed with an older architecture.[1] The minimal interior of the Frankfurt library, by comparison, has all the trappings of the new. The bookshelves to the right are only partially filled and no visible traces of wear and tear are discernible. Architecture and interior design harmonize, each minute detail announcing and echoing the overall minimal rhetoric. Implicit in Höfer's photograph is the slightly ironic realization that some years hence this architecture will itself become recognizable as a period style, and its purist vision will likely be compromised by later additions and marked by the patina of everyday use. C. M.

Saint Louis Art Museum, Funds given by the Honorable and Mrs. Thomas F. Eagleton 27:2000

Vorarlberg Nature Display, Dornbirn, Austria III
Vorarlberger Naturschau Dornbirn III, 1999
Color coupler print
Image: 23 13/16 × 23 5/8 in. (60.5×60 cm)
Sheet: 33 9/16 × 33 9/16 in. (85.3×85.3 cm)

Höfer's photographs stage public interiors to sometimes surreal effect.
Vorarlberg Nature Display III, an image of a natural history display in Austria,
is not so much a record of that specific subject as of methods of exhibition
that didactically represent nature. Numerous levels of staging the "real
world" add up to excruciating artifice removed from a natural environment
by several degrees: an artificially created bird habitat, replete with grass,
stones, and a simulated shoreline, provides a stage for the taxidermist and
curator, who collaborated to create picturesque groups of predators and
prey in an unnaturally crowded enclosure. The smaller display cases seen
in the background indicate that the continuum of the natural environment
has been turned into a fragmented series of small tableaux, each
individually illuminated by electrical light. Höfer shows how these "natural"
vignettes are further punctured by an institutional framework: explanatory
labels identifying the various bird species in German and Latin, and the
visual rhetoric of vitrines, chairs, and carpeting that divide the interior into
display areas and viewing spaces. If the camera is traditionally a technical
device that collaborates in the naturalizing of a view and renders that
which appears in front of it as a coherent and logical whole, Höfer instead
uses it here to function self-reflexively as an ultimate framing device,
drawing attention to the institution's fragmented staging of the "natural."
C. M.

Saint Louis Art Museum, Funds given by the Honorable and Mrs. Thomas F. Eagleton 28:2000

Portrait (Pia Fries)
Porträt (Pia Fries), 1988
Color coupler print
Image: 62½ × 47¼ in. (158.8 × 120 cm)

Thomas Ruff
Other Portrait
No. 109A/32
Anderes Porträt Nr.
109A/32, 1994–95
Silkscreen print
2 editions
Courtesy of the artist

Despite the monumental scale and excruciating amount of detail offered to the viewer in this portrait, it is striking less as a document of the subject's individuality than of her anonymity. Nineteenth-century positivists delighted in physiognomic studies and used portrait photography as a misguided tool to map character, mental abilities, and ethnic differences according to "types." In other words, the exterior was seen as the reflection of character and mental acumen. Ruff uses portraits like this one to make the opposite case. Every aspect of the sitter's depiction draws attention to surfaces. The face is evenly lit and the sitter's frontal pose, inexpressive yet direct gaze, and combed-back hair make her seem impenetrable. Since all the subjects in his portrait series are similarly youthful and without special characteristics, the cumulative effect is homogenizing rather than individualizing.

Ruff's photographic formula is clearly reminiscent of passport photographs and mug shots. He took his first portrait photographs in 1981, depicting individuals from his circle of friends and acquaintances in a non-expressive style that makes many of his sitters appear androgynous, a tendency further underlined by the generic title and the use of first name initials "identifying" each of the portrayed. Initially, he used colored backgrounds inspired by the weekly covers of a German television magazine, but when he began to make life-size enlargements of his portraits in 1986, he considered the colors too prominent and eliminated them in favor of neutral backgrounds, thus arriving at the visual formula seen here.[1]

In 1994–95, Ruff embarked on a series called *Other Portraits* that further links his 1980s portraits to photo identification practices used in connection with criminal investigations. The artist borrowed a Minolta Montage Synthesizer, used by the German police to generate phantom images of criminal suspects, to create his own virtual portraits by fusing two of his earlier portraits. *Portrait (Pia Fries)* was merged with a second one to form a phantom image, further eroding the already blurred boundaries of individuality in his portraits and collapsing any notion of photographic authenticity (see fig.).[2]

True to his dictum that "a good photograph should also always reflect the medium and critically question the constellation between photographer, camera and subject,"[3] Ruff seems to offer a portrait of the medium rather than portraits of individuals. His probing approach to photography is informed by the knowledge (and occasional use) of digital processes, which allow the artist to alter a photograph to yield an image that is not a representation of reality but constitutes its own reality. C. M.

Saint Louis Art Museum, Friends Fund 5:1991

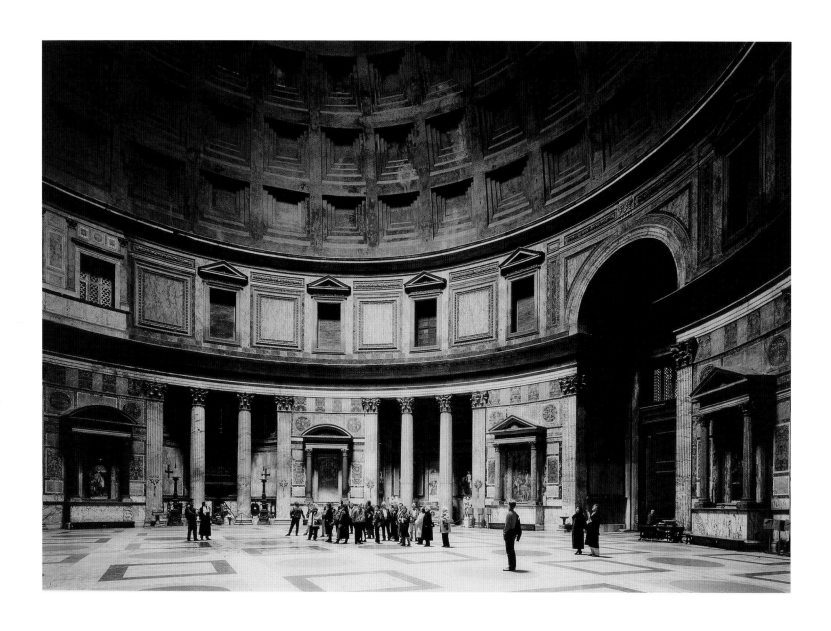

Pantheon, Rome

Pantheon, Rom, 1990
Color coupler print
Image: 54×76½ in. (137.2×194.3 cm)

"I began to photograph people in museum galleries who were looking at paintings that also depicted people. I wanted to recall what art initially meant by creating a kind of time-tunnel situation, an act of remembrance."[1] Struth's *Pantheon, Rome*, in which dwarfed groups of visitors are seen below the building's enormous coffered dome, sets up a network of gazes: members of a tour group glance in different directions; a well-dressed couple on the right looks at the oculus, one of the building's defining architectural features, which lies outside the frame of the photographic image; an isolated figure in the foreground contemplates a painting across the room; and the gray-haired man near the entrance faces the viewer. This method of indirect pointing is familiar from Renaissance and Baroque pictorial traditions. In religious paintings especially, a figure gazing out of the picture is meant to draw viewers closer to the depicted religious scene. In Struth's photograph, the same outward look implicates the viewer in this intricate web of glances, which includes the painted figures captured by Struth in the shadows of the Pantheon's alcoves. Although the artist generally declines to stage his museum photographs, he made an exception here, arranging visitors into groups, and employed the compositional device of intersecting glances. Yet Struth's duplication of this Old Master compositional strategy is not meant to elicit the viewer's empathy for religious subjects, nor is it the continuation of a painterly tradition that depicted learned visitors in contemplation before famous works of art; instead it draws attention to the viewing process.[2]

The Pantheon was not conceived as a museum, of course. Built under the emperor Hadrian between AD 118 and 128, the enormous building with its expansive dome was originally a temple consecrated to all the Roman gods before being rededicated as the Church of Santa Maria ad Martyres by Pope Boniface VIII in AD 608. For centuries, the Pantheon has been one of the city's most famous historic sites and a popular tourist destination, which has resulted in a merging of religious and secular functions. Struth's large-scale photograph is situated precisely at this juncture. The viewer of the photograph is distanced from the space of contemplation and invited to reconsider the dynamics of viewing. One of the questions raised by Struth's now-classic image seems to be whether the modern tourist's pilgrimage to famous monuments and museums has not become a quasi-religious ritual. C. M.

Saint Louis Art Museum, Funds given by Mr. and Mrs. Donald L. Bryant Jr., Senator and Mrs. Thomas F. Eagleton, Mr. and Mrs. James D. Burke, Dr. and Mrs. Alvin R. Frank, Dr. and Mrs. Robert D. Fry, Suzy and Richard Grote, Bob and Signa Hermann, Mr. and Mrs. John Peters MacCarthy, Eleanor J. Moore, Mr. and Mrs. Joseph Pulitzer Jr., and the Contemporary Art Society in honor of Michael and Lisa Shapiro 229:1992

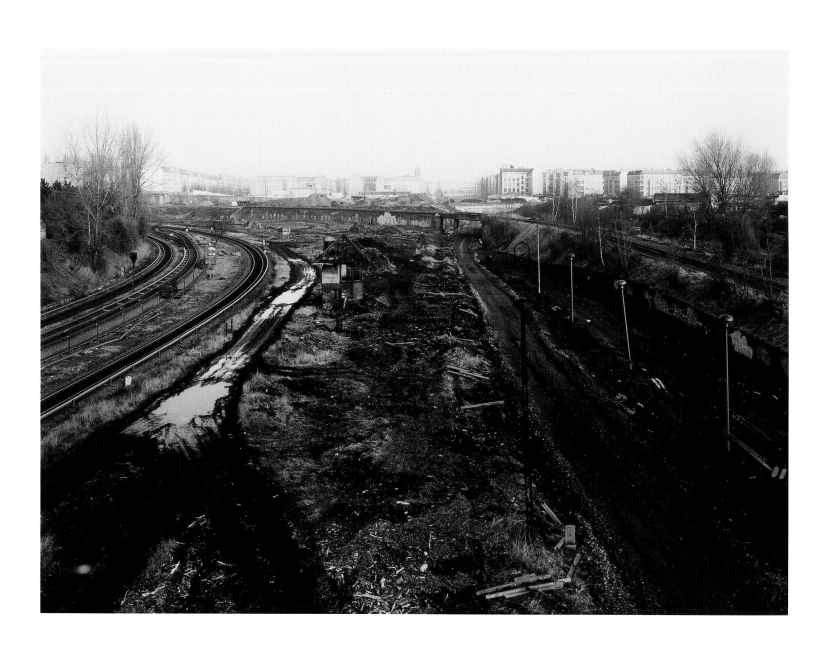

At the Swinemünde Bridge, Berlin
An der Swinemünder Brücke, Berlin, 1992
Color coupler print
Image: 19¹¹/₁₆ × 27⁹/₁₆ in. (50 × 70 cm)
Sheet: 25³/₁₆ × 31⁷/₈ in. (64 × 81 cm)

The tangle of railroad tracks seen here, lined by graffiti-covered walls and scattered construction debris, has the familiar appearance of the urban wastelands that one encounters at the fringes of many western cities. Yet Struth's image, taken from a small bridge overlooking a Berlin subway line in the heart of the German metropolis, has a historical dimension, for it looks toward a stretch of the former security zone and the Berlin Wall that had divided the city and the country from 1961 until 1989. At that time, the railroad tracks to the left connected two West Berlin subway stations, while the nondescript tenement houses in the distance were on the other side of the Wall, in East Berlin.

By 1992 reunification euphoria had evaporated, large stretches of the Wall had been torn down, and Struth, following the strategy of his city photographs from the early and middle 1980s, sought out a peripheral rather than a representational view of the formerly divided city. Instead of popular tourist destinations such as the Brandenburg Gate or Checkpoint Charlie, which were almost immediately reintegrated into the urban fabric, Struth settled on a gritty stretch of land where the division between East and West was still palpable. The artist's photograph of this urban no-man's-land, void of people as well as traffic, seems to allude not only to the former physical separation of the city, but also to the ongoing mental separation between the eastern and western parts of Germany and the identity crisis following reunification. Geographically united, the country was still intellectually and emotionally split in two, beset by rising unemployment in the East and a growing tax burden in the West. The image articulates the country's many uncertainties three years into the reunification process; if Struth's *Pantheon* visualizes historical processes through a celebrated cultural and artistic monument, the oblique site of *At the Swinemünde Bridge* marks the passage of a recent historic event whose eventual outcome as history is still under negotiation. C. M.

Saint Louis Art Museum, Gift of Mr. and Mrs. Robert H. Quenon 9:1996

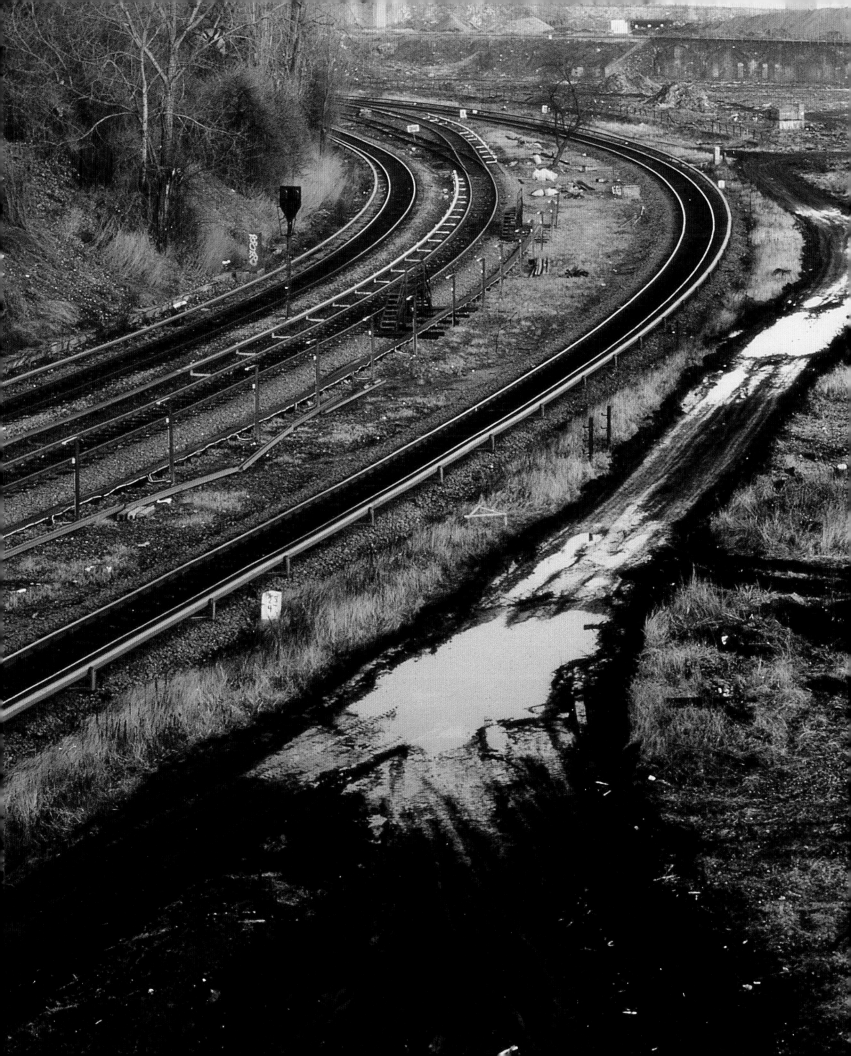

Bernd and Hilla Becher

Blast Furnaces, U.S.A.

1 "In Baltimore, they decided to build the biggest blast furnace in the western world. And then the crisis in steel-making came. They are like dinosaurs. And they have consumed each other." Bernd Becher, interview with James Lingwood, "Bernd et Hilla Becher: The Music of the Blast Furnaces," *Art Press* (summer 1996), p. 23.

2 The Bechers' itemized list identifies four of the images as having been taken in Pittsburgh and three in Baltimore, but the typological arrangement is neither chronological nor geographical.

Dillenberg, Hessen, Germany

1 It would be hard to date the Dillenberg house based on this photograph. The stepped-back ground floor is a traditional device, first used in medieval times, which allows more space for traffic in narrow and congested streets.

Andreas Gursky

Library

1 Peter Galassi has described the artist's process: "Gursky begins with one or more conventional [chemical] negatives. Sometimes the image needs no further work … Otherwise the negative is scanned to produce a digital file that may be displayed on the computer monitor and revised at will—pixel by pixel if necessary" (Peter Galassi, *Andreas Gursky*). New York: The Museum of Modern Art, 2001, p. 39).

2 There are many possible examples; Rachel Whiteread's negative casts of a library, *Untitled (Books)*, visualizes the cultural loss resulting from the devastation of the Holocaust, and Gerhard Richter's painting *Cell*, part of his cycle *October 18, 1977*, prominently showcases a bookshelf in Andreas Baader's prison cell to rethink the bourgeois pantheon of knowledge and learning through the lens of ideological fanaticism. Artistic explorations of the archive are a closely related theme; further information on this topic can be found in Ingrid Schaffner and Matthias Winzen, eds., *Deep Storage: Collecting, Storing and Archiving in Art*. Munich and New York: Prestel, 1998, and *Interarchive: Archival Practices and Sites in the Contemporary Art Field*. Cologne: Verlag der Buchhandlung Walther König, 2002.

Candida Höfer

German National Library, Frankfurt am Main IV

1 The term "patina of use" was coined by Siegfried Gohr and is an apt description for the incongruence between the historical moment when a building was erected, historical events that have taken place within it, and the visible signs of wear and tear, refurbishing and renovation at the historical moment when the image was taken. See Siegfried Gohr, "Unlike Likeness – Notes on Recent Photographs by Candida Höfer," in *Candida Höfer: Photographie* (exh. cat.), Munich: Schirmer/Mosel, 1998), pp. 15–22.

Thomas Ruff

Portrait (Pia Fries)

1 See Matthias Winzen, *Thomas Ruff: Fotografien 1979 – Heute*. Cologne: Verlag der Buchhandlung Walther König, 2001, p. 180.

2 The phantom image appears to be a fusion of *Portrait (P. Fries)* and *Portrait (A. Knobloch)* of 1990.

3 Quoted from Ute Eskildsen, "Technik, Bild, Funktion: Recherche und Reflexion fotografischer Darstellungsmodelle im Werk von Thomas Ruff," in Winzen, *Thomas Ruff*, p. 164. Translation by the author.

Thomas Struth

Pantheon, Rome

1 Thomas Struth, *Aperture* (fall 1992), p. 26.

2 Two years following the creation of *Pantheon, Rome*, and perhaps in reaction to the staging experiments such as the one carried out here, Struth declared: "I also realized that the visitors must not be posed, because even if I succeeded in arranging a situation with visitors that was fairly natural, you could instantly feel that it was, in fact, artificial." Ibid. Marian Goodman confirmed that *Pantheon, Rome* was staged, and indeed the carefully arranged groups and perfectly balanced directional glances contrast sharply with other museum images from this period.

Documentation

Georg Baselitz

Georg Baselitz was born Hans-Georg Kern on January 23, 1938, in Deutschbaselitz, Saxony, a region which later became part of the German Democratic Republic. In 1956, Baselitz studied painting in East Berlin at the Academy of Visual and Applied Arts (Hochschule für Bildende und Angewandte Kunst). After being expelled for "socio-political" immaturity, he continued to pursue his art studies in 1957 under the Art Informel painter Hann Trier at the Academy of Visual Arts (Hochschule der Bildenden Künste) in West Berlin. During this period he changed his name to Baselitz, assuming the name of his birthplace.

In 1961, together with fellow student Eugen Schönebeck, Baselitz organized his first exhibition and issued a manifesto, *Pandemonium*, which was followed by a second version in 1962. Already in his early work Baselitz rejected the leading styles of Socialist Realism and Art Informel, opting instead for a more expressive form of representational painting. In 1963, Baselitz's inaugural one-man show at the gallery of Michael Werner and Benjamin Katz in West Berlin caused a public scandal when two of his paintings were confiscated on a charge of obscenity and the police closed the exhibition.

After moving from Berlin to Osthofen, near Worms, in 1966, Baselitz created his first woodcuts and his so-called Fracture Paintings, in which the compositional motifs were severed into individual components. The "fracture" was the artist's first attempt to reduce the narrative significance of the object. Baselitz continued to pursue this approach until 1969, when he began to make paintings in which the motif was shown upside down. This effort to disrupt the unity of the pictorial space in order to highlight other compositional elements such as form, color, and gesture has remained a central focus in Baselitz's paintings.

In addition to his paintings, Baselitz has produced an impressive body of graphic work as well as sculptures in wood. The first of his unpolished and forcefully expressive sculptures was exhibited at the 1980 Venice Biennale. Both mediums continue to play a central role in Baselitz's oeuvre.

At the age of thirty-nine, Baselitz started working as a professor, first at the State Academy of Creative Arts (Staatliche Akademie der Bildenden Künste) in Karlsruhe (1977–82), and later at the Academy of Visual Arts (Hochschule der Bildenden Künste) in West Berlin, from which he resigned in 1988. He was reappointed to the Karlsruhe Academy in 1992.

Georg Baselitz currently lives and works in Derneburg, Germany, and Imperia, on the Italian Riviera.

Bernd and Hilla Becher

Bernhard Becher was born on August 20, 1931, in Siegen, Germany. He studied decorative painting before turning to lithography and painting from 1953 to 1956 at the State Art Academy (Staatliche Kunstakademie) in Stuttgart. In 1957 he settled in Düsseldorf, where he studied typography at the State Art Academy until 1961. Hilla Becher was born Hilla Wobeser on on September 2, 1934, in Potsdam. After training in her native city as a photographer and briefly working as a commercial photographer in Hamburg, she moved in 1957 to Düsseldorf to study painting at the State Art Academy, where she met Bernd Becher in 1959. The two married in 1961.

Working as freelance photographers, the couple initiated a new approach to surveying and capturing the images of neglected industrial architecture around the world. In order to promote the neutrality of the camera, the subjects were centered, frontally framed, and taken early in the morning with overcast sky, so as to eliminate shadows and distribute light evenly. Apart from concentrating on objective and almost documentary investigations of mine shafts, cooling towers, water towers, blast furnaces, and other structures, the Bechers sought to capture their subjects' sculptural qualities. In doing so, the artists attempted to raise social, cultural, and aesthetic awareness of industrial architecture and to broach the subject of the rising threat of demolition to many derelict structures.

From 1972 to 1973, the Bechers worked as guest lecturers at the Academy of Visual Arts (Hochschule für Bildende Künste) in Hamburg. In 1976, Bernd Becher was appointed professor at the State Art Academy in Düsseldorf. In addition to the Bechers' impact as teachers and mentors on generations of German photographers, their artwork continues to be critically acclaimed throughout the world.

Bernd and Hilla Becher continue to live and work in Düsseldorf.

Joseph Beuys

Andreas Gursky

Joseph Beuys was born in Krefeld, Germany, on May 12, 1921. As a young man he studied to become a physician, but had to abandon his career plans in 1940 when he was drafted by the German army to serve as a radio operator and combat pilot. Upon his return from the war, Beuys enrolled at the State Art Academy (Staatliche Kunstakademie) at Düsseldorf to study sculpture under Joseph Enseling and Ewald Mataré. During this time the artist met the brothers Franz Joseph and Hans van der Grinten, who organized Beuys's first one-person show in Kranenburg in 1953.

In the early 1960s, Düsseldorf developed into an important center for contemporary art, with Beuys emerging as an integral member of the Fluxus movement. Their activities, aimed at blurring the boundaries between life and art, further inspired Beuys to generate his own performances: he began staging "actions" that incorporated large-scale sculptures, small objects, drawings, and installations. During this time the artist also started referring to an experience that occurred during a mission in the winter of 1943, when his plane crashed in the Crimea, a desolate region in southern Russia. The injured Beuys had been discovered in deep snow by a group of nomads who looked after him for days, treating his injuries with animal fat and wrapping him in felt to keep him warm. The event was a formative one for Beuys and led to the frequent use of felt and fat in his oeuvre.

Beuys was appointed Professor of Monumental Sculpture at the Düsseldorf State Art Academy in 1961. His charismatic presence and innovative approach to art influenced generations of students. In October 1972 Beuys was dismissed amidst great controversy over his insistence that admission to the art school be open to anyone. The same year he founded the Free International University (Freie Internationale Universität), which emphasized his belief that creativity is within everyone's reach.

Beuys's ongoing commitment to social and political reforms found expression in the founding of several activist groups: in 1967, the German Student Party; in 1970, the Organization for Direct Democracy; and in 1979, the Green Party. The last two decades of his life were marked by numerous exhibitions throughout Europe and the United States, including a large retrospective of his work held at the Solomon R. Guggenheim Museum in New York in 1979. Beuys represented Germany at the Venice Biennale in 1976 and 1980, and his work was exhibited at six consecutive Documenta exhibitions in Kassel from 1964 to 1992.

Joseph Beuys died on January 23, 1986, in Düsseldorf.

Andreas Gursky was born in Leipzig on January 15, 1955. As the son of a successful commercial photographer, Willy Gursky (whose father also had been a photographer), he became acquainted with the medium at an early age. The Gursky family left the East and moved to Essen before finally settling in Düsseldorf in 1957. In the late 1970s, Gursky spent two years in nearby Essen at the Folkwang School (Folkwangschule), which offered professional training for young photographers. After a few futile attempts upon graduation to find work as a photojournalist in Hamburg, Gursky took the advice of his friend Thomas Struth and applied to the State Art Academy in Düsseldorf (Staatliche Kunstakademie). In 1981, he became a student of Bernd and Hilla Becher.

Gursky's early works showed the strong mark left by the Bechers. In the early 1990s, however, the artist began recording a broad range of contemporary imagery in a more spontaneous, abstract manner. His photographs explore the places and spaces of contemporary human beings such as hotel lobbies, warehouses, parliaments, displays of brand-name merchandise, international stock exchanges, and rave parties. From Singapore to Los Angeles, Hong Kong, Cairo, New York, Chicago, Paris, and elsewhere, Gursky's work encompasses an ever-growing range of locations around the globe. The artist's images, which are permeated with color and detail, convey the fast pace of life as they narrate the story of globalization and modern living.

Andreas Gursky lives and works in Düsseldorf.

Candida Höfer

Jörg Immendorff

Candida Höfer was born on February 4, 1944, in Eberswalde, near Berlin. In 1964 she began her studies at the Applied Arts School (Werkkunstschule) in Cologne. Following her graduation in 1968 she became a freelance artist, photographing various cities in Europe, before working as a photographer at a studio in Hamburg. In 1973 Höfer began studying film at the State Art Academy (Staatliche Kunstakademie) in Düsseldorf under Ole John, and in 1976 she transferred to the photography department where she remained a student of the Bechers until 1982.

Since the late 1980s Höfer's compositions have depicted institutional interiors such as museums, libraries, and colleges, surveyed in a straightforward manner to emphasize the architecture of the space. She does not significantly alter the lighting nor manipulate the space, which is always shot in color and at the viewer's eye level. The room's architecture thus inadvertently reflects the daily life and lifestyle of its inhabitants, as it allows the artist to document culture over time.

In 2002 Höfer moved away from her snapshots of public space interiors. With her photographic series *The Burghers of Calais*, created for the *Documenta 11* exhibition in Kassel, she photographed sculptures by Auguste Rodin and the original molds now in collections all over the world.

Candida Höfer worked from 1997 to 2000 as a professor at the College of Design (Staatliche Hochschule für Gestaltung) in Karlsruhe.

Candida Höfer currently works and lives in Cologne.

Jörg Immendorff was born on June 14, 1945, in Bleckede, West Germany. He began his studies in the field of stage design under Teo Otto in 1963 at the State Art Academy (Staatliche Kunstakademie) in Düsseldorf. In 1964 the artist was admitted to a class with Joseph Beuys, under whose influence he embraced more conceptual notions of art. During those years when he was one of Beuys's favorite students, Immendorff staged a number of political and social performances known as *Lidl*. The term *Lidl* became synonymous with performances first in Düsseldorf and then in other cities in Germany and abroad between 1968 and 1970. In the late 1970s Immendorff's political commitment led him to shift his focus from painting to teaching. From 1968 to 1980 Immendorff worked as an art instructor at the Dumont-Lindemann secondary school in Düsseldorf.

During the late 1970s Immendorff resumed painting after coming to the conclusion that art still remained a great catalyst for social reform. The artist's ongoing social commitment and Maoist tendencies prompted him to travel in 1976 to East Berlin, where he met A. R. Penck. The two wrote a manifesto and met again in 1979, when they decided to organize joint artistic performances and exhibitions. It was also during this period that Immendorff began his *Café Deutschland* series, using a fictional bar environment as a setting for the two opposing ideological systems in Germany.

Immendorff spent the following years working as a professor at a number of academies in Germany and abroad. Parallel to his teaching career, the artist devoted much of his attention to other projects, such as the stage design for Richard Strauss's opera *Elektra*, the mural design for the foyer of St. Paul's Church in Frankfurt am Main, and the stage and costume design for Igor Stravinsky's opera *The Rake's Progress*. Since 1996 Immendorff has been teaching at the Düsseldorf State Art Academy, and in 1997 he accepted a guest professorship at the Tianjin Academy of Fine Arts in the People's Republic of China.

Jörg Immendorff lives and works in Düsseldorf.

Anselm Kiefer

Anselm Kiefer was born on March 8, 1945, in the town of Donaueschingen in Baden-Württemberg. In 1965 he was admitted to the Albert Ludwig University in Freiburg, where he studied law and romance languages and literature. The very next year he abandoned his plans in order to pursue an art degree at the academies in Freiburg and Karlsruhe. In 1970 Kiefer transferred to the State Art Academy (Staatliche Kunstakademie) in Düsseldorf, where he met Joseph Beuys.

It was during 1969 that Kiefer first gained prominence as an artist with his photo series titled *Occupations* (*Besetzungen*). These staged tableaux show Kiefer in the infamous Nazi *Sieg heil* salute at various locations in Switzerland, Italy, and France. *Occupations* became Kiefer's first attempt to encourage a dialogue with the past.

In 1971 Kiefer moved to Hornbach in Odenwald, where he began to develop a visual vocabulary that not only addressed issues of recent German history, but also incorported iconography of Nordic mythology, literary and biblical themes, and Jewish mysticism. His explorations resulted in heavily textured, large-scale artworks created with unconventional yet symbolic materials such as lead, tar, cloth, sand, pottery, wire, and straw. Kiefer invited further contextual interpretations of the depicted subject matter by inserting writing into his works.

Kiefer's investigations of issues such as national identity and heritage, memory, alchemy, and mysticism have compelled him to experiment with book-making as another vehicle of expression. Alongside his paintings and books, the artist has created large-format lead sculptures, works on paper, and photographs. In recent years, Kiefer has been transforming his studio in Barjac, in southern France, into a vast *Gesamtkunstwerk* that consists of numerous installations.

Anselm Kiefer lives and works in Barjac, France.

Markus Lüpertz

Markus Lüpertz was born in Liberec, Bohemia, on April 25, 1941. Seven years later, the Lüpertz family moved to the town of Rheydt in West Germany. From 1956 to 1961 Lüpertz studied at the Applied Arts School (Werkkunstschule) in Krefeld and at the State Art Academy (Staatliche Kunstakademie) in Düsseldorf. In 1963 Lüpertz settled in West Berlin where he established himself as an artist. One year later he founded Galerie Grossgörschen 35 as an artist's cooperative in West Berlin, which became a hotbed of vibrant avant-garde experiments.

During the early 1960s the artist created his early dithyrambic paintings, and in 1966 he wrote his manifesto of the *Dithyramb*, interpreting the philosopher Friedrich Nietzsche's established praises to the god Dionysus. In 1970 Lüpertz started painting a series of *German Motifs*, in which he depicted such objects such as helmets and breastplates, confronting his audience with recent German history. Since 1981 Lüpertz has produced sculptures in bronze and in 1985 he embarked on a series of paintings that were inspired by classical themes. Over the years the artist has revealed another dimension of his creativity through his poetry. In recent years Lüpertz has initiated a number of paintings series, most notably *Men without Women – Parsifal*, *Monte Santo*, *Vanitas*, and *Vesper*.

Lüpertz began teaching in 1974, first as guest lecturer and later as professor at the Karlsruhe State Academy of Applied Arts (Staatliche Akademie der Bildenden Künste). The artist transferred to the State Art Academy in Düsseldorf in 1986 and was appointed Dean there in 1988.

Markus Lüpertz currently lives and works in Düsseldorf.

A. R. Penck

A. R. Penck was born Ralf Winkler on October 5, 1939, in Dresden, East Germany. As a five-year-old boy he witnessed the bombing and devastation of his birthplace, an experience that left a lasting impression on the artist. In 1955 and 1956 he unsuccessfully applied for admission to the art academies in Dresden and East Berlin. At the same time, Winkler served a one-year apprenticeship as a draughtsman before working at a number of different jobs ranging from a newspaper seller to a postman. After the erection of the Berlin Wall in 1961, Winkler chose to stay in East Germany, but he came under growing pressure from state authorities.

In the first years of the 1960s he began working on his *Standart* paintings. Depicting a wide range of standardized signs derived from mathematics and cybernetics, these pictographs were intended to explore the clash of ideologies between East and West. In response to repeated obstacles and constant difficulties in trying to show his work in East Germany, in 1968 Ralf Winkler assumed the pseudonym A.R. Penck (the name of a German geologist and specialist on the Ice Age) in order to be able to exhibit in the West, initially with the Galerie Michael Werner in Cologne.

In the early 1970s A. R. Penck adopted other pseudonyms and under the name of Mike Hammer, and subsequently T. M. (Tancred Mitchell or Theodor Marx), "A; Alpha" and "Y; Psilon", he departed from his *Standart* series. He worked with sculpture increasingly in the late 1970s, while continuing to be involved in jazz publications, film, and polemical writings.

In 1980, after decades of the German Democratic Republic's refusal to exhibit his work, A. R. Penck emigrated to the West. In 1989 he accepted a teaching post at the State Art Academy (Staatliche Kunstakademie) in Düsseldorf. Since the early 1990s, the artist has reverted to his earlier pictographic imagery, fusing it with newly developed prototypes. Penck has also been working on a number of portfolios of lithographs and etchings as well as his sculptures in wood and bronze.

A. R. Penck lives and works in Ireland and Germany.

Sigmar Polke

Sigmar Polke was born in in Oels, present-day Olesnica, Poland, on February 13, 1941. After growing up in the eastern part of Germany, his family moved in 1953 to Willich in West Germany. At the beginning of his career Polke apprenticed as a glass painter in Düsseldorf, before enrolling at the State Art Academy (Staatliche Kunstakademie) in Düsseldorf in 1961. In 1963, alongside fellow students Gerhard Richter, Manfred Kuttner and Konrad Lueg, Polke instigated a *Demonstration for Capitalist Realism* in a furniture store in Düsseldorf. This performance served as a reaction against leading art movements of the time, such as Art Informel, and it was an attempt to adapt and adjust aspects of Pop Art into a German context.

Polke's early work incorporated the banal imagery and clichés of everyday life. This iconography, which became a recurring element in his oeuvre, borrowed heavily from mass media, often lifting fragments directly from the popular press. In contrast to his American contemporaries, Polke commented on the themes of modern commercialism, playfully mocking the viewer's perception of material culture and consumer ideology. In other works, the artist challenged the traditional notions of painting by incorporating heavily patterned fabrics as the subject matter.

From the mid-1960s Polke experimented with photography, using the medium to record everyday life. Altering photographs to increase the sense of unfamiliarity and blur the boundary between the real and the visible became his standard practice. In the 1980s Polke began experimenting with various types of technical manipulation; he attempted to change materials by exposing them to light, moisture, and heat, thus incorporating the element of chance. Throughout his career the artist has experimented with a wide variety of themes and techniques in an attempt to reinterpret various media and unveil the relationship between art and life.

From 1977 to 1991 Polke held a professorship at the Academy of Fine Arts (Hochschule für Bildende Künste) in Hamburg.

Sigmar Polke lives and works in Cologne.

Gerhard Richter

Thomas Ruff

Gerhard Richter was born on February 9, 1932, in Dresden, East Germany. Between 1952 and 1957, he studied painting at the Art Academy (Kunstakademie) in Dresden, until he settled in the West German city of Düsseldorf in 1961. For the next two years Richter studied at the Düsseldorf State Art Academy (Staatliche Kunstakademie) under an Art Informel painter, Karl Otto Götz, and it was there that he met the young professor Joseph Beuys.

At his first exhibition in West Germany with Manfred Kuttner, held in 1962 at the Galerie Junge Kunst in Fulda, Richter exhibited early work that was still primarily inspired by Art Informel. The very next year he abandoned this early influence to introduce a photo-painting style, in which he appropriated motifs from his own photographs and found images of landscapes, portraits, advertisements, and aerial views. Together with his fellow students Sigmar Polke, Konrad Lueg, and Manfred Kuttner, Richter instigated a *Demonstration for Capitalist Realism* in 1963 at a furniture store in Düsseldorf; their demonstration served both as an interpretation of the Pop Art phenomenon and as a refusal to conform to the leading art movements of the time. In the 1960s and early 1970s Richter's paintings were distinguished by the blurring of the depicted subjects by which he meant to comment on the transience of human perception.

In late 1960s Richter started moving away from representational art to explore more theoretical issues of painting. After working on the project of color charts in the early 1970s, the artist created his first *Gray Paintings*, in which his primary objective was to experiment with various textures and brushstrokes. At the same time, Richter also worked on townscapes that were informed by photographs, which helped blur the borders between abstraction and representation. In recent years the artist's work has continued to function on parallel tracks, moving between the representational and theoretical syntax.

In 1971 Richter was appointed professor at the Düsseldorf State Art Academy.

Gerhard Richter moved in 1983 to Cologne, where he still lives and works.

Thomas Ruff was born in 1958 in Zell am Harmersbach. From 1977 to 1985 he attended the State Art Academy (Staatliche Kunstakademie) in Düsseldorf, studying photography with the Bechers. Between 1979 and 1981 Ruff created a series depicting everyday interiors, before producing oversized, full-frontal portraits that became his first acclaimed work. These monumental photographs closely scrutinize anonymous people and present them with deadpan authenticity in front of neutral backgrounds.

In 1987 Ruff began to work on a photographic cycle titled *Haus* that depicted postwar apartment buildings. The artist's 1990s work is marked by a number of series: the *Sterne* series, in which he charted and enlarged astral constellations; the *Zeitungsphoto* series, which is distinguished by images that were cut from newspapers, enlarged and displayed; the *Night* series, which served as a reaction to night-time images captured by the military during the Gulf War period; and the series *Andere Porträts*, which was inspired by police imaging techinques. During the late 1990s, Thomas Ruff embraced digital technology to create political propaganda imagery that is reminiscent of photography before 1950.

In recent years the artist has been experimenting with a more painterly quality of photography, particularly in the series titled *Nudes*. This work is based on images appropriated from pornographic websites; it features blurred, naked bodies that confront the viewer with the explicitness of the porn industry.

Thomas Ruff lives and works in Düsseldorf.

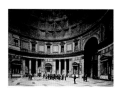

Thomas Struth

Thomas Struth was born in Geldern in 1954. From 1973 to 1980 he studied at the Düsseldorf State Art Academy (Staatliche Kunstakademie), first as a student of painting under Gerhard Richter and Peter Kleeman, and later as a student of photography under the Bechers. His work of the early 1980s is characterized by mostly black-and-white images of buildings and city streets. These snapshots, taken in Japan, Europe, and the United States, are mostly devoid of human activity, thereby commenting on contemporary urban reality and the severed bond between humans and their environment. In the 1980s, after studying family snapshots with the psychoanalyst Ingo Hartmann, Struth created portraits of individuals and family groups.

The early 1990s are marked by Struth's major project, which became known as the *Museum Photographs*. These images, inspired by well-known works of art and architecture, depict the interactive relationship between artwork, audience, and public space. Struth's recent work investigates cities across the globe and attempts to convey the complexities of our contemporary environment.

From 1993 to 1996 Struth served as a professor of photography at the College of Design (Staatliche Hochschule für Gestaltung) in Karlsruhe.

Thomas Struth currently lives and works in Düsseldorf.

This exhibition history attempts to highlight when and how the artists gained recognition on a national and international level. We have listed the important gallery exhibitions where each artist showed, first in Germany and then abroad. These lists have been prepared selectively; all the artists have exhibited frequently with numerous galleries in Germany and have been featured in gallery exhibitions in other countries as their international reputations have grown.

Baselitz

1961
Baselitz/Schönebeck: Bilder, Zeichnungen, Schaperstr. 22 am Fasanenplatz, Berlin-Wilmersdorf

1963
Baselitz, Galerie Werner & Katz, Berlin

1964
1. Orthodoxer Salon (Oberon), Galerie Michael Werner, Berlin (continues showing at this gallery)

1965
Georg Baselitz: Ölbilder und Zeichnungen, Galerie Friedrich & Dahlem, Munich

1966
Baselitz, Galerie Springer, Berlin (continues showing at this gallery)

1970
Georg Baselitz, Galerie Heiner Friedrich, Munich (continues showing at this gallery)

Georg Baselitz: Zeichnungen, Kunstmuseum Basel

Georg Baselitz, Wide White Space Gallery, Antwerp

1972
Georg Baselitz, Kunstverein Hamburg

Georg Baselitz: Bilder 1964–1972, Galerie Rudolf Zwirner, Cologne (continues showing at this gallery)

Georg Baselitz – Bilder 1959–1969, Galerie Loehr, Frankfurt am Main (continues showing at this gallery)

1974
Georg Baselitz: Das druckgraphische Werk, Städtisches Museum Leverkusen

1976
Georg Baselitz: Malerei, Handzeichnungen, Druckgraphik, Kunsthalle Bern

Georg Baselitz, Galerieverein München, Staatsgalerie Moderner Kunst, Munich

1978
Georg Baselitz: Schilderijen/Tekeningen, Galerie Helen van der Meij, Amsterdam (continues showing at this gallery)

1979
Georg Baselitz, Galerie Nancy Gillespie – Elisabeth de Laage, Paris (continues showing at this gallery)

1981
Georg Baselitz – Malerei auf Papier, 1977, Galerie Fred Jahn, Munich (continues showing at this gallery)

Georg Baselitz: New Paintings and Drawings, 1979–1981, Xavier Fourcade, New York

1982
Georg Baselitz: Paintings, Sonnabend Gallery, New York

Georg Baselitz: Paintings 1966–69, Anthony d'Offay Gallery, London (continues showing at this gallery)

1983
Monumental Prints: Georg Baselitz and Rolf Iseli, The Museum of Modern Art, New York

Georg Baselitz: Sculptures and Linocuts, Los Angeles County Museum of Art

1984
Georg Baselitz: Zeichnungen 1958–1983, Kunstmuseum Basel

1986
Georg Baselitz, Muzej Savremene Umetnosti, Belgrade

Georg Baselitz: Bilder, Zeichnungen, Galerie Thaddäeus Ropac, Salzburg

1987
Georg Baselitz: Pastorale, Gemälde und Zeichnungen 1985–86, Museum Ludwig, Cologne

1990
Georg Baselitz – The Woman of Dresden, Pace Gallery, New York (continues showing at this gallery)

1993
Georg Baselitz: Dessins 1962–1992, Musée National d'Art Moderne, Centre Georges Pompidou, Paris

1994
Couplet III: Georg Baselitz: recente schilderijen – Recent Paintings, Stedelijk Museum, Amsterdam

1995
Georg Baselitz, Solomon R. Guggenheim Museum, New York. Traveling exhibition

1996
Georg Baselitz, Musée d'Art Moderne de la Ville de Paris

1997
Baselitz, Galleria d'Arte Moderna di Bologna

Georg Baselitz: Portraits of Elke, Modern Art Museum of Fort Worth. Traveling exhibition

1998
Georg Baselitz, Museo Rufino Tamayo, Mexico City

1999
Georg Baselitz: Reise in die Niederlande, 1972–1999, Stedelijk Museum, Amsterdam

Georg Baselitz: Nostalgie in Istanbul, Deutsche Guggenheim, Berlin

Georg Baselitz: Das grosse Pathos, Hamburger Kunsthalle

2000
Baselitz: Im Walde von Blainville/Malerei 1996–2000, Sammlung Essl – Kunst der Gegenwart, Klosterneuburg / Vienna

2001
Georg Baselitz – Escultura frente a pintura/Escultura enfront de pintura, IVAM Institut Valencià d'Art Modern, Centre Julio Gonzalez

2002
Bir Baselitz Retrospektifi, 1958–2001, Resim Sergisi, Beyoğlu, Kâzım Taskent Sanat Galerisi, Yapı Kredi Bankası, Yapı Kredi Kültür Sanat Yayıncılık, Istanbul

Bernd & Hilla Becher

1963
Galerie Ruth Nohl, Siegen

1966
Staatliche Kunstakademie, Düsseldorf

1967
Industriebauten 1830–1930: eine fotografische Dokumentation, Die Neue Sammlung, Staatliches Museum für angewandte Kunst Museum, Munich. Traveling exhibition

Kunstakademie, Copenhagen

1968
Institute for Building Research, Wachsman, University of Southern California, Los Angeles

Goethe Institute, San Francisco

Bouwen voor de Industrie, Stedelijk Van Abbemuseum, Eindhoven

1969
Anonyme Skulpturen: Formvergleiche industrieller Bauten, Städtische Kunsthalle Düsseldorf

1970
Form genom Funktion, Moderna Museet, Stockholm

Galerie Konrad Fischer, Düsseldorf (continues showing at this gallery)

1972
Hilla and Bernd Becher, Sonnabend Gallery, New York (continues showing at this gallery)

Bennington College, Bennington, Vermont

Nigel Greenwood Inc., London

1973
Galerie D, Brussels

Galleria Forma, Genoa

1974
Bernd and Hilla Becher, La Jolla Museum of Contemporary Art, California

National Gallery of Canada, Ottawa

1975
Galleria Alessandra Castelli, Milan

Bernd und Hilla Becher: Fotografien 1957 bis 1975, Rheinisches Landesmuseum, Bonn. Traveling exhibition

Projects: Bernhard and Hilla Becher, The Museum of Modern Art, New York

1976
Galerie Rolf Preisig, Basel

1978
Photographs of Hilla and Bernhard Becher, Milwaukee Art Center, Wisconsin

1979
Galerie Schweinebraden, East Berlin

1981
Bernd und Hilla Becher: Arbeiten 1957–1981, Stedelijk Van Abbemuseum, Eindhoven

1985
Bernd & Hilla Becher: Fördertürme = Chevalements = Mineheads, Museum Folkwang, Essen

1986
Carnegie Mellon University Art Gallery, Pittsburgh

Kamakura Gallery, Chuo-ku, Tokyo

1989
Palais des Beaux-Arts, Brussels

1990
Gallery 360, Shibuya-Ku, Tokyo

1991
Pennsylvania Coal Mine Tipples: Bernd & Hilla Becher, Dia Center for the Arts, New York

1993
Fraenkel Gallery, San Francisco

1994
Olga Korper Gallery, Toronto

Centre d'Art Contemporain, Fribourg, Switzerland

1996
Bernd and Hilla Becher, Albright-Knox Gallery, Buffalo

Works 1963–1995, IVAM Centro Julio Gonzalez, Valencia

Bernd and Hilla Becher: A Survey, Frankel Gallery and Daniel Weinberg Gallery, San Francisco

1999
Bernd & Hilla Becher: Bergwerke, Objekt und Beschreibung, Die Photographische Sammlung/SK Stiftung Kultur, Cologne. Traveling exhibition

2001
Bernd & Hilla Becher: Photographs from the 1960s and 70s, Gallery Zwirner & Wirth, New York

2002
Bernd & Hilla Becher, Stedelijk Museum, Amsterdam

Beuys

*denotes performance (*Aktion*)

1953
Josef Beuys, Haus van der Grinten, Kranenburg. Traveling exhibition

1961
Josef Beuys: Zeichnungen, Aquarelle, Ölbilder, Plastische Bilder aus der Sammlung van der Grinten, Städtisches Museum Haus Koekkoek, Kleve

1963
Festum Fluxorum Fluxus, "Komposition für 2 Musikanten," February 3,* and *Sibirische Symphonie 1. Satz*, February 4,* Staatliche Kunstakademie, Düsseldorf

Josef Beuys Fluxus aus der Sammlung van der Grinten, Haus van der Grinten, Kranenburg

1964
Der Chef,* Galerie René Block, Berlin (continues showing at this gallery)

1965
Joseph Beuys … irgendein Strang … "Wie man dem toten Hasen die Bilder erklärt," November 26,* Galerie Schmela, Düsseldorf (continues showing at this gallery)

1966
Infiltration Homogen für Konzertflügel, der Komponist der Gegenwart ist das Contergandkind,* Staatliche Kunstakademie, Düsseldorf

Zeichnungen, Galerie Nächst St. Stephan, Vienna (continues showing at this gallery)

1967
Beuys, Städtisches Museum Mönchengladbach. Traveling exhibition

1968
Drawings, Sculptures, Wide White Space Gallery, Antwerp

Image – Head – Mover – Head (Eurasian Staff) Parallel Progress 2, The Moving Insulator, February 9*

Sammlung 1968 Karl Ströher, Galerie Verein München, Neue Pinakothek, Haus der Kunst, Munich. Traveling exhibition

1969
Live in Your Head. When Attitudes Become Form: Works – Concepts – Processes – Situations – Information, Kunsthalle Bern. Traveling exhibition

Joseph Beuys: Zeichnungen, Kleine Objekte, Kunstmuseum Basel

1970
Tebernacle, Louisiana Museum of Modern Art, Humlebaek, Denmark

Block Beuys, Hessisches Landesmuseum, Darmstadt

1971
Joseph Beuys: Aktioner, Aktionen, Moderna Museet, Stockholm

1972
Seven Exhibitions, Tate Gallery, London *Information*, February 26–27*

1973
Joseph Beuys: Drawings 1947–1972, Ronald Feldman Gallery, New York. Traveling exhibition

Joseph Beuys: Zeichnungen und Gouachen, Wide White Space Gallery, Antwerp

1974
Joseph Beuys: The Secret Block for a Secret Person in Ireland, Museum of Modern Art, Oxford. Traveling exhibition

1976
Lithographische Mappenwerke, Galerie Schellmann und Klüser, Munich (continues showing at this gallery)

1977
Joseph Beuys: Richtkräfte, Nationalgalerie Berlin, Staatliche Museen zu Berlin, Preussischer Kulturbesitz

Galerie Konrad Fischer, Düsseldorf (continues showing at this gallery)

1980
Stripes from the House of Shaman and Words Which Can Hear, Anthony d'Offay Gallery, London (continues showing at this gallery)

1987
Terrae Motus, Grand Palais, Paris

Brennpunkt Düsseldorf: Joseph Beuys – Die Akademie – Der allgemeine Aufbruch 1962–1987, Kunstmuseum Düsseldorf. Traveling exhibition

Joseph Beuys, Dia Center for the Arts, New York

1988
Joseph Beuys: Skulpturen und Objekte and *Joseph Beuys: The Secret Block for a Secret Person in Ireland (Zeichnungen)*, Martin-Gropius-Bau, Berlin. Traveling exhibition

1990
Joseph Beuys: Eine innere Mongolei: Dschingis Kahn, Schamanen, Aktricen (Ölfarben, Wasserfarben und Bleistiftzeichnungen aus der Sammlung van der Grinten), Kestner Gesellschaft, Hanover. Traveling exhibition

1991
Brennpunkt 2, Düsseldorf 1970–1991, Die Siebziger Jahre, Entwürfe, Joseph Beuys zum 70. Geburtstag, Kunstmuseum Düsseldorf

Joseph Beuys: Natur, Materie, Form, Kunstsammlung Nordrhein-Westfalen, Düsseldorf

1993
Thinking Is Form: The Drawings of Joseph Beuys, Philadelphia Museum of Art. Traveling exhibition

Joseph Beuys – 4 Bücher aus "Projekt Westmensch" 1958, Museum für Gegenwartskunst, Öffentliche Kunstsammlung, Basel

1997
Lehmbruck/Beuys, Galerie Michael Werner, Cologne

1999
Joseph Beuys Editionen – Sammlung Reinhard Schlegel, Hamburger Bahnhof – Museum für Gegenwart, Staatliche Museen zu Berlin, Preussischer Kulturbesitz, Berlin. Traveling exhibition

2002
Joseph Beuys – Pflanze, Tier und Mensch, Museum und Galerie im Prediger, Schwäbisch-Gmünd

Joseph Beuys: Besondere Säfte, Horst-Janssen-Museum, Oldenburg

Gursky

1987
Düsseldorf Airport

1988
Galerie Johnen & Schöttle, Cologne (continues showing at this gallery)

1989
Centre Genevois de Gravure Contemporaine, Geneva

303 Gallery, New York (continues showing at this gallery)

Andreas Gursky, Museum Haus Lange, Krefeld

1991
Galerie Rüdiger Schöttle, Munich (continues showing at this gallery)

Künstlerhaus, Stuttgart

1992
Andreas Gursky, Kunsthalle Zürich

Victoria Miro Gallery, London

Galleria Lia Rumma, Naples

1993
Monika Sprüth Galerie, Cologne (continues showing at this gallery)

1994
Andreas Gursky: Fotografien 1984–1993, Deichtorhallen, Hamburg. Traveling exhibition

Le Case d'Arte, Milan

1995
Lumen Travo, Amsterdam

Andreas Gursky: Images, Tate Gallery Liverpool

Galerie Mai 36, Zurich (continues showing at this gallery)

1996
Galerie Jean Bernier, Athens

Galerie Ghislaine Hussenot, Paris

Galleri Specta, Copenhagen

1997
Matthew Marks Gallery, New York (continues showing at this gallery)

1998
Currents 27: Andreas Gursky, Milwaukee Art Museum, Wisconsin. Traveling exhibition

Andreas Gursky: Fotografien 1984–1998, Kunstmuseum Wolfsburg. Traveling exhibition

Andreas Gursky: Fotografien 1984 bis heute, Kunsthalle Düsseldorf

1999
Andreas Gursky: Photographs 1994–1998, Dean Gallery, Edinburgh

Van Abbe entr'acte, Eindhoven

Regen Projects, Los Angeles

2001
Andreas Gursky, The Museum of Modern Art, New York. Traveling exhibition

Höfer

1975
Galerie Konrad Fischer, Düsseldorf

1982
Öffentliche Innenräume 1979–82, Museum Folkwang, Essen

1984
Innenraum, Fotografien 1979–1984, Rheinisches Landesmuseum, Bonn

1985
Räume, Galerie Rüdiger Schöttle, Munich (continues showing at this gallery)

1988
Galerie Johnen & Schöttle, Cologne (continues showing at this gallery)

1989
Fotografien, Kunstverein Bremerhaven

Galerie Faust, Geneva

1990
Nicole Klagsbrun Gallery, New York

Galerie Franz Pauldetto, Turin

1991
Galerie Walcheturm, Zurich

1992
Räume, Städtische Galerie Haus Seel, Siegen

Räume/Spaces, Portikus, Frankfurt am Main

Galerie Grita Insam, Vienna

1993
Photographie II: Zoologische Gärten, Hamburger Kunsthalle. Traveling exhibition

Photographie: Öffentliche Innenräume, Leonhardi-Museum, Dresden

1994
Anderson O'Day Gallery, London

1996
Sonnabend Gallery, New York

Galerie Fotomania, Rotterdam

Robert Prime, London

Rena Bransten Gallery, San Francisco

1997
Goethe-Institut, Galerie Condé, Paris

1998
Galerie Laage-Salomon, Paris

1999
Leseräume, Kunsthalle Basel

2000
Candida Höfer – Orte, Jahre, Fotografien 1968–1999, Kunsthalle, Nürnberg

Rena Brandsten Gallery, San Francisco

2001
Galerie Hauser & Wirth, Zurich

Candida Höfer: Zwölf = Twelve, Musée des Beaux-arts de Calais

2002
Candida Höfer – Konserviert, Kupferstich-Kabinett, Staatliche Kunstsammlungen Dresden

Immendorff

1961
New Orleans Jazz Club, Bonn

1965
Galerie Schmela, Düsseldorf

1966
deutsch deutsch deutsch, Galerie Fulda

vietnam vietnam vietnam,
Galerie Aachen

1967
Für alle Lieben in der Welt,
Galerie Art Intermedia,
Cologne

1968
Galerie Patio, Frankfurt am
Main

1969
Lidl-Week, A379089,
Antwerp

*Planungsübersicht einer
Arbeitswoche, August
1968*, Galerie Michael
Werner, Cologne (continues
showing at this gallery)

1971
Galerie Heiner Friedrich,
Munich

1973
*Hier und jetzt: Das tun, was
zu tun ist*, Westfälischer
Kunstverein, Münster

Galerie Loehr, Frankfurt am
Main

1974
Daner Galleriet,
Copenhagen

1975
Galerie Nächst St. Stephan,
Vienna

1977
Jörg Immendorff, Museum
for Hedendaagse Kunst,
Utrecht

1979
Café Deutschland,
Kunstmuseum Basel

1980
Malermut rundum,
Kunsthalle Bern

1981
Pinselwiderstand (4x),
Stedelijk Van

Abbemuseum, Eindhoven
Teilbau, Galerie Hans
Neuendorf, Hamburg

1982
*Café Deutschland/
Adlerhälfte*, Kunsthalle
Düsseldorf

Grüsse von der Nordfront,
Galerie Fred Jahn, Munich

Galerie Daniel Templon,
Paris

Ileana Sonnabend Gallery,
New York

Galerie Rudolf Springer,
Berlin

Jörg Immendorff,
Vereinigung Aktuele Kunst,
Ghent

1983
*Café Deutschland gut:
Linolschnitte 82–83*,
Stedelijk Van
Abbemuseum, Eindhoven.
Traveling exhibition

New 57 Gallery, Edinburgh

Studio d'Arte Cannaviello,
Milan

Nigel Greenwood Gallery,
London

*Sammler – übermalte
Linoldrucke*, Galerie Sabine
Knust, Munich (continues
showing at this gallery)

Immendorff, Kunsthaus
Zürich

1984
Jörg Immendorff, Museo
de Bilbao

*Café Deutschland and
Related Works*, Museum of
Modern Art, Oxford

Jörg Immendorff, Mary
Boone/Michael Werner
Gallery, New York

1988
*Jörg Immendorff in
Auckland*, Auckland City
Gallery, Auckland

Die Zauberflöte, Galerie
Thaddaeus Ropac, Salzburg

1990
*Das Grossartige, ewige 1.
Semester*, Portikus,
Frankfurt am Main

Jörg Immendorff, Galeria
Juana de Aizpuru, Madrid

Peintures 1981–1989,
Galerie de l'Ecole d'Art,
Marseille

*Bilder und Arbeiten auf
Papier*, Galerie Raymond
Bollag, Zurich

Galerie Frank Hänel,
Frankfurt am Main

1991
*Jörg Immendorff: Malerei
1983–1990*, Museum für
Moderne Kunst, Vienna.
Traveling exhibition

1992
Jörg Immendorff, Museum
Boymans-van Beuningen,
Rotterdam. Traveling
exhibition

Galerie Beaumont,
Luxemburg

Sonje Museum of
Contemporary Art, Korea

1993
Collection Traces, Musée
National d'Art Moderne,
Centre Georges Pompidou,
Paris
ACE Galleries
Contemporary Exhibitions,
Los Angeles

Works and Lidl, Horsens
Kunstmuseum, Denmark

1995
The Rake's Progress,
Barbican Art Gallery,
London

1998
*Jörg Immendorff.
Malerdebatte*,
Kunstmuseum Bonn

Jörg Immendorff, Muzeum
Narodowe w Warszwawie,
Warsaw

2001
*Lidl Work and Recent
Paintings*, Anton Kern
Gallery, New York

2002
*Fang Lijun i Jörg
Immendorff*, Millennium-
Monument, Peking.
Traveling exhibition

Kiefer

1973
Notung, Galerie Michael
Werner, Cologne (continues
showing at this gallery)

Der Niebelungen Lied,
Goethe-Institut, Amsterdam

1977
Heroische Sinnbilder,
Galerie Helen van der Meij,
Amsterdam (continues
showing at this gallery)

1978
*Anselm Kiefer: Bilder und
Bücher*, Kunsthalle Bern

1979
Anselm Kiefer, Stedelijk Van
Abbemuseum, Eindhoven

1980
Anselm Kiefer,
Württembergischer
Kunstverein, Stuttgart

1981
*Anselm Kiefer: Bilder und
Bücher*, Museum Folkwang,
Essen. Traveling exhibition

*Anselm Kiefer: Urd,
Werdandi, Skuld*, Galerie
Paul Maenz, Cologne
(continues showing at this
gallery)

Anselm Kiefer, Marian
Goodman Gallery, New York
(continues showing at this
gallery)

Anselm Kiefer, Galleria
Salvatore Ala, Milan

1983
*Anselm Kiefer: Paintings
and Watercolours
1970–1982*, Anthony
d'Offay Gallery, London
(continues showing at this
gallery)

1984
Anselm Kiefer, Städtische
Kunsthalle Düsseldorf.
Traveling exhibition

1987
Anselm Kiefer, Galerie
Foksal, Warsaw

Anselm Kiefer, The Art
Institute of Chicago.
Traveling exhibition

1990
*Anselm Kiefer: Bücher
1969–1990*, Kunsthalle
Tübingen. Traveling
exhibition

Anselm Kiefer,
Nationalgalerie Berlin,
Staatliche Museen zu Berlin,
Preussischer Kulturbesitz

1992
*Anselm Kiefer: The Winged
Zeitgeist*, Fuji Television
Gallery, Tokyo

1996
*Del Paisaje a la Metaphora.
Anselm Kiefer en Mexico.
Pinaturas y Libros Del Artista
Aleman*, Centro Cultural
Arte Contemporáneo,
Mexico City

1998
*Anselm Kiefer: Works on
Paper 1969–1993*, The
Metropolitan Museum of
Art, New York

*Dein und mein Alter und
das Alter der Welt*,
Gagosian Gallery, New York
(continues showing at this
gallery)

1999
*Anselm Kiefer: Die Frauen
der Antike*, Galerie Yvon
Lambert, Paris

*Anselm Kiefer: Stelle
cadenti*, Galerie d'Arte
Moderna di Bologna

2000
*Anselm Kiefer: Recent
Works 1996–1999*, Stedelijk
Museum voor Actuele
Kunst, Ghent

2001
*Anselm Kiefer: Seven
Heavenly Palaces
1973–2001*, Foundation
Beyeler, Basel

*Anselm Kiefer: Paintings
1998–2000*, Louisiana
Museum of Modern Art,
Humlebaek

2002
La vie secrete des plantes,
Yvon Lambert, Paris

*Surface Tension: Works by
Anselm Kiefer from the
Broad Collections and the
Harvard University Art
Museums*, Busch-Reisinger
Museum, Cambridge,
Massachusetts

Lüpertz

1964
Dithyrambische Malerei,
Galerie Grossgörschen 35,
Berlin

1966
Kunst, die im Wege steht, Galerie Grossgörschen 35, Berlin

1968
Markus Lüpertz, Galerie Rudolf Springer, Berlin (continues showing at this gallery)

Markus Lüpertz, Galerie Michael Werner, Cologne (continues showing at this gallery)

Dachpfannen dithyrambisch – es lebe Caspar David Friedrich, Galerie Hake, Cologne

1969
Galerie Gerda Bassenge, Berlin

1973
Markus Lüpertz: Bilder, Gouachen und Zeichnungen, 1967–1973, Staatliche Kunsthalle Baden-Baden

1975
13 neue Bilder, Galerie Hans Neuendorf, Hamburg

1976
Markus Lüpertz: Bilder 1972–76, Galerie Rudolf Zwirner, Cologne

Galerie Seriaal, Amsterdam

1977
Markus Lüpertz, Hamburger Kunsthalle

Dithyrambische und Stil-Malerei, Kunsthalle Bern

Markus Lüpertz, Stedelijk Van Abbemuseum, Eindhoven

1978
Galerie Heiner Friedrich, Munich

Galerie Helen van der Meij, Amsterdam

Galerie Gillespie-Laage, Paris (continues showing at this gallery)

1979
"Stil" Paintings 1977–79, Whitechapel Art Gallery, London

Markus Lüpertz: Gemälde und Handzeichnungen, Josef-Haubrich-Kunsthalle, Cologne

1981
Lüpertz, Galleri Rijs, Oslo

Marian Goodman Gallery, New York (continues showing at this gallery)

Markus Lüpertz: The Alice in Wonderland Paintings, Waddington Galleries, London (continues showing at this gallery)

Zeichnungen, Gouachen, Aquarelle, 1964–1981, Galerie Fred Jahn, Munich

1982
Galerie Fred Jahn, Munich (continues showing at this gallery)

1983
Markus Lüpertz: Hölderlin, Stedelijk Van Abbemuseum, Eindhoven

Markus Lüpertz: Ölbilder, Galerie Maeght, Zurich

Über Orpheus, Galerie Thaddaeus Ropac, Salzburg

1984
Sculptures in Bronze, Waddington Galleries, London

Markus Lüpertz, Mary Boone/Michael Werner Gallery, New York

Galerie Maeght Lelong, Zurich (continues showing at this gallery)

Maximilianverlag Sabine Knust, Munich (continues showing at this gallery)

1986
Markus Lüpertz, Städtische Galerie im Lenbachhaus, Munich

1987
Markus Lüpertz: Schilderijen 1973–1986, Museum Boymans-van Beuningen, Rotterdam

1988
Markus Lüpertz: Dipinti e sculture, Galleria Due Ci, Artemoderna, Rome

Markus Lüpertz: Maalauksia, guasseja, veistoksia, Galerie Kaj Forsblom, Helsinki

1989
Markus Lüpertz: Slike 1979–89, Obalne Galerije Piran, Ljubljana
Markus Lüpertz, Galleria in Arco, Turin

1990
Markus Lüpertz, Venice Design Art Gallery, Venice

1991
Markus Lüpertz: retrospectiva 1963–1990: pintura, escultura, dibujo, Museo Nacional Centro de Arte Reina Sofía, Madrid

1994
Markus Lüpertz, Museum Moderner Kunst Stiftung Ludwig, Palais Liechtenstein, Vienna

1996
Markus Lüpertz: Gemälde, Skulpturen, Kunstsammlung Nordrhein-Westfalen, Düsseldorf

1996–97
Markus Lüpertz: Titan, Staatliche Antikensammlungen und Glyptothek, Munich

1997
Markus Lüpertz, Kunsthalle der Hypo-Kulturstiftung, Munich

Markus Lüpertz: Schilderijen, Stedelijk Museum, Amsterdam

2001
Markus Lüpertz: Ölbilder, Zeichnungen und Skulpturen, Galerie im Stadtmuseum Göhre, Städtische Museen Jena

2002
Markus Lüpertz: Gemälde, Gouachen, Grafik, Galerie am Hauptplatz, Fürstenfeldbruck

Markus Lüpertz: the memory and the form – la memoria y la forma, IVAM Institut Valencia d'Art Modern

Markus Lüpertz: Malerei, Zeichnung, Skulptur, Museum Würth, Künzelsau

Penck

1968
deutsche avant-garde 3. a.r. penck, bilder, Galerie Hake, Cologne

1969
A. R. Penck, erstes training mit Standart, Galerie Michael Werner, Cologne (continues showing at this gallery)

1971
A. R. Penck, Galerie Heiner Friedrich, Munich

A. R. Penck – Dresden, Zeichen als Verständigung, Bücher und Bilder, Museum Haus Lange, Krefeld

1972
A. R. Penck, Training mit Standart, Galerie Stampa, Basel. Traveling exhibition

1973
A. R. Penck, L'Uomo et L'Arte, Milan

A. R. Penck – DDR, Daner Galleriet, Copenhagen

1974
Ralf Winkler, Dresden. Frühe Arbeiten, EP Galerie Jürgen Schweinebraden, Berlin

Penck, Zeichnungen, Galerie Nächst St. Stephan, Vienna

1975
A. R. Penck, Mike Hammers Vermächtnis, Galerie Neuendorf, Hamburg

A. R. Penck, Penck Mal TM, Kunsthalle Bern

A. R. Penck, Stedelijk Van Abbemuseum, Eindhoven

1976
Ralf Winkler, Peter Graf, Club junger Künstler, Budapest

1977
A. R. P.: Bilder 1967–1977, Galerie Fred Jahn, Munich (continues showing at this gallery)

1978
Y., Galerie Rudolf Springer, Berlin (continues showing at this gallery)

A. R. Penck/Y. schilderijen, gouaches, Galerie Helen van der Meij, Amsterdam

A.R.Penck.Y. Zeichnungen bis 1975, Kunstmuseum Basel. Traveling exhibition

1979
A. R. Penck, Concept Conceptruimte/Konzept Konzeptraum, Museum Boymans-van Beuningen, Rotterdam

1981
A. R. Penck, Kunstmuseum Basel

A. R. Penck, Gemälde, Handzeichnungen, Josef-Haubrich-Kunsthalle, Cologne

a.Y. (a. r. penck) T. Standart-West, Kunsthalle Bern

A.R. Penck: Paintings, Ileana Sonnabend Gallery, New York

1982
Galleria Lucio Amelio, Naples

Studio d'Arte Cannaviello, Milan

a.Y.a.r. penck à Paris, Gillespie-Laage-Salomon, Paris (continues showing at this gallery)
Waddington Galleries, London

A. R. Penck, 45 Zeichnungen. Bewusstseinsschichten, Städtisches Kunstmuseum Bonn. Traveling exhibition

1983
Galerie Sabine Knust, Munich (continues showing at this gallery)

1984
A. R. Penck, Mary Boone/ Michael Werner Gallery, New York (continues showing at this gallery)

A. R. Penck, Bilder und Zeichnungen 1980–1983, Galerie Maeght Lelong, Zurich (continues showing at this gallery)

A. R. Penck: BROWN'S HOTEL and other works, Tate Gallery, London

1985
A. R. Penck. Mike Hammer. Konsequenzen, Städtisches Museum Abteiberg, Mönchengladbach

1987
A. R. Penck. The Northern Darkness, Orchard Gallery, Londonderry. Traveling exhibition

1988
A. R. Penck: Skulpturen und Zeichnungen, 1971–1987, Kestner-Gesellschaft, Hanover

A. R. Penck: Vor dem Übergang – Frühe Arbeiten aus deutsch / deutschen Privatsammlungen, Aquarelle, Zeichnungen und Druckgraphik, Galerie Frank Hänel, Frankfurt am Main (continues showing at this gallery)

1989
A. R. Penck – Werke aus 20 Jahren, Galerie Beyeler, Basel

1992
A. R. Penck in Dresden: Analyse einer Situation, Staatliche Kunst-sammlungen Dresden

1993
Galerie Michael Schultz, Berlin (continues showing at this gallery)

1995
A. R. Penck: Tekeningen, Schilderijen, Skulpturen 1962–1990, Museum Het Domein, Sittard. Traveling exhibition

1996
A. R. Penck: Pintura y escultura 1986–1994, Museo Rufino Tamayo, Mexico City

1998
A. R. Penck, Setagaya Art Museum, Tokyo. Traveling exhibition

1999
A. R. Penck – der Künstler als Bildhauer, Georg-Kolbe-Museum, Berlin

2000
A. R. Penck: Erinnerung. Modell. Denkmal. (Memory. Model. Memorial.), Städtische Museen Heilbronn, Frankfurt am Main

2001
A. R. Penck – Bilder, Kunstkabinett, Regensburg

2002
Galerie Holm & Wirth, Zurich

A. R. Penck – Grafik, Museum Ostdeutsche Galerie, Regensburg

Polke

1966
Galerie René Block, Berlin (continues showing at this gallery)

Hommage à Schmela, Galerie Alfred Schmela, Düsseldorf

1967
Zeichnungen und Ölbilder, Galerie Heiner Friedrich, Munich

1969
Galerie Rudolf Zwirner, Cologne (continues showing at this gallery)

1970
Galerie Konrad Fischer, Düsseldorf (continues showing at this gallery)

Zeichnungen, Galerie Toni Gerber, Bern (continues showing at this gallery)

Bilder, Galerie Michael Werner, Cologne (continues showing at this gallery)

1972
Goethe-Institut, Amsterdam

1974
Original + Fälschung, Städtisches Kunstmuseum Bonn

Hallo Shiva ... Neue Bilder, Galerie Klein, Bonn (continues showing at this gallery)

1976
Bilder – Tücher – Objekte: Werkauswahl 1962–1972, Kunsthalle Tübingen. Traveling exhibition

Galerie Helen van der Meij, Amsterdam

1978
Dokumentation 2, InK, Halle für Internationale Neue Kunst, Zurich

1982
Galerie Bama, Paris

Works 1972–1981, Holly Solomon Gallery, New York

1983
Sigmar Polke, Städtisches Museum Abteiberg, Mönchengladbach. Traveling exhibition

Carte/Fotografie/Tele, Studio d'Arte Cannaviello, Milan

1984
Sigmar Polke, Kunsthaus Zürich. Traveling exhibition

Paintings, Marian Goodman Gallery, New York

1985
Sigmar Polke: Recent Paintings, Anthony d'Offay Gallery, London

1986
Mary Boone Gallery, New York (continues showing at this gallery)

1990
Sigmar Polke, San Francisco Museum of Modern Art. Traveling exhibition

1992
Sigmar Polke, Stedelijk Museum, Amsterdam

Neue Bilder 1992, Städtisches Museum Abteiberg, Mönchengladbach

1995
Join the Dots, Tate Gallery, Liverpool

Sigmar Polke: Editions 1966–1995, Walker Art Center, Minneapolis. Traveling exhibition

1996
Sigmar Polke Photoworks: When Pictures Vanish, Museum of Contemporary Art, Los Angeles. Traveling exhibition

1997
Sigmar Polke: Die drei Lügen der Malerei, Kunst-und Ausstellungshalle der Bundesrepublik Deutschland, Bonn. Traveling exhibition

1999
Sigmar Polke: Works on Paper 1963–1974, The Museum of Modern Art, New York. Traveling exhibition

2000
Sigmar Polke: Die gesamten Editionen 1967–2000, Württembergischer Kunstverein, Stuttgart. Traveling exhibition

On Goya, Fundació Joan Miró, Barcelona

Sigmar Polke – Werke aus der Sammlung Froehlich, Zentrum für Kunst und Medientechnologie, Karlsruhe

Sigmar Polke – Kaiserringträger der Stadt Goslar, Mönchehaus – Museum für Moderne Kunst, Goslar

2001
Sigmar Polke: Alchimist, Astrup Fearnley Museum of Modern Art, Oslo. Traveling exhibition

2002
Sigmar Polke – Recent Paintings and Drawings, Dallas Museum of Art, Texas. Traveling exhibition

Richter

1964
Gerd Richter: Bilder des Kapitalistischen Realismus, Galerie René Block, Berlin (continues showing at this gallery)

Gerhard Richter, Galerie Schmela, Düsseldorf

Gerhard Richter: Fotobilder, Porträts und Familien, Galerie Friedrich und Dahlem, Munich

1966
Gerd Richter, Galleria la Tartaruga, Rome

Richter, Galleria del Leone, Venice

Gerhard Richter, Galerie Bruno Bischofberger, Zurich

1967
Gerhard Richter, Wide White Space, Antwerp

Kunstpreis Junger Westen 67, Kunsthalle Recklinghausen

Neue Bilder, Galerie Heiner Friedrich, Munich (continues showing at this gallery)

Gerhard Richter, Galerie Rudolf Zwirner, Cologne (continues showing at this gallery)

1969
Gerhard Richter: Graphik 1965–1970, Museum Folkwang, Essen

Galleria Lucio Amelio, Naples

1970
Gerhard Richter, Galerie Konrad Fischer, Düsseldorf (continues showing at this gallery)

1972
Gerhard Richter, Suermondt-Museum, Amsterdam

Gerhard Richter: Atlas van de foto's en schetsen, Museum voor Hedendaagse, Utrecht

1973

Gerhard Richter, Kunstmuseum Luzern

Gerhard Richter, Reinhard Onnasch Gallery, New York

1974

Gerhard Richter, Städtisches Museum Abteiberg, Mönchengladbach

Gerhard Richter: Bilder aus den Jahren 1962–1974, Kunsthalle Bremen. Traveling exhibition

1976

Gerhard Richter: Atlas der Fotos, Collagen und Skizzen, Museum Haus Lange, Krefeld

1977

Gerhard Richter, Galerie Expérimentale, Centre National d'Art et de Culture Georges Pompidou, Paris

1978

Bilder/Schilderijen, Stedelijk Van Abbemuseum, Eindhoven. Traveling exhibition

Gerhard Richter: 17 Pictures, Nova Scotia College of Art and Design, Halifax

New Paintings, Sperone Westwater Fischer, New York (continues showing at this gallery)

1979

Gerhard Richter: Bilder und Druckgraphik, 1962–1978, Galerie Bernd Lutze, Friedrichshafen (continues showing at this gallery)

1981

Aquarelle und Zeichnungen, Galerie Fred Jahn, Munich (continues showing at this gallery)

1984

Gerhard Richter: Zwei Skulpturen für einen Raum von Palermo, 1971, Städtische Galerie im Lenbachhaus, Munich

Gerhard Richter, Galerie Liliane & Michel Durand-Dessert, Paris (continues showing at this gallery)

1985

Gerhard Richter, Galerie Jean Bernier, Athens

1986

Bilder 1962–1985, Städtische Kunsthalle und Kunstverein für die Rheinlande und Westfalen, Düsseldorf. Traveling exhibition

1987

Gerhard Richter: Matrix 95, Wadsworth Atheneum, Hartford

1988

Gerhard Richter: The London Paintings, Anthony d'Offay, London (continues showing at this gallery)

Gerhard Richter: Paintings, Art Gallery of Ontario, Toronto. Traveling exhibition

1989

Atlas der Fotos, Collagen und Skizzen, Städtische Galerie im Lenbachhaus, Munich. Traveling exhibition

1990

Paintings, Marian Goodman Gallery, New York (continues showing at this gallery)

Gerhard Richter: 18. Oktober 1977, The Saint Louis Art Museum. Traveling exhibition

1991

Gerhard Richter, Tate Gallery, London

1993

Gerhard Richter: Retrospective, Musée d'Art Moderne de la Ville de Paris. Traveling exhibition

Gerhard Richter, Wako Works of Art, Tokyo (continues showing at this gallery)

1995

Gerhard Richter, Israel Museum, Jerusalem

Atlas: 1964–1995, Dia Center for the Arts, New York

1999

Atlas, Consorci del Museu d'Art Contemporani de Barcelona

Gerhard Richter: Det umuliges kunst, Malerier 1964–1998/The Art of the Impossible, Paintings 1964–1998, Astrup Fearnley Museet for Moderne Kunst, Oslo

Gerhard Richter: Zeichnungen und Aquarelle, 1964–1999, Kunstmuseum Winterthur. Traveling exhibition

2000

Gerhard Richter in Dallas Collections, Dallas Museum of Art

Gerhard Richter, Museo Pecci, Prato

Gerhard Richter: Übersicht, Institut für Auslandsbeziehungen e.V., Stuttgart. Traveling exhibition

2001

Gerhard Richter: Malerei 1966–1997, Kunstverein Friedrichshafen, Zeppelin Museum

2002

Gerhard Richter: 40 Years of Painting, The Museum of Modern Art, New York. Traveling exhibition

Ruff

1981

Galerie Rüdiger Schöttle, Munich (continues showing at this gallery)

1984

Galerie Konrad Fischer, Düsseldorf

1986

Galerie Philip Nelson, Lyon (continues showing at this gallery)

1987

Galerie Johnen & Schöttle, Cologne (continues showing at this gallery)

Galerie Sonne, Berlin
Galerie Croussel-Robelin, Paris

1988

Thomas Ruff Porträts, Museum Schloss Hardenberg, Velbert, The Netherlands. Traveling exhibition

Mai 36 Galerie, Lucerne (continues showing at this gallery)

Ydessa Hendeless Art Founation, Toronto

1989

Galerie Bébert, Rotterdam

Cornerhouse, Manchester

303 Gallery, New York (continues showing at this gallery)

Thomas Ruff: Portretten, huizen, sterren = des portraits, des maisons, des étoiles = Porträts, Häuser, Sterne, Stedelijk Museum, Amsterdam. Traveling exhibition

1993

Deweer Art Gallery, Ottegem, Belgium

1996

Fraenkel Gallery, San Francisco

Thomas Ruff, Rooseum, Center for Contemporary Art, Malmö, Sweden

1997

Thomas Ruff: Kleine Porträts, Dryphoto, Prato

Galerie Helga de Alvear, Madrid

Oeuvres 1979–1997, Centre National de la Photographie, Paris

1998

Gallery Koyanagi, Tokyo

2000

Thomas Ruff: Selected Photographs, Galerie David Zwirner, New York (continues showing with this gallery)

2001

Thomas Ruff: Fotografien 1979 – heute, Staatliche Kunsthalle Baden-Baden

Thomas Ruff, Ester Partegàs, De Alvear, Madrid

2002

Thomas Ruff: Interieurs – Porträts – Häuser 1979–1991, Museum Folkwang, Essen

Thomas Ruff: Nudes 2001, Galerie und Edition Schellmann, Munich

Thomas Ruff: Fotografien von 1979 bis heute, Städtische Galerie im Lenbachhaus, Munich

Struth

1978

P.S.1/Institute for Art and Urban Resources, Long Island City, New York

1980

Galerie Rüdiger Schöttle, Munich (continues showing at this gallery)

1986

Gallery Shimada, Yamaguchi

1987

Galerie Max Hetzler, Cologne (continues showing at this gallery)

Unconscious Places, Kunsthalle Bern. Traveling exhibition

1988

Galerie Meert-Rihoux, Brussels

1989

Halle Sud, Geneva

Galerie Peter Pakesch, Vienna

1990

Photographs, The Renaissance Society, Chicago

Photographs, Marian Goodman Gallery, New York (continues showing at this gallery)

Galerie Giovanna Minelli, Paris

Galerie Paul Andriesse, Amsterdam

1992
Directions, Hirshhorn Museum and Sculpture Garden, Washington, D.C.

1993
Gallery Shimada, Tokyo

Museum Photographs, Hamburger Kunsthalle

Currents 56: Thomas Struth, The Saint Louis Art Museum

Gallery Senda, Hiroshima

1994
Strangers and Friends, Institute of Contemporary Art, Boston. Traveling exhibition

1995
Strassen, Kunstmuseum Bonn

1996
Valokuvia Fotografier, Kluuvin Galleria, Helsinki

1997
Thomas Struth: Portraits, Sprengel Museum, Hanover

1998
Thomas Struth: Still, Carré d'Art, Musée d'Art Contemporain, Nîmes. Traveling exhibition

2000
Thomas Struth: Mein Porträt, The National Museum of Modern Art, Tokyo. Traveling exhibition

2001
Galerie Meert-Rihoux, Brussels

2002
Thomas Struth: New Pictures from Paradise, Centro de Fotografia, Universidad de Salamanca. Traveling exhibition

Thomas Struth 1977–2002, Dallas Museum of Art. Traveling exhibition

Selected Group Exhibitions

1963
Demonstrative Ausstellung, Kaiserstrasse, Düsseldorf (Polke, Richter)

1964
Documenta 3, Kassel (Beuys)

1966
Polke/Richter, Galerie h, Hanover

1967
Hommage à Lidice, Galerie René Block, Berlin (Immendorff, Polke, Richter)

1968
Documenta 4, Kassel (Beuys)

14 x 14 Junge Deutsche Künstler, Staatliche Kunsthalle Baden-Baden (Baselitz, Richter)

1969
14 x 14 junge deutsche Künstler, Staatliche Kunsthalle Baden-Baden (Lüpertz)

Konzeption – Conception: Dokumentation einer heutigen Kunstrichtung, Städtisches Museum Leverkusen, Schloss Morsbroich (Bechers)

1970
Information, The Museum of Modern Art, New York (Bechers)

1971
Grafik des Kapitalistischen Realismus, Galerie René Block, Berlin (Polke, Richter)

1972
36th Biennale di Venezia (Beuys, Richter)

Documenta 5, Kassel (Baselitz, Bechers, Beuys, Immendorff, Penck, Polke, Richter)

Szene Rhein-Ruhr '72, Museum Folkwang, Essen (Bechers)

1973
8th Biennale de Paris, Musée National d'Art Moderne, Paris (Lüpertz)

Bilder. Objekte. Filme. Konzepte, Städtische Galerie im Lenbachhaus, Munich (Baselitz, Immendorff, Penck, Polke)

14 x 14 junge deutsche Künstler, Staatliche Kunsthalle Baden-Baden (Kiefer)

1974
1st Biennale der Kunst, Berlin (Lüpertz). Traveling exhibition

1975
XII Bienal de São Paulo (Baselitz, Polke)

The Extended Document, International Center of Photography at George Eastman House, Rochester, New York (Bechers)

1976
Drawing Now, The Museum of Modern Art, New York (Beuys). Traveling exhibition

37th Biennale di Venezia (Beuys, Immendorff)

1977
Documenta 6, Kassel (Baselitz, Bechers, Beuys, Kiefer, Penck, Polke, Richter)

Europe in the Seventies: Aspects of Recent Art, The Art Institute of Chicago (Richter). Traveling exhibition

XIV Bienal de São Paulo (Bechers)

Penck mal Immendorff, Immendorff mal Penck, Galerie Michael Werner, Cologne (Immendorf, Penck)

1978–79
Werke aus der Sammlung Crex, Zurich, InK, Zurich (Lüpertz, Penck, Polke). Traveling exhibition

1979
3rd Biennale of Sydney (Penck)

In Deutschland – Aspekte gegenwärtiger Dokumentarfotografie, Rheinisches Landesmuseum, Bonn (Höfer, Struth)

1980
Les nouveaux Fauves: die neuen Wilden, Stadt Aachen, Neue Galerie – Sammlung Ludwig (Baselitz, Immendorff, Kiefer, Penck)

Georg Baselitz, A. R. Penck, Joseph Beuys: 300 Dessins allemands 1945–1978, Centre d'Arts Plastiques Contemporains, Bordeaux (Baselitz, Beuys, Penck)

39th Biennale di Venezia (Baselitz, Beuys, Immendorff, Kiefer, Richter)

1981
A New Spirit in Painting, Royal Academy of Arts, London (Baselitz, Kiefer, Lüpertz, Penck, Polke, Richter)

Georg Baselitz/Gerhard Richter, Kunsthalle Düsseldorf

Schilderkunst in Duitsland, Paleis voor Schone Kunsten, Brussels (Immendorff, Kiefer, Penck)

Art allemagne aujourd'hui, Musée d'Art Moderne de la Ville de Paris (Baselitz, Beuys, Immendorff, Lüpertz, Penck, Polke, Richter)

Jörg Immendorff, Per Kirkeby, Markus Lüpertz, A. R. Penck. Hunden tillstter under veckans lopp. Der Hund stösst im Laufe der Woche zu mir, Moderna Museet, Stockholm

1982
Documenta 7, Kassel (Baselitz, Bechers, Beuys, Immendorff, Kiefer, Lüpertz, Penck, Polke, Richter)

Contemporary German Drawings: German Drawings of the Sixties, Yale University Art Gallery, New Haven (Baselitz, Beuys, Immendorff, Lüpertz, Penck, Polke, Richter). Traveling exhibition

Zeitgeist: Internationale Kunstausstellung, Martin-Gropius-Bau, Berlin (Baselitz, Beuys, Immendorff, Lüpertz, Penck, Polke)

4th Biennale of Sydney (Baselitz, Immendorff, Lüpertz)

Avanguardia transavanguardia, Mura Aureliane, Rome (Baselitz, Immendorff, Kiefer, Lüpertz, Polke)

1983
New Figuration – Contemporary Art from Germany, F. S. White Art Gallery, University of California – Los Angeles (Immendorff, Kiefer, Lüpertz)

Expressions: New Art from Germany, The Saint Louis Art Museum (Baselitz, Immendorff, Kiefer, Lüpertz, Penck). Traveling exhibition

XVII Bienal de São Paulo (Lüpertz, Penck)

1984
5th Biennale of Sydney (Beuys, Immendorff, Kiefer, Penck)

Aufbrüche, Manifeste, Manifestationen: Positionen in der bildenden Kunst zu Beginn der sechzier Jahre in Berlin, Düsseldorf und München, Städtische Kunsthalle Düsseldorf (Baselitz, Lüpertz, Penck, Polke, Richter)

1985
1945–1985: Kunst in der Bundesrepublik Deutschland, Neue Nationalgalerie, Berlin (Baselitz, Bechers, Beuys, Immendorff, Kiefer, Lüpertz, Penck, Polke, Richter)

German Art in the Twentieth Century: Painting and Sculpture 1905–1985, Royal Academy of Arts, London (Baselitz, Beuys, Immendorff, Kiefer, Lüpertz, Penck, Polke, Richter). Traveling exhibition

Carnegie International, Carnegie Museum of Art, Pittsburgh (Immendorff, Lüpertz, Polke, Richter)

*Das Auge des Künstlers –
Das Auge der Kamera*,
Frankfurter Kunstverein
(Ruff)

1986
6th Biennale of Sydney
(Beuys)

42nd Biennale di Venezia
(Polke)

1987
Documenta 8, Kassel
(Beuys, Kiefer, Richter)

Avant-garde in the Eighties,
Los Angeles County
Museum of Art,
(Immendorff, Kiefer, Polke)

Berlinart 1961–1987, The
Museum of Modern Art,
New York (Baselitz, Beuys,
Lüpertz). Traveling exhibition

XIX Bienal de São Paulo
(Kiefer)

1988
43rd Biennale di Venezia
(Lüpertz, Ruff)

Another Objectivity,
Institute of Contemporary
Art, London (Struth)

1989
*Refigured Painting: the
German Image 1960–1988*,
Toledo Museum of Art,
Ohio (Baselitz, Immendorff,
Kiefer, Lüpertz, Polke,
Richter). Traveling
exhibition

Bilderstreit, Museum
Ludwig, Cologne (Bechers)

*Erste Internationale Photo-
Triennale*, Galerie der Stadt
Esslingen (Gursky, Ruff)

*Photo-Kunst: Arbeiten aus
150 Jahren: du XXème au
XIXème siècle, aller et
retour*, Staatsgalerie
Stuttgart (Gursky, Struth)

*Erster Deutscher Photopreis
'89: Wettbewerb zur
Förderung der künst-
lerischen Photographie in
Deutschland*, Galerie
Landesgirokasse, Stuttgart
(Gursky, Höfer, Ruff)

XX Bienal de São Paulo
(Beuys)

1990
8th Biennale of Sydney
(Beuys)

44th Biennale di Venezia
(Bechers, Gursky, Ruff,
Struth)

*Günther Förg, Andreas
Gursky, Candida Höfer,
Thomas Ruff*,
Kunstverein Ulm

German Photography,
The Aldrich Museum of
Contemporary Art,
Ridgefield (Höfer)

1991
Typologies, Newport Harbor
Art Museum, Newport
Beach, California (Bechers,
Gursky, Höfer, Ruff, Struth)

Aus der Distanz,
Kunstsammlung Nordrhein -
Westfalen, Düsseldorf
(Bechers, Gursky, Höfer,
Ruff, Struth)

*Brennpunkt Düsseldorf 2:
Die siebziger Jahre,
Entwürfe – Joseph Beuys
zum 70. Geburtstag,
1970–1991*, Kunstmuseum
Düsseldorf im Ehrenhof
(Bechers)

*Surgence: La Création
photographique
contemporaine en
Allemagne*, Comédie de
Reims (Ruff, Struth).
Traveling exhibition

1992
Documenta 9, Kassel
(Beuys, Penck, Richter, Ruff,
Struth)

*Photography in
Contemporary German Art:
1960 to the Present*,
Walker Art Center,
Minneapolis (Bechers,
Beuys, Gursky, Höfer,
Kiefer, Polke, Richter,
Ruff, Struth).
Traveling exhibition

1992/93
9th Biennale of Sydney
(Beuys, Kiefer, Richter)

1993
45th Biennale di Venezia
(Lüpertz, Polke)

*Deutsche Kunst mit
Photographie: Die 90er
Jahre*, Deutsches
Architekturmuseum and
Deutsche Fototage,
Frankfurt (Gursky)

1994
*Five German Artists: Georg
Baselitz, Jörg Immendorff,
Per Kirkeby, Markus Lüpertz,
A. R. Penck*, MASP Brasil,
Fundacão Bienal de
São Paulo

1995
46th Biennale di Venezia
(Baselitz, Immendorff,
Lüpertz, Ruff)

Carnegie International,
Carnegie Museum of Art,
Pittsburgh, Pennsylvania
(Baselitz)

*Reconsidering the Object of
Art, 1965–1975*, The
Museum of Contemporary
Art, Los Angeles (Baselitz,
Bechers)

1996
*Beuys and After:
Contemporary Art from the
Collection of the
Kunstmuseum Bonn*, The
Museum of Modern Art,
New York (Beuys,
Immendorff, Richter)

11th Biennale of Syndey
(Gursky)

Distanz und Nähe, Institut
für Auslandsbeziehungen,
Stuttgart (Gursky, Höfer,
Ruff, Struth)

1997
Documenta 10, Kassel
(Richter)

47th Biennale di Venezia
(Kiefer)

*Deutschlandbilder: Kunst
aus einem geteilten Land*,
Martin-Gropius-Bau, Berlin
(Baselitz, Beuys,
Immendorff, Lüpertz,
Penck, Polke, Richter)
Traveling exhibition

*Absolute Landscape:
Between Illusion and
Reality*, Yokohama Museum
of Art (Gursky)

*Landschaften/Landscapes:
Michael Bach, Andreas
Gursky, Axel Hütte, Michael
van Ofen, Andreas Schön*,
Kunstverein für die
Rheinlande und Westfalen,
Düsseldorf

*Deep Storage: Arsenale der
Erinnerung*, Haus der
Kunst, Munich (Bechers,
Beuys). Traveling exhibition

1998
*Positionen künstlerischer
Photographie in
Deutschland seit 1945*,
Martin-Gropius-Bau, Berlin
(Bechers, Gursky, Polke,
Ruff, Struth)

12th Biennale of Sydney
(Struth)

1999
48th Biennale di Venezia
(Polke)

*Reconstructing Space:
Architecture in Recent
German Photography*,
Architectural Association,
London (Bechers, Gursky,
Höfer, Ruff, Struth)

2000
13th Biennale of Sydney
(Polke)

*Ansicht, Aussicht, Einsicht:
Andreas Gursky, Candida
Höfer, Axel Hütte, Thomas
Ruff, Thomas Struth*, Kunst-
geschichtliches Institut der
Ruhr-Universität, Bochum

2001
49th Biennale di Venezia
(Beuys, Richter)

2002
Documenta 11, Kassel
(Bechers, Höfer)

XXV Bienal de São Paulo
(Gursky, Ruff)

Georg Baselitz
Bibliography

Ackermeier, Hartmut. *Georg Baselitz: Bilder aus Berliner Privatbesitz* (exh. cat.), Berlin: Staatliche Museen zu Berlin, Nationalgalerie, Altes Museum; Berlin: Nicolaische Verlagsbuchhandlung, 1990

Baselitz: Escultura Frente a Pintura = Sculpture versus Painting (exh. cat.), Madrid: Aldeasa, 2001

Baselitz, Georg. *Manifeste und Texte zur Kunst 1966–2001.* Bern: Gachnung & Springer, 2001

Eccher, Danilo. *Baselitz* (exh. cat.), Bologna: Galleria d'Arte Moderna; Milan: Charta, 1997

Franzke, Andreas, and Edward Quinn. *Georg Baselitz.* Translated by David Britt. Munich: Prestel Verlag, 1989; distributed in the U.S. and Canada by te Neues Publishing Company

Fuchs, R. H., ed. *Georg Baselitz, Bilder 1977–1978* (exh. cat.), Eindhoven: Stedelijk Van Abbemuseum, 1979

Kunsthalle Bern. *Georg Baselitz: Malerei, Handzeichnungen, Druckgraphik* (exh. cat.), Bern: Kunsthalle Bern, 1976

Pagé, Suzanne, et al. *Georg Baselitz.* (exh. cat.) Paris: Musée d'Art Moderne de la Ville de Paris, 1996

Schwerfel, Hans Peter, and Georg Baselitz. *Georg Baselitz im Gespräch mit Heinz Peter Schwerfel.* Kunst heute, no. 2. Cologne: Kiepenheuer & Witsch, 1989

Szeemann, Harald, et al. *Georg Baselitz* (exh. cat.), Edited by Harald Szeeman. Zurich: Kunsthaus Zürich; Düsseldorf: Städtische Kunsthalle Düsseldorf, 1990

Waldman, Diane. *Georg Baselitz* (exh. cat.), New York: Solomon R. Guggenheim Museum, 1995

Bernd and Hilla Becher
Bibliography

Andre, Carl. "A Note on Bernhard and Hilla Becher." *Artforum* XI, no. 4 (December 1972), pp. 59–61

Becher, Bernhard, and Hilla Becher. *Anonyme Skulpturen: A Typology of Technical Constructions* (exh. cat.), Düsseldorf: Städtische Kunsthalle; New York: Wittenborn & Co., 1970

Catoir, Barbara. "Goldener Löwe für Anonyme Skulpturen. Bernd und Hilla Becher in Venedig." *Kultur Chronik* 5 (1990), pp. 11–14

Chevrier, Jean-François, and James Lingwood. *Another Objectivity* (exh. cat.), Paris: Centre National des Arts Plastiques; Prato: Museo d'Arte Contemporanee Luigi Pecci; Milan: Idea Books, 1989

Duve, Thierry De, *Bernd and Hilla Becher: Basic Forms.* New York: te Neues Publishing Company, 1993

Honnef, Klaus, *Bernd und Hilla Becher: Fotografien 1957 bis 1975* (exh. cat.), Bonn: Rheinisches Landesmuseum Bonn; Tübingen: Kunsthalle Tübingen, 1975

Kaufhold, Enno. "The Mask of Opticality: Photographs by Bernd and Hilla Becher, Bernhard Prinz, Thomas Ruff, Axel Hütte, Andreas Gursky, Günther Förg, and Thomas Struth." *Aperture* 123 (Spring 1991), pp. 56–69

Lange, Angela. "Die Industriephotographien von Bernd und Hilla Becher: Eine monographische Untersuchung vor dem Hintergrund entwicklungshistorischer Zusammenhänge." Ph.D. diss., Johann-Wolfgang von Goethe Universität zu Frankfurt am Main, 1998

Lingwood, James. "Bernd et Hilla Becher: The Music of the Blast Furnaces." *art press* 209 (January 1996), pp. 21–28

Ziegler, Ulf Erdmann. "The Bechers' Industrial Lexicon." *Art in America* 90, no. 6 (June 2002), pp. 93–101, 140–41, 143

Joseph Beuys
Bibliography

"Beuys: The Twilight of Idol, Preliminary Notes for a Critique." *Artforum* (January 1980), pp. 35–43. Reprinted in Benjamin H.D. Buchloh, *Neo-avantgarde and Culture Industry: Essays on European and American Art from 1955 to 1975.* Cambridge, Mass.: MIT Press, 2000

Hergott, Fabrice, et al. *Joseph Beuys* (exh. cat.), Zurich: Kunsthaus Zürich; Madrid: Museo Nacional Centro de Arte Reina Sofia; Paris: Éditions du Centre Pompidou, 1994

Joseph Beuys: Aktioner, Aktionen–Teckningar och Objekt 1937–1970 ur Samling van Grinten (exh. cat.), Stockholm: Moderna Museet, 1971

Joseph Beuys: Ideas and Actions (exh. cat.), New York: Hirschl & Adler Modern, 1988

Schellmann, Jörg, ed. Joseph Beuys, *The Multiples: Catalogue Raisonné of Multiples and Prints* (exh. cat.), Cambridge, Mass.: Busch-Reisinger Museum, Harvard University Museum; Minneapolis, Minn.: Walker Art Center; Munich: Edition Schellmann; distributed in the U.S. and Asia by D.A.P. / Distributed Art Publishers, 1997

Schneede, Uwe M. *Joseph Beuys, die Aktionen: kommentiertes Werkverzeichnis mit fotografischen Dokumentationen.* Ostfildern-Ruit bei Stuttgart: G. Hatje, 1994

Schulz, Rosmarie, and Stefan Graupner, eds. *Joseph Beuys: A Private Collection* (exh. cat.), Munich: A11 Artforum, 1990. Originally published in: Bastian, Heiner, and Götz Adriani, eds. *Joseph Beuys: Skulpturen und Objekte* (exh. cat.), Berlin: Martin-Gropius-Bau; Munich: Schirmer/Mosel, 1988

Stachelhaus, Heiner. *Joseph Beuys.* Düsseldorf: Claassen, 1987

Tisdall, Caroline. *Joseph Beuys* (exh. cat.), New York: Solomon R. Guggenheim Museum, 1979

Tisdall, Caroline, and Dieter Koepplin. *Joseph Beuys: The Secret Block for a Secret Person in Ireland* (exh. cat.), Basel: Kunstmuseum Basel, 1977

Andreas Gursky
Bibliography

Bryson, Norman. "The Family Firm: Andreas Gursky & German Photography." *Art/Text* no. 67 (November 1999/January 2000), pp. 76–81

Durand, Régis. "Andreas Gursky: Distance and Emptiness." *art press* 226 (July–August 1997), pp. 20–25

Felix, Zdenek, ed. *Andreas Gursky: Photographs 1984–1998* (exh. cat.), Hamburg: Deichtorhallen; Amsterdam: De Appel Foundation; Munich: Schirmer/Mosel, 1994

Galassi, Peter. *Andreas Gursky.* (exh. cat). New York: The Museum of Modern Art, 2001

Gronert, Stefan, ed. *Thomas Demand, Andreas Gursky, Edward Ruscha* (exh. cat.), Bonn: Kunstmuseum Bonn, 1999

Hess, Barbara, and Otto Kapfinger. *Lucinda Devlin, Andreas Gursky, Candida Höfer. Räume/Rooms* (exh. cat.), Bregenz: Kunsthaus Bregenz; Cologne: Verlag der Buchhandlung Walther König; Munich: Schirmer/Mosel, 1998

Jocks, Heinz Norbert. "Das Eigene steckt in den visuellen Erfahrungen: Andreas Gursky im Gespräch mit Heinz Norbert Jocks." *Kunstforum International* 145 (May–June 1999), pp. 249–65

Kaufhold, Enno. "The Mask of Opticality: Photographs by Bernd and Hilla Becher, Bernhard Prinz, Thomas Ruff, Axel Hütte, Andreas Gursky, Günther Förg, and Thomas Struth." *Aperture* 123 (Spring 1991), pp. 56–69

Ratcliff, Carter. "The Seeing Game." *Art in America* 86, no. 7 (July 1998), pp. 87–89

Steinhauser, Monika, and Ludger Derenthal, eds. *Ansicht, Aussicht, Einsicht: Andreas Gursky, Candida Höfer, Axel Hütte, Thomas Ruff, Thomas Struth: Architekturphotographie* (exh. cat.), Bochum: Kunstgeschichtliches Institut der Ruhr-Universität; Düsseldorf: Richter Verlag, 2000

Syring, Marie Luise, ed. *Andreas Gursky: Photographs from 1984 to the Present* (exh. cat.), Düsseldorf: Kunsthalle Düsseldorf; Munich: Schirmer/Mosel, 1998

Candida Höfer
Bibliography

Candida Höfer, Zoologische Gärten, Photographien (exh. cat.), Hamburg: Hamburger Kunsthalle; Bern: Kunsthalle Bern; Munich: Schirmer/Mosel, 1993

Hess, Barbara, and Otto Kapfinger. *Lucinda Devlin, Andreas Gursky, Candida Höfer. Räume/Rooms* (exh. cat.), Bregenz: Kunsthaus Bregenz; Cologne: Verlag der Buchhandlung Walther König, 1998

Hofmann, Barbara, et al. *Candida Höfer: Orte, Jahre. Photographien 1968–1999* (exh. cat.), Cologne: Photographische Sammlung/SK Stiftung Kultur; Nüremberg: Kunsthalle Nürnberg; Munich: Schirmer/Mosel, 1999

Magnani, Gregorio. *Candida Höfer: Räume/Spaces* (exh. cat.), Frankfurt am Main: Portikus; Cologne: Verlag der Buchhandlung Walther König, 1992

Pfleger, Susanne, ed. *Candida Höfer: Photographie* (exh. cat.), Translated by J. W. Gabriel. Wolfsburg: Kunstverein Wolfsburg; Recklinghausen: Kunstverein Recklinghausen; Oldenburg: Oldenburger Kunstverein; Munich: Schirmer/Mosel, 1998

Steinhauser, Monika, and Ludger Derenthal, eds. *Ansicht, Aussicht, Einsicht: Andreas Gursky, Candida Höfer, Axel Hütte, Thomas Ruff, Thomas Struth: Architekturphotographie* (exh. cat.), Bochum: Kunstgeschichtliches Institut der Ruhr-Universität; Düsseldorf: Richter Verlag, 2000

Jörg Immendorff
Bibliography

Adolphs, Volker, and Doris Hansmann, eds. *Jörg Immendorff: Malerdebatte* (exh. cat.), Bonn: Städtisches Kunstmuseum Bonn; Cologne: Wienand, 1998

Belgin, Tayfun, et al. *Immendorff: Bilder* (exh. cat.), Dortmund: Museum am Ostwall; Heidelberg: Edition Braus, 2000

Fuchs, R. H., et al. *Jörg Immendorff* (exh. cat.), Rotterdam: Museum Boymans van Beuningen; The Hague: Haags Gemeentemuseum, 1992

Gachnang, Johannes, et al. *Immendorff* (exh. cat.), Zurich: Kunsthaus Zürich, 1983

Immendorff, Jörg. *Hier und jetzt, das tun, was zu tun ist: Materialien zur Diskussion: Kunst im politischen Kampf: auf welcher Seite stehst Du, Kulturschaffender?* Cologne: Verlag ser Buchhandlung Walther König, 1973

Immendorff, Jörg. *LIDL 1966–1970* (exh. cat.), Eindhoven: Stedelijk Van Abbemuseum, 1981

Jörg *Immendorff: "Café Deutschland."* (exh. cat.) Basel: Kunstmuseum Basel, 1979

Kort, Pamela, and Jörg Immendorff. *Jörg Immendorff im Gespräch mit Pamela Kort.* Kunst heute, no. 11. Cologne: Kiepenheuer & Witsch, 1993

Schmidt, Marianne, and Johannes Gachnang, eds. *Jörg Immendorff: Malermut rundum* (exh. cat.), Bern: Kunsthalle Bern, 1980

Anselm Kiefer
Bibliography

Adriani, Götz, ed. *Anselm Kiefer: Bücher 1969–1990* (exh. cat.), Tübingen: Kunsthalle Tübingen; Munich: Kunstverein München; Zurich: Kunsthaus Zürich; Stuttgart: Edition Cantz, 1990

Anselm Kiefer (exh. cat.), Eindhoven: Stedelijk Van Abbemuseum, 1979

Biro, Matthew. *Anselm Kiefer and the Philosophy of Martin Heidegger.* Cambridge: Cambridge University Press, 1998

Gallwitz, Klaus. *Über Räume und Völker.* Frankfurt am Main: Suhrkamp Verlag, 1990

Harten, Jürgen, et al. *Anselm Kiefer* (exh. cat.), Düsseldorf: Städtische Kunsthalle Düsseldorf; Paris: ARC Musée d'Art Moderne de la Ville de Paris; Jerusalem: The Israel Museum, 1984

Rosenthal, Mark, et al. *Anselm Kiefer* (exh. cat.), Chicago: Art Institute of Chicago; Philadelphia: Philadelphia Museum of Art, 1987; distributed in the U.S. and Canada by te Neues Publishing Company

Rosenthal, Mark, and Angela Schneider, eds. *Anselm Kiefer* (exh. cat.), Berlin: Nationalgalerie Berlin, Staatliche Museen Preussischer Kulturbesitz, 1991

Rosenthal, Nan. *Anselm Kiefer: Works on Paper in the Metropolitan Museum of Art* (exh. cat.), New York: The Metropolitan Museum of Art, 1998; distributed by Harry N. Abrams

Saltzman, Lisa. *Anselm Kiefer and Art after Auschwitz.* Cambridge: Cambridge University Press, 1999

Schmidt-Miescher, Marianne, and Johannes Gachnang, eds. *Anselm Kiefer: Bilder und Bücher* (exh. cat.), Bern: Kunsthalle Bern, 1978

Markus Lüpertz
Bibliography

Caradnente, Giovanni. *Markus Lüpertz.* Milan: Fabbri Editori, 1994

Fuchs, R. H. *Markus Lüpertz* (exh. cat.), Eindhoven: Stedelijk Van Abbemuseum, 1977

Gohr, Siegfried. *Markus Lüpertz.* Barcelona: Ediciones Polígrafa, 2001

Gohr, Siegfried, and Kevin Power. *Markus Lüpertz, deutsche Motive.* Ostfildern-Ruit bei Stuttgart: Edition Cantz, 1993

Gretenkort, Detlev, and Ulrich Weisner, eds. *Raumbilder in Bronze: Per Kirkeby, Markus Lüpertz, A. R. Penck* (exh. cat.), Bielefeld: Kunsthalle Bielefeld, 1986

Markus Lüpertz: Gemälde und Handzeichnungen, 1964 bis 1979. (exh. cat.) Cologne: Josef-Haubrich-Kunsthalle, 1979

Markus Lüpertz: Rezeptionen – Paraphrasen (exh. cat.), Karlsruhe: Städtische Galerie im PrinzMaxPalais, 1991

Schwerfel, Hans Peter, and Markus Lüpertz. *Markus Lüpertz im Gespräch mit Heinz Peter Schwerfel.* Kunst heute, no. 4. Cologne: Kiepenheuer & Witsch, 1989

Titan: Markus Lüpertz in der Glyptothek (exh. cat.), Munich: Staatliche Antikensammlung und Glyptothek, 1996

Zweite, Armin, ed. *Markus Lüpertz: Gemälde, Skulpturen* (exh. cat.), Düsseldorf: Kunstsammlung Nordrhein-Westfalen; Ostfildern-Ruit bei Stuttgart: Edition Cantz, 1996

Zweite, Armin, et al. *Markus Lüpertz: Belebte Formen und kalte Malerei: Gemälde und Skulpturen* (exh. cat.), Munich: Städtische Galerie im Lenbachhaus; Munich: Prestel Verlag, 1986

A. R. Penck
Bibliography

A. R. Penck: Concept Conceptruimte / Konzept Konzeptraum (exh. cat.), Rotterdam: Museum Boymans van Beuningen, 1979

BROWN'S HOTEL and other works. (exh. cat.) London: Tate Gallery, 1984

Brunner, Dieter, et al. *A. R. Penck: Erinnerung, Modell, Denkmal = memory, model, memorial* (exh. cat.), Heilbronn; Städtische Museen Heilbronn; Heidelberg: Umschau/Braus, 1999

Dickhoff, Wilfried, and A. R. Penck. *A. R. Penck im Gespräch mit Wilfried Dickhoff.* Kunst heute, no. 6. Cologne: Kiepenheuer & Witsch, 1990

Gachnang, Johannes, and Marianne Schmidt, eds. *A. R. Penck* (exh. cat.), Bern: Kunsthalle Bern, 1975

Grisebach, Lucius, Thomas Kirchner, and Toni Stoss, eds. *A.R. Penck* (exh. cat.), Berlin: Nationalgalerie Berlin, Staatliche Museen Preussischer Kulturbesitz; Zurich: Kunsthaus Zürich, 1988; distributed by Prestel Verlag

Marcadé, Bernard. *A. R. Penck.* Classiques du XXIe siècle 2. Paris: Editions de la Différence, 1988

Werner, Michael, et al. *Zeichnungen bis 1975 / a. r. penck. Y* (exh. cat.), Basel: Kunstmuseum Basel, 1978

Yau, John. *A. R. Penck.* New York: Harry N. Abrams, 1993

Sigmar Polke
Bibliography

Buchloh, B. H., ed. *Sigmar Polke: Bilder, Tücher, Objekte: Werkauswahl 1962–1971* (exh. cat.), Tübingen: Kunsthalle Tübingen; Düsseldorf: Städtische Kunsthalle Düsseldorf; Eindhoven: Stedelijk Van Abbemuseum, 1976

Hentschel, Martin, et al. *Sigmar Polke: The Three Lies of Painting* (exh. cat.), Bonn: Kunst- und Ausstellungshalle der Bundesrepublik Deutschland; Hamburg: Nationalgalerie im Hamburger Bahnhof; Berlin: Museum für Gegenwart, Staatliche Museen zu Berlin, Stiftung Preussischer Kulturbesitz; Ostfildern-Ruit bei Stuttgart: Cantz, 1997

Schimmel, Paul, et al. *Sigmar Polke: Photoworks, When Pictures Vanish* (exh. cat.), Los Angeles: Museum of Contemporary Art; Santa Fe: Site Santa Fe; Washington, DC: Corcoran Gallery of Art; Zurich: Scalo, 1995

Sigmar Polke. (exh. cat). Rotterdam: Museum Boymans van Beuningen; Bonn: Städtisches Kunstmuseum Bonn, 1984

Sigmar Polke. (exh. cat). Paris: Amis du Musée d'Art Moderne de la Ville Paris, 1988

Stemmler, Dierk, ed. *Athanor: il padiglione; XLII. Biennale di Venezia 1986* (exh. cat.), Düsseldorf: Polk Studiolo, 1986

Vogel, Carl, ed. *Grafik des Kapitalistischen Realismus: K.P. Brehmer, Hödicke, Lueg, Polke, Richter, Vostell, Werkverzeichnisse bis 1971* (exh. cat.), Berlin: Galerie René Block, 1971

Gerhard Richter
Bibliography

Buchloh, Benjamin H. D. *Gerhard Richter* (exh. cat.), Paris: Centre National d'Art et de Culture Georges Pompidou, Musée National d'Art Moderne, 1977

Buchloh, Benjamin H. D. *Gerhard Richter: Abstract Paintings* (exh. cat.), London: Whitechapel Art Gallery, 1979

Buchloh, Benjamin H. D. et al. *Photography and Painting in the Work of Gerhard Richter: Four Essays on Atlas* (exh. cat.), Barcelona: Consorci del Museu d'Arte Contemporani de Barcelona, 2000

Buchloh, Benjamin H. D., Stefan Germer, and Gerhard Storck. *Gerhard Richter: 18. Oktober 1977* (exh. cat.), Krefeld: Museum Haus Esters; Frankfurt am Main: Portikus; Cologne: Verlag der Buchhandlung Walther Konig, 1989

Buchloh, Benjamin H. D., Peter Gidal, and Birgit Pelzer. *Gerhard Richter* (exh. cat.), 3 vols. Paris: Musée d'Art Moderne de la Ville de Paris; Bonn: Kunst- und Ausstellungshalle der Bundesrepublik Deutschland; Stockholm: Moderna Museet; Madrid: Museo Nacional Centro de Arte Reina Sofia, 1993

Harten, Jürgen, ed. *Gerhard Richter: Bilder/Paintings 1962–1985.* Cologne: DuMont, 1986

Obrist, Hans-Ulrich, ed. *Gerhard Richter: The Daily Practice of Painting: Writings and Interviews, 1962–1993* (exh. cat.), Cambridge, Mass.: MIT Press; London: Anthony d'Offay Gallery, 1995

Rainbird, Sean, Stefan Germer, and Neal Ascherson. *Gerhard Richter* (exh. cat.), London: Tate Gallery, 1991

Storr, Robert. *Gerhard Richter: Forty Years of Painting.* (exh. cat). Chicago: The Art Institute of Chicago; San Francisco: San Francisco Museum of Modern Art; Washington, DC: Hirshhorn Museum and Sculpture Garden, Smithsonian Institution; New York: The Museum of Modern Art, 2002

Vogel, Carl, ed. *Grafik des Kapitalischen Realismus: K. P. Brehmer, Hödicke, Lueg, Polke, Richter, Vostell, Werkverzeichnesse bis 1971.* Berlin: Galerie René Bloch, 1971

Thomas Ruff
Bibliography

Eskildsen, Ute. "On the Ambivalence of Photographic Representation." *Junge Leute.* Munich: Goethe Institut München, 1987

Kaufhold, Enno. "The Mask of Opticality: Photographs by Bernd and Hilla Becher, Bernhard Prinz, Thomas Ruff, Axel Hütte, Andreas Gursky, Günther Förg, and Thomas Struth." *Aperture* 123 (Spring 1991): pp. 56–69

Pohlen, Annelie. *Thomas Ruff* (exh. cat.), Arnsberg: Kunstverein Arnsberg; Braunschweig: Kunstverein Braunschweig; Sindelfingen: Kunst + Projekte Sindelfingen; Bonn: Kunstverein Bonn, 1991

Steinhauser, Monika, and Ludger Derenthal, eds. *Ansicht, Aussicht, Einsicht: Andreas Gursky, Candida Höfer, Axel Hütte, Thomas Ruff, Thomas Struth: Architekturphotographie* (exh. cat.), Bochum: Kunstgeschichtliches Institut der Ruhr-Universität; Düsseldorf: Richter Verlag, 2000

Thomas Ruff (exh. cat.), Malmö: Center for Contemporary Art, 1996

Thomas Ruff: Andere Porträts + 3D (exh. cat.), Ostfildern-Ruit bei Stuttgart: Edition Cantz, 1995

Winzen, Matthias, ed. *Thomas Ruff. Fotografien 1979–heute* (exh. cat.), Baden-Baden: Staatliche Kunsthalle Baden-Baden; Essen: Museum Folkwang; Oslo: Museet for Samtidskunst; Munich: Städtische Galerie im Lenbachhaus; Dublin: Irish Museum of Modern Art; Vitoria-Gasteiz: Artium, Centro-Museo Vasao de Arte Contemporaneo; Porto: Museo de Arte Contemporanea de Serralves; Liverpool: Tate Liverpool; Cologne: Verlag der Buchhandlung Walther König, 2001

Thomas Struth
Bibliography

Belting, Hans. *Thomas Struth: Museum Photographs* (exh. cat.), Hamburg: Hamburger Kunsthalle; Munich: Schirmer/Mosel, 1993

Chevrier, Jean-François. "Bernd und Hilla Becher, Thomas Struth." *Galeries Magazine* (December 1988)

Durand, Regis. "Realism and Recollection." *Art Press* 213 (May 1996), pp. 28–33

Eklund, Douglas, et al. *Thomas Struth, 1977–2002* (exh. cat.), Dallas: Dallas Museum of Art; Los Angeles: Museum of Contemporary Art; New York: The Metropolitan Museum of Art; New Haven: Yale University Press, 2002

Kaufhold, Enno. "The Mask of Opticality: Photographs by Bernd and Hilla Becher, Bernhard Prinz, Thomas Ruff, Axel Hütte, Andreas Gursky, Günther Förg, and Thomas Struth." *Aperture* 123 (Spring 1991), pp. 56–69

Lingwood, James, Kiyoshi Okutsu, Norman Bryson, and Peter Schjeldahl. "Open Vision," "Photography as Tautegory," "Not Cold, Not Too Warm," and "Epiphany." *Parkett* 50/51 (1997), pp. 136–74

Look, Ulrich. *Thomas Struth: Unconscious Places* (exh. cat.), Bern: Kunsthalle Bern; Edinburgh: The Fruitmarket Gallery; Münster: Westfälisches Landesmuseum; Frankfurt am Main: Portikus, 1987

Steinhauser, Monika, and Ludger Derenthal, eds. *Ansicht, Aussicht, Einsicht: Andreas Gursky, Candida Höfer, Axel Hütte, Thomas Ruff, Thomas Struth: Architekturphotographie* (exh. cat.), Bochum: Kunstgeschichtliches Institut der Ruhr-Universität; Düsseldorf: Richter Verlag, 2000

Weski, Thomas, et al. *Thomas Struth: Portraits* (exh. cat.), Hanover: Sprengel Museum; Munich: Schirmer/Mosel, 1997

General Bibliography:
Paintings and Sculpture

Art Allemagne aujourd'hui: différents aspects de l'art actuel en République fédérale d'Allemagne (exh. cat.), Paris: ARC/Musée d'Art Modern de la Ville Paris, 1981

Bonito Oliva, Achille. *Avanguardia, transavanguardia* (exh. cat.), Milan: Electa, 1982

Cowart, Jack, and Siegfried Gohr. *Expressions: New Art from Germany: Georg Baselitz, Jörg Immendorff, Anselm Kiefer, Markus Lüpertz, A. R. Penck* (exh. cat.), Munich: Prestel Verlag in association with the Saint Louis Art Museum, 1983

Dietrich-Borsch, Dorothea, *German Drawings of the 60s* (exh. cat.), New Haven, Connecticut: Yale University Art Gallery, 1982

Gillen, Eckhart, ed. *German Art from Beckmann to Richter: Images of a Divided Country* (exh. cat.), Cologne: DuMont Buchverlag in association with Berliner Festspiele GmbH and Museumpädagogischer Dienst Berlin, 1997; distributed by Yale University Press

Hunden tillstöter under veckans lopp = Der Hund stösst in Laufe der Woche zu mir: Jörg Immendorff, Per Kirkeby, Markus Lüpertz, A. R. Penck (exh. cat.), Stockholm: Moderna Museet, 1981

Joachimides, Christos M., and Norman Rosenthal. *Zeitgeist* (exh. cat.), Berlin: Martin-Gropius-Bau; Berlin: Frölich & Kaufmann, 1982

Joachimides, Christos M., Norman Rosenthal, and Nicholas Serota, eds. *A New Spirit in Painting* (exh. cat.), London: Royal Academy of Arts, 1981

Joachimides, Christos M., Norman Rosenthal, Wieland Schmied, Werner Becker. *German Art in the 20th Century: painting and sculpture, 1905–1985* (exh. cat.), London: Royal Academy of Arts; Stuttgart: Staatsgalerie Stuttgart; Munich: Prestel Verlag, 1985

Krens, Thomas, Michael Govan, and Joseph Thompson, eds. *Refigured Painting: the German Image, 1960–88* (exh. cat.), Munich: Prestel Verlag; New York: Solomon R. Guggenheim Museum, 1989

McShine, Kynaston, ed. *Berlinart, 1961–1987* (exh. cat.), New York: The Museum of Modern Art; Munich: Prestel Verlag, 1987

Schilderkunst in Duitsland 1981. (exh. cat.) Brussels: Paleis voor Schone Kunsten, 1981

General Bibliography:
Photographs

Butler, Susan. "The mis-en-scène of the everyday." *Art & Design* 10, nos. 9–10 (September–October 1995), pp. 17–23

Chevrier, Jean-François, "Bernd and Hilla Bechar, Thomas Struth." *Ceqleries Magazine* (December 1988)

Chevrier, Jean-François, and Ann Goldstein. *A Dialogue about Recent American and European Photography* (exh. cat.), Los Angeles: Museum of Contemporary Art, 1991

Freidus, Marc, et al. *Typologies: Nine Contemporary Photographers* (exh. cat.), Newport Beach, Calif.: Newport Harbor Museum; New York: Rizzoli International Publications, 1991

Herzogenrath, Wulf, ed. *Distanz und Nähe: Fotografische Arbeiten von Bernd und Hilla Becher, Andreas Gursky, Candida Höfer, Axel Hütte, Simone Nieweg, Thomas Ruff, Jörg Sasse, Thomas Struth, Petra Wunderlich* (exh. cat.), Stuttgart: Institut für Auslandsbeziehungen; Ostfildern-Ruit bei Stuttgart: Edition Cantz, 1996

Hofmann, Barbara, et al. *Insight Out: Landschaft und Interieur als Themen zeitgenössischer Photographie.* Zürich: Edition Stemmle, 1999

Mack, Michael, ed. *Reconstructing Space: Architecture in Recent German Photography* (exh. cat.), London: Architectural Association, 1999

Magnani, Gregorio. "Ordering Procedures. Photography in Recent German Art." *Arts Magazine* (March 1990), pp. 78–83

Schaffner, Ingrid, and Matthias Winzen, eds. *Deep Storage: Arsenale der Erinnerung. Sammeln Speichern, Archivieren in der Kunst* (exh. cat.), Munich: Haus der Kunst; Berlin: Nationalgalerie SMPK, Sonderausstellungshalle am Kulturforum; Düsseldorf: Kunstmuseum Düsseldorf im Ehrenhof; Seattle: Henry Art Gallery; Munich: Prestel Verlag, 1997

Wauters, Anne. "Realist Photographs, Ordinary Buildings." *Art Press* 209 (January 1996), pp. 40–47

p. 20 Staatliche Museen zu Berlin – Preussischer Kulturbesitz, Neue Nationalgalerie. © Bildarchiv Preussischer Kulturbesitz. © 2003 Artists Rights Society (ARS), New York/VG Bild-Kunst, Bonn. Photo by Jörg P. Anders, Berlin, 1990; p. 23 Tate, London. © Tate, London 2002; p. 24 Tate, London. © Tate, London 2002; p. 25 Tate, London. © Tate, London 2002; p. 32 Courtesy Michael Werner, New York and Cologne. © Georg Baselitz, Courtesy of Galerie Michael Werner, New York and Cologne. Photo by Jean Paul Torno; p. 34 Collection of Anabeth and John Weil. © Georg Baselitz, Courtesy of Galerie Michael Werner, New York and Cologne. Photo by Jean Paul Torno; p. 35 Öffentliche Kunstsammlung Basel, Kupferstichkabinett. © Georg Baselitz, Courtesy Galerie Michael Werner, New York and Cologne. Photo by Martin Bühler; p. 36 Saint Louis Art Museum. © Georg Baselitz, Courtesy of Galerie Michael Werner, New York and Cologne. Photo by Robert Pettus; p. 37 Stadt Aachen – Ludwig Forum für Internationale Kunst, Sammlung Ludwig. © Georg Baselitz, Courtesy Galerie Michael Werner, New York and Cologne. Photo by Anne Gold; p. 38 Saint Louis Art Museum. © Georg Baselitz, Courtesy of Galerie Michael Werner, New York and Cologne. Photo by David Ulmer; p. 39 Courtesy of the artist. © Georg Baselitz, Courtesy Galerie Michael Werner, New York and Cologne. Photo by Jochen Littkemann, Berlin; p. 40 Saint Louis Art Museum. © Georg Baselitz, Courtesy of Galerie Michael Werner, New York and Cologne. Photo by Jean Paul Torno; p. 42 Saint Louis Art Museum. © 2003 Artists Rights Society (ARS), New York/VG Bild-Kunst, Bonn. Photo by Robert Pettus; p. 43 Collection van der Grinten. Courtesy of Kestner-Gesellschaft Hannover. © 2003 Artists Rights Society (ARS), New York/VG Bild-Kunst, Bonn; p. 44 Saint Louis Art Museum. © 2003 Artists Rights Society (ARS), New York/VG Bild-Kunst, Bonn. Photo by David Ulmer; p. 45 © Ute Klophaus. © 2003 Artists Rights Society (ARS), New York/VG Bild-Kunst, Bonn. Photo by Ute Klophaus; p. 46 Saint Louis Art Museum. © 2003 Artists Rights Society (ARS), New York/VG Bild-Kunst, Bonn. Photo by David Ulmer; p. 47 Ströher Collection, Hessisches Landsmuseum, Darmstadt. © 2003 Artists Rights Society (ARS), New York; p. 48 Saint Louis Art Museum. © 2003 Artists Rights Society (ARS), New York/VG Bild-Kunst, Bonn. Photo by David Ulmer; p. 49 © Ute Klophaus. © 2003 Artists Rights Society (ARS), New York/VG Bild-Kunst, Bonn. Photo by Ute Klophaus; p. 50 Saint Louis Art Museum. © Jörg Immendorff, Courtesy of Galerie Michael Werner, New York and Cologne. Photo by Robert Pettus; p. 51 Courtesy Michael Werner, New York and Cologne. © Jörg Immendorff, Courtesy Galerie Michael Werner, New York and Cologne; p. 52 Saint Louis Art Museum. © Jörg Immendorff, Courtesy of Galerie Michael Werner, New York and Cologne. Photo by Jean Paul Torno; p. 53 Collection Garnatz, Cologne. © Jörg Immendorff, Courtesy Galerie Michael Werner, New York and Cologne; p. 54 Collection of Anabeth and John Weil. Photo by Bob Kolbrener; p. 56 Saint Louis Art Museum. Photo by Bob Kolbrener; p. 58 Saint Louis Art Museum. Photo by Bob Kolbrener; p. 60 Saint Louis Art Museum. © Markus

Lüpertz, Courtesy of Galerie Michael Werner Cologne, New York. Photo by Robert Pettus; p. 62 Saint Louis Art Museum. © Markus Lüpertz, Courtesy of Galerie Michael Werner Cologne, New York. Photo by Robert Pettus; p. 64 Saint Louis Art Museum. © Markus Lüpertz, Courtesy of Galerie Michael Werner, New York and Cologne. Photo by Robert Pettus; p. 65 Saint Louis Art Museum. © 2003 Artists Rights Society (ARS), New York/VG Bild-Kunst, Bonn. Photo by Bob Kolbrener; p. 66 Saint Louis Art Museum. © Markus Lüpertz, Courtesy of Galerie Michael Werner, New York and Cologne. Photo by Robert Pettus; p. 67 National Archaeological Museum, Athens; p. 68 Saint Louis Art Museum. © A. R. Penck, Courtesy of Galerie Michael Werner, New York and Cologne. Photo by Jean Paul Torno; p. 70 Saint Louis Art Museum. © A. R. Penck, Courtesy of Galerie Michael Werner, New York and Cologne. Photo by Jean Paul Torno; p. 71 Fukuoka Art Museum. © A. R. Penck, Courtesy Galerie Michael Werner, New York and Cologne; p. 72 Courtesy Michael Werner, New York and Cologne. © A. R. Penck, Courtesy of Galerie Michael Werner, New York and Cologne. Photo by Robert Pettus; p. 73 Saint Louis Art Museum. © A. R. Penck, Courtesy of Galerie Michael Werner, New York and Cologne. Photo by Robert Pettus; p. 76 Courtesy Michael Werner, New York and Cologne. © A. R. Penck, Courtesy of Galerie Michael Werner, New York and Cologne. Photo by Jean Paul Torno; p. 77 Courtesy Michael Werner, New York and Cologne. © A. R. Penck, Courtesy of Galerie Michael Werner, New York and Cologne. Photo by Jean Paul Torno; p. 78 Saint Louis Art Museum. © Sigmar Polke, Courtesy of Galerie Michael Werner, New York and Cologne. Photo by Robert Pettus; p. 80 Courtesy Michael Werner, New York and Cologne. © Sigmar Polke, Courtesy of Galerie Michael Werner, New York and Cologne. Photo by Galerie Michael Werner; p. 81 Private Collection. © Sigmar Polke, Courtesy Galerie Michael Werner, New York and Cologne; p. 82 Saint Louis Art Museum. © Sigmar Polke, Courtesy of Galerie Michael Werner, New York and Cologne. Photo by Robert Pettus; p. 83 © Timepix. © The George and Helen Segal Foundation/Licensed by VAGA, New York, NY. Photo by Roberto Brosan; p. 84 Saint Louis Art Museum. © Sigmar Polke, Courtesy of Galerie Michael Werner, New York and Cologne. Photo by Robert Pettus; p. 85 The Froehlich Collection, Stuttgart. © Sigmar Polke, Courtesy Galerie Michael Werner, New York and Cologne; p. 86 Saint Louis Art Museum. Photo by David Ulmer; p. 87 Sammlung Frieder Burda; p. 87 Courtesy of the artist; p. 88 Saint Louis Art Museum. Photo by Robert Pettus; p. 90 Saint Louis Art Museum. Photo by Anthony d'Offay Gallery; p. 91 Museum Ludwig, Cologne. © Rheinisches Bildarchiv Köln; p. 94–95 Saint Louis Art Museum. Photo by Bob Kolbrener; p. 96–97 Saint Louis Art Museum. Photo by Bob Kolbrener; p. 98–99 Saint Louis Art Museum. Photo by Bob Kolbrener; p. 100 Saint Louis Art Museum. Photo by Bob Kolbrener; p. 101 Private Collection. Photo courtesy of Gerhard Richter; p. 107 Courtesy of the artist and Marian Goodman Gallery, New York; p. 108 Berlinische Galerie, Photographische Sammlung. Courtesy of the artist and 303 Gallery, New York; p. 109 Courtesy of the artist

and Metro Pictures; p. 110 Tate, London. © Tate, London 2002. © 2003 Artists Rights Society (ARS), New York/VG Bild-Kunst, Bonn; p. 111 Courtesy of the artist and Andrea Rosen Gallery, New York; p. 118 Saint Louis Art Museum. Courtesy of the artists and Sonnabend Gallery, New York. Photo by David Ulmer; p. 120 Saint Louis Art Museum. Courtesy of the artists and Sonnabend Gallery, New York. Photo by David Ulmer; p. 121 Museum Ludwig, Cologne. Courtesy of the artists and Sonnabend Gallery, New York. © Rheinisches Bildarchiv Köln; p. 122 Saint Louis Art Museum. © 2003 Artists Rights Society (ARS), New York/VG Bild-Kunst, Bonn. Photo by David Ulmer; p. 124 Saint Louis Art Museum. © 2003 Artists Rights Society (ARS), New York/VG Bild-Kunst, Bonn. Photo by David Ulmer; p. 126 Saint Louis Art Museum. © 2003 Artists Rights Society (ARS), New York/VG Bild-Kunst, Bonn. Photo by David Ulmer; p. 128 Saint Louis Art Museum. © 2003 Artists Rights Society (ARS), New York/VG Bild-Kunst, Bonn. Photo by Greenberg Gallery, St. Louis; p. 129 Courtesy of the artist and David Zwirner, New York; p. 130 Saint Louis Art Museum. © 2003 Artists Rights Society (ARS), New York/VG Bild-Kunst, Bonn. Photo by Bob Kolbrener; p. 132 Saint Louis Art Museum. © 2003 Artists Rights Society (ARS), New York/VG Bild-Kunst, Bonn. Photo by David Ulmer